KENNEDY'S

GUIDE TO ARTS MARKETING

RHINEGOLD
PUBLISHING LIMITED
2A FLORAL STREET LONDON WC

First published 1984 in Great Britain by Rhinegold Publishing Ltd., 52A
Floral St., London WC2E 9DA, Great Britain.

© Keith Diggle 1984

Guide To Arts Marketing

Keith Diggle

ISBN 0 946890 01 3 (Paperback)
ISBN 0 946890 00 5 (Hardback)

Printed in Great Britain by Perfectaprint, Byfleet, Surrey.

This book is dedicated to:

My wife, Heather, who resisted the temptation to carry out research for me, check my spelling and grammar, edit my drafts and do my typing, wisely leaving these matters to me, in order to concentrate on her own far more important career as a teacher of English and Drama and, as mother of our two demanding sons, who gave me time off from my paternal duties to enable me to write this book and attend to its production.

My colleagues and friends, Tony Gamble and Colin Wills, who have made possible the framework of my professional life for the past five years or so and have been more supportive and encouraging in a practical way than anyone else—and the staff of Classical Music *magazine, a family of sorts, with whom I have lived in happy symbiosis, part consultant, part tenant, and now part owner. Also, Hugh Barton, without whose prodigious energies our* Subscribe Now! *campaign in 1980 would not have succeeded as it did.*

All those with whom I have worked since I started to play the gambler's game of arts promotion and have helped me to learn how to beat the odds: Neville Dilkes, the conductor and founder of the English Sinfonia who wooed me away from jazz promotion to the even riskier world of classical music and who taught me how to enjoy it, and my hard working and talented colleagues from Merseyside Arts Association days, Peter Bevan, Lynne Burton and David Pratley, who learned their craft with me in that hard school and have all gone on to bring credit to themselves in other, even more demanding, roles.

My many and various clients over the years and in particular Christopher Bishop, managing director of the Philharmonia Orchestra, who has always known where my talents, such as they are, begin and end and has, within those two extremes, fully exercised them. He has also made me laugh more than most and for that he holds a special place.

Escaping the chronology of these dedications and transcending them, Danny Newman, the American who got there years before me and whose ability to guide and inspire I shall always admire and envy. We approach our goal in different ways (not so very different these days) but it is the same goal and that is why we are, and always will be, firm friends. I join the thousands of people in the world who pay tribute to his unique contribution as the man who made an art out of arts marketing.

Penultimately, and only so placed because hers is almost the final task in making this book fit for human consumption, Marianne Barton, the Editor of the British Music Yearbook, a valued colleague, who has agreed to put the final touches to this book and is my editor.

And finally, the Arts Council of Great Britain, without which . . .

Other publications by Keith Diggle:

Marketing the Arts, an introduction and practical guide, published in 1976 by The City University, London.

"Only Connect", the arts provision system in the UK, published in 1980 by The Calouste Gulbenkian Foundation (UK and Commonwealth Branch).

CONTENTS

v

Graphs and diagrams/illustrations by Ann Chasseaud.

FOREWORD

by Danny Newman

Don't let the fact that Keith Diggle, the author of *Guide to Arts Marketing* is, amongst his other activities, a university lecturer, mislead you, for his book is anything but academic, although it is literate, lively and lucid. And it is replete with sound counsel for both novitiate and veteran in the stewardship of the performing arts (and the visual ones, too). It is born out of a richness of experience in the front lines of the on-going battle for arts survival and thrival, 'gainst the background of society's benign neglect of the aesthetic values which only a small minority holds dear.

If you're an artistic director, arts administrator, marketer, or controller, or a volunteer member of a board of trustees, Diggle offers you numerous, important insights and valuable instruction, ranging across the entire spectrum of our daily, normally abnormal considerations. All of this should be as mother's milk for those who labour in the vineyards of our special world, which in certain respects closely resembles conventional commerce, but in other respects, not at all. And it is in the latter area of listening for—and hearing—the beat of our own drummer, that his book scores greatly. Yet, when common sense does cry for the very same approaches which are favoured by the marts of trade, the book advises that course of action, with directness and clarity.

While for me, the committed (read 'subscriber') audience remains a single-minded, obsessive, interest, Diggle has, in this book, evidenced much greater broad-mindedness, I admit. For he marshals, illuminates and elucidates upon the best strategies for entrapping those slothful, fickle, single ticket-buyers who I may have sometimes too hastily given up on, and have, for some years now, been vigorously and vengefully excoriating on five continents, hardly to mention a number of islands.

In my own book, *Subscribe Now!*, which I am proud to say is now in use in more than 30 countries and which originally brought Keith Diggle and myself together as colleagues, I purposefully short-shrifted those occasional ticket-wicket patrons who, of course, didn't fit into my subscription Procrustean bed. However, Diggle has now redressed this imbalance (although I am not yet prepared to say 'injustice'), and has thus made a more all-encompassing contribution than I did. What he has to say also applies, of course, to our quest for the saintly subscriber and this he offers (he kindly informs me) as both a complement and a compliment to my own work in the field.

1

He has, in the process, provided painstaking and penetrating analysis of the methodologies he espouses, and he injects no small quotient of amusing, satirical commentary on the stock myths which so many people 'round the arts have traditionally repeated as if they were articles of faith, but which do not stand up in the light of Diggle's practical and pragmatic knowledgeability. Overall, he has dealt in depth, and most thoughtfully, with the everyday perplexities and vexations of the arts' promotional practitioners, and has buttressed them with the philosophical base and the attitudinal rationale which can serve them well through their vicissitudes. This may well, I hope, inculcate a higher level of *esprit-de-marketing-corps* than is often found in arts circles, where pride of vocation is the province of artists, but not for those who give so much in the struggle to provide those artists with audiences, when 'hits' are, as we all know too well, so few and far between.

While there are libraries full of books about drama, music, dance, painting and sculpture, with additional volumes of that genre being regularly published in increasing numbers (and this is certainly preferable to having more and more books about many subjects that I can think of), there are really very few—really too few—books concerning the concepts and methods through which people may be brought to attendance of those arts in the greater numbers that are required for their economic viability and their honour. That is why the appearance of the *Guide to Arts Marketing* is a significant development. It has been conceived and written by a person whose entire life and distinguished professional career has been focused on seeking and finding the solutions to the questions propounded and answered in this fine work for which I have the privilege of writing a brief foreword at this time.

I recommend it to you and wish you well as you address yourselves to the task of finding, building and keeping firm hold of the audiences that give purpose to the arts we all hold dear.

Danny Newman
Chicago, Illinois, USA.
January, 1984

PREFACE

I should like to think that this book will be read by everyone who is involved in 'putting on shows'—not just publicists, but administrators, artistic directors, financial directors, box-office managers, senior and junior staff alike, professional and amateur. I should also like it to be read by the people who give their time to sit on the boards, executive committees and councils of our arts bodies, who have the power to hire and fire the professionals and to influence what they do. I hope that it will be read by the people who work for the Arts Council of Great Britain, for the arts councils of Scotland and Wales and the regional arts associations. If it found its way into the hands of politicians in national and local government who are interested in the arts and how they may be sustained, and onto the desks of the civil servants and local government officers who have responsibility for the arts, it would be no bad thing. It would do no harm for it to be read by the people who give money to the arts or support them through sponsorship.

Now, that is just in Great Britain. I hope that it will be read much further afield because what I have to say in the book should be of interest to anyone, anywhere, who faces the problems (or shall we say *challenges*?) of putting on shows or managing or funding the people who put on shows.

In my own British sort of way I am every bit as passionate about what I do for a living as my good friend and transatlantic colleague, Danny Newman—and, given an audience, I can be almost as spirited as he in my attacks on those who fail to see that *growth* means life to us. In one sense I have been very lucky in my career because I have never occupied a warm seat; each job has been the start of a new project and there has been no alternative but to grow. It has been hard work but there has been growth—which means that more has been achieved; I have found the experience very stimulating and, sooner or later, good fun. This book is about how to make things grow and, I hope, how to enjoy doing it.

I am reasonably confident that my *Guide to Arts Marketing* will help the individual understand the principles and practice of the job but I am less happy about its chances of changing the context in which the individual works. People who work in the arts really must work together if they are to learn from each other; we are, I believe, a pretty insecure bunch, and we prefer to hide our failures rather than talk about them and learn from them. We must educate ourselves and that means wholehearted co-operation and frank discussion; this book cannot do it alone.

There must be a change in the way public money is used to support the arts organisations so that growth, not stasis, is encouraged. I believe that

art without people ain't no art at all and the never-ending babble about subsidy—how much, who's getting it, who's not getting it—distracts us from our purpose which is to bring art and people together. You need subsidy to do that, of course, but the arguments about subsidy hardly ever mention *people*; the debate is an intellectual exercise that never seems to put its feet on the ground. Full houses are the ultimate argument and justification for subsidy.

The arts have always been a bit of a political battleground but never more so than today, as I write, in Great Britain. Yes, I am sure that more middle-class people attend arts events than do working-class people and I am sure that this is probably very wrong but I also know from some 20 years' experience that we are talking about the relative sizes of two grains of sand—one may be bigger than the other but if you have a house to build, who cares when you need a ton of sand? Like the subsidy argument, it is a distraction that wastes time. There are enough people out *there* from whatever class who are not buying your tickets so cut the cackle and start selling.

I hope that you enjoy reading this book and that it helps you.

Keith Diggle
London, England.
January, 1984

CHAPTER ONE

WHY WE DON'T MARKET THE ARTS

The public knows what it wants and there's nothing we can do to change that.

Our reduced audiences are the result of a general recession in the economy and until things improve there is no point in throwing good money after bad.

As artistic director my job is to produce it—*your* job is to sell it.

If we could identify precisely what it is that the public wants, then we could supply it.

We must have a more popular programme. If only there were more stars around.

Art is currently only for the middle classes—I want a new, working class audience.

We seem to be attracting only old people. Let's aim for a young audience.

I hate this word 'marketing'; commercialism has no place in the arts.

All I want to see on that poster is What it is, Where it is, When it is and How Much it is.

Why don't we produce a standard handbill in sufficient quantity to last us for a couple of years and then just fill in the details for each event ?

But we've always produced 5000 brochures.

I have just cleaned out the mailing list and I've got it down to just over a thousand. That will save us some money.

We'll leave it to the designer to flesh out the idea.

Basically I disapprove of all advertising whether in the commercial world or in the arts: it is wrong to make people want things they don't need.

If we are going to attract big new audiences we've got to zap up the advertising—sell it BIG! sell it BOLD! sell it like SOAP POWDER!

We must advertise in that paper because they give us a marvellous discount.

Of course people must send us a stamped, addressed envelope with their orders; we certainly can't afford the cost of posting tickets back to them.

Catch me paying commission to a credit card company!

You must always have expensive seats for the wealthy and cheap seats for the poor.

Discounting tickets is simply throwing money away and it makes us look cheap.

I'm not having my staff telephoning customers to sell tickets: it's a gross intrusion on people's privacy.

The Union agreement does not permit us to offer incentives to our personnel.

Do you remember what e.e. cummings said? 'A salesman is an it that stinks excuse.'

Sales not doing too well? 'Phone around the schools.

I'm afraid that audience income is below estimate so we're going to cut expenditure. How much can we save on publicity?

This campaign is very attractive but how can we be sure that it is going to work?

Supposing we go ahead and implement this scheme and suppose it is successful. How are we to know that it was due to the scheme and that the improvement in audiences wouldn't have happened anyway?

Whatever we do we must always have seats available for the person who comes at the last minute.

A good show sells itself.

Succeeding? Of course we're succeeding; we're right on target to meet our forecast deficit.

Things aren't looking too good. I'll ask the chairman to write to the Arts Council of Great Britain.

Things. aren't looking too good. We'd better start looking for some sponsorship.

Things aren't looking too good. I wonder what jobs are being advertised this week.

It'll be all right on the night.

Tickets cannot be exchanged or returned after purchase.

Of course we market our shows—we have a marketing officer, don't we?

Telephone bookings must be confirmed and tickets collected at least one day before the performance.

If we lose less money than our estimates show they'll cut our grant next year.

Look, they've lost less money than they estimated. Let's cut their grant next year.

This subscription scheme has created an awful lot of work for the box office—they're not happy down there.

The only successful form of advertising is word-of-mouth.

My uncle is a printer . . .

If art is to be accessible it must be free.

All publicity is good publicity.

A concessional reduction of 10 per cent is available to parties of 20 or more.

If I admit I need help they'll think I'm not up to the job.

CHAPTER TWO

A STATE OF THE ART REPORT

'Money is Allocated and Then it is Spent'

Several years ago, just after the publication of my first book on this subject in 1976, I went to see an eminent civil servant who was concerned with the allocation of money to the arts. I had sent him a copy of the book and suggested that we might meet for a talk about it. I was hoping that by going to the top, or very near to it, I might influence some of the thinking behind the government's approach to the funding of the arts.

The man listened to me very politely and then he disabused me of my naïvety. 'The simple fact is', he said, 'money is allocated and then it is spent. All that matters from a political viewpoint is how much is allocated. And that is the end of the matter as far as we are concerned.'

Sponsorship Takes the Limelight

That particular civil servant has moved on. Government policy has changed a little but not very much; certainly not very much as far as arts marketing is concerned. The change has been in the way in which Government has embraced the idea of arts sponsorship which, over the past few years, has had the spotlight of official publicity directed upon it. This has had an excellent effect upon one aspect of arts funding, and through this official endorsement a climate has been created in which the commercial sector can feel that an involvement with arts projects is worthwhile and will be smiled upon from on high. Since the mid-seventies there has been the Association for Business Sponsorship for the Arts (ABSA) and this body, through its own efforts and the positive support it has received from Government, has contributed considerably to this benevolent climate. The activities of small, busy, commercial,'middleman' agencies, whose business is the bringing together of arts and business organisations so that sponsored events will be the outcome, have also made a considerable contribution. The arts organisations themselves have, quite understandably, welcomed the developments enthusiastically and have done quite a lot to spread the gospel of sponsorship.

The arts need money. It is a simple enough statement and, as my civil servant said, all that seems to matter is how much is allocated. More is better and if more can be obtained through sponsorship then that is much

better. One can well appreciate the appeal of sponsorship to the politician, particularly to the politician in hard times.

It seems difficult for the arts community (and here I include the whole shebang from Minister for the Arts onwards) to concentrate on more than one thing at a time and in the enthusiastic rush for sponsorship the case for arts marketing has been overlooked. The arts produce deficits, therefore they must have money to cover those deficits: the money must come from Government, via the Arts Council of Great Britain, and from sponsorship. End of story. But there is more to the story.

Stock Going Bad on the Shelves

Towards the end of 1979, just before my friends Tony Gamble, Colin Wills and Hugh Barton, and I, introduced the American 'evangelist' of subscription marketing, Danny Newman, to the UK arts world as a whole, I made a few observations and calculations. In the 1977/78 financial year (the most recent at the time for which figures were available) the Arts Council of Great Britain had paid out more than £32 million in grants to this country's arts organisations direct and £7 million more to the Scottish and Welsh Arts Councils. Nearly £40 million were going to meet the operating deficits of the arts. On top of that figure there was more going in from Local Government and from sources such as the charitable bodies and so on. At around the same time a figure of £4 to £5 million was being estimated as the value of the money coming from the business community in the form of arts sponsorship. A fair estimate of the size of the macro-deficit was in the order of £50 million plus.

At the same time I tried to work out a figure for the total value of the tickets that had not been sold during the same period and I arrived at a figure of (very approximately) £10 million. No-one has ever challenged that figure and, indeed, when the secretary-general of the Arts Council of Great Britain at that time, Sir Roy Shaw, made his own estimate in 1982, he put the amount at £20 million of 'lost' money (he attributed the figure to me, incorrectly as it happens, but he was probably more accurate, being in a far better position to make such assessments), and I am sure that the situation is not improving.

Whatever the figure, it is a lot of money to go down the drain, a lot of 'stock going bad on the shelves'. What it means is that a lot of good things have been there ready to be experienced, the product of much human energy and imagination (not to mention considerable funding), and they have not been experienced. It means that those millions of pounds of public and private money have not been stretched to the limit in terms of public benefit.

Had all those tickets been sold, the Arts Council or the recipient arts organisations would have had another £10 million to spend; if we accept Sir Roy Shaw's figure than it would have had another £20 million.

All the indications are that since I made those rough calculations audiences have been declining. One reason is obvious enough; money is tight these days and with higher transport costs and all the other peripheral expenses that go along with a night out, people watch their pockets. So real income from audiences is probably declining. In a situation where grants (in relation to inflation) are frozen, the next step for arts bodies is to reduce expenditure so that the very things that are likely to build audiences are reduced. We thus see the beginning of the downward deficit spiral.

One would have to be extremely optimistic of the potential of arts sponsorship to believe that it could ever grow at such a pace that it could keep up with the ever widening gap betwen expenditure and income. Indeed, times are equally hard for business, and there is much to suggest that the early, rapid growth in sponsorship has levelled off.

The only real hope lies in our learning how to market our art successfully. To sell all our tickets, to have our art galleries thronged in our world where we are always trying to expand the range of experiences offered, may be beyond our wildest dreams, but to sell *most* of them—to have our galleries and museums *very* busy—is within the realms of possibility. Think of the benefits if we could achieve this. We would be using public money to the full, stretching every pound to its limit. We would be dealing with more people; that is our job. We would be offering the sponsor a much better deal; more people to influence. Most important of all, we would be experiencing real success, we would be gaining in self-confidence, we would be arresting that downward spiral and starting an upward, growing spiral with success breeding success. We would be feeling very good.

As I write this we have in this country a Conservative government that is dedicated to encouraging the spirit of free enterprise, self-reliance and growth but is blinkered when it comes to the arts. In the early years of its government it did what a government should do in respect of providing grant aid. But it has failed to recognise that the arts organisations are businesses, trading concerns, and they have very similar economic problems to those of commercial businesses. The fact that they lose money at the end of the day does not stop them from being businesses nor protect them from the need to be businesslike. The government does not exhort the business community to look for hand-outs, it tells them to get out there and sell. When it comes to the arts it recommends sponsorship.

I am not saying that sponsorship has no place in our world, but surely it must take second place to the importance of encouraging arts bodies to get out there and sell?

The Influence of Individuals Rather than Organisations

I tend to think of the development of arts marketing in terms of how things looked to me at the time I wrote *Marketing the Arts* (published by The City University 1976) and how things have changed since then. The publication of the Council of Regional Theatres' (CORT) marketing manuals in three volumes from 1977 onwards and their subsequent revised editions under the aegis of the Theatrical Management Association (TMA) is good progress; the manuals are published with the assistance of the Arts Council and written by people who do the job.

When I visited Australia in 1979 to conduct marketing seminars I met Tim Mason, an Englishman who was running the Western Australia Arts Council; the rapport we established then gave that Arts Council an orientation towards arts marketing that travelled with Tim Mason to his new position as director of the Scottish Arts Council, leading to much good work being done in encouraging the practice of good arts marketing, and the training of arts administrators. The Theatr Clwyd in Mold, North Wales, had as its administrator Roger Tomlinson, who was particularly interested in theatre marketing. When he became drama director of the Welsh Arts Council his influence on this aspect of the work of Welsh Arts Council clients was quickly noticeable. Ian Lancaster, who did much good work on the development of mailing systems when working in East Midlands Arts Association, went on to become assistant director (Arts) with the Calouste Gulbenkian Foundation. In his time there he took many initiatives that moved arts marketing forward and was an enthusiastic supporter of the drive Tony Gamble, Colin Wills, Hugh Barton and I had started to encourage the use of subscription based marketing. There are plenty of other examples of individuals who see the improvement of arts marketing as being perhaps the only real hope for the future.

The Arts Council of Great Britain has developed its own direct involvement in the marketing work of some of its clients and through, for example, seminars arranged with the TMA, has contributed to training programmes. However, although these are moves in the right direction, the Council has never really put the weight of its authority and power behind any major drive for progress.

Progress has been made in the arts marketing field but this has been as the result of the efforts of comparatively few individuals not because of shifts in policy at the highest level.

Impetus Provided by the Subscription Idea

Since 1976 my contribution has been that of an independent working on my own account but in very close contact with the subsidised sector. Without

doubt the most exciting time for me was our 'Subscribe Now!' campaign involving Danny Newman, which started in January 1980. When an organisation waves a banner as colourful and strident as Newman's 'Dynamic Subscription Promotion' it is likely to become controversial. The whole idea of subscription marketing became a major talking point with both professional arts administrators and people in the media engaging in the debate on whether subscription was a good thing or not. As a result there was more discussion and more media coverage on the subject of audience building in the year following Newman's visit than there had been in the ten years before.

When my friends and I got to know Danny Newman we were surprised to learn that he had already spoken to many people of influence in arts administration in the UK and none appeared to have realised the wider implications of what he was saying. Certainly no-one had done anything about spreading the word. He had carried out consultancy work with Scottish Opera, the Scottish National Orchestra and the Birmingham Repertory Theatre before we came on the scene but his visits here had all happened, as it were, in isolation with no wider benefits for the arts community as a whole. We set out to give the whole idea a public airing, and created our own consultancy company to make advice available to those who were inspired by Newman at the seminars we arranged for him. In the four seminars held, we brought together what must have been the largest collection of senior arts administrators ever seen in the UK. Newman was retained as our consultant and with him we then set out to analyse the marketing of many arts organisations, to make recommendations as to whether subscription was right for them and to provide a consultancy service where required.

The interest was considerable and has been sustained. At the time of Newman's visit there was but a handful of arts bodies using the subscription method and now there can hardly be more than a handful who have not either introduced it or at least seriously considered it. There were many administrators who asked what all the fuss was about. They pointed out that subscription was not a new thing, that most music clubs in the UK encouraged their members to attend a series of concerts rather than going on an occasional basis. They missed the essential thrust of the argument which was a total shift of emphasis in what was to be sold and how it was to be sold. Apart from anything else, Newman's message was about determination to succeed, the importance of energy and the personal satisfaction that comes from achievement. His was a very 'Conservative' argument.

Many arts administrators turned to us for guidance. Some decided to tackle the task themselves, others asked us to plan campaigns for them. Hugh Barton and I were the roving consultants of the company formed

with Colin Wills and Tony Gamble, called 'Subscribe Now! (UK) Ltd.' and in the two years or so following Danny's visit life consisted of train and aeroplane journeys, lengthy reports, meetings, planning sessions, worry, tension, and moments of great excitement and fun. During this period I was fortunate in being able to work on the development of a subscription scheme for the Churchill Theatre, Bromley which, because of the determination of its then artistic director, Ian Watt-Smith, and its subscription manager at the time, Sheila Dunn, followed the classic pattern of a Danny Newman-style runaway success. Halfway through the run of the final play in the first season (Neil Simon's *Barefoot In The Park*), I paid a surprise visit to the theatre where, because of the capacity audience, I watched the show sitting on the steps in the aisle. The theatre had never before experienced audience attendances like it. I also had the privilege of becoming the marketing consultant to the Philharmonia Orchestra and since that time we have together built a fine, loyal (and large!) group of subscribers with the orchestra regularly beating all comers in the battle to win audiences at the Royal Festival Hall. There were many others, some successful, others not, but none so exciting and rewarding as the Churchill Theatre and the Philharmonia Orchestra.

The wonderful thing about subscription is the way in which it focuses the organisation on success; it changes the whole orientation so that the organisation stops thinking that success is only good shows and the achievement of a planned deficit and begins to realise all the benefits that will flow from *real* achievement. Artistic directors think about what they might do if they had the security of a capacity audience on a regular basis. Financial administrators begin to think of expenditure as something which can generate greater income rather than greater losses. Publicity officers think of bigger budgets, stronger campaigns and (during sleepless nights when their thoughts wander) the interview for their next job when they can trot out an impressive list of achievements. Chairmen of executive committees think of the prestige that will accrue to them. And so on.

Not all subscription campaigns have been successful. Some organisations have jumped enthusiastically on the band wagon, produced their colourful brochures, shouted the magic words 'Subscribe Now!' and watched their subscribing audiences grow to only a few hundred. There are times when it seems impossible to break out of a situation where audience levels have matured at an unsatisfactory level and nothing can shift them. But even if the result is disappointing at least the attempt has been made and more has been learned. What I learned from it was that to be successful subscription has to be handled by a good marketer, and that in the hands of a tyro it can prove a costly failure.

Since 1980 we have been working more or less in isolation and without the back-up of official support. We have never asked for support in the

form of money but would have valued highly an association with the Arts Council and organisations such as the TMA that permits the regular exchange of ideas, joint projects that will test ideas and help us all to develop, and to receive the acknowledgement that we are part of the same world, with the same ideals and goals. We have, sadly, been kept very firmly outside the 'official' world of arts administration almost as if the fact that we do not seek subsidy, and we earn our livings in the market place like the majority of people, makes our work irrelevant.

Progress in arts marketing is also limited by the financial risk inherent in almost all schemes intended either to build audiences or, as we did with the 'Subscribe Now!' project, to contribute to the training of arts administrators. When we launched our project we made two trips to Chicago and one to New York to consult Danny Newman and to visit many American arts bodies that were using subscription successfully. We imported hundreds of copies of Newman's book, *Subscribe Now!* and marketed them through direct mail. We brought Danny to the UK and promoted his seminars heavily; we retained him as our company's consultant. We invested our time and our money in the belief that it would be worthwhile. For a new, unsubsidised company it represented a very substantial risk which Hugh Barton and I could not have taken had we not been supported morally and financially by Colin Wills and Tony Gamble who believed in us and the idea. It might fairly be said that a system that truly recognised the importance of building audiences would have done what we did some years before or would, once it saw what we were about, have offered at least dialogue. We remember with pleasure and gratitude the reactions first of the Scottish Arts Council which, on learning of our plans immediately volunteered to run its own Danny Newman Seminar, and secondly of the Calouste Gulbenkian Foundation which, through the influence of Ian Lancaster, made funds available to certain arts bodies to enable them to pay our consultancy fees. Without the Gulbenkian Foundation we should not have been able to work on schemes with the Everyman Theatre, Liverpool, the Arnolfini Gallery, Bristol and the Nash Ensemble.

Financial Support for Marketing Schemes

To try to change an existing, matured, but unsatisfactory, marketing scheme needs considerable courage on the part of the prime mover. This is true in both the commercial and subsidised sectors. Investment of money, time and energy is vital. And it is a risky business. If one is operating commercially and the existing situation is unacceptable then the choice is either to close down or to find the necessary backing and buckle down to some very hard work which, at the end of the day, may yield rewards or

bankruptcy. In the subsidised sector this pressure forward, this imperative to do something, is far less intense. Our system of subsidy is still very heavily biased towards artistic quality as the principal criterion for receiving financial support. Marketing achievement appears to figure far less in the judgements of those who make the grants. Marketing under-achievement is tolerated because it is overshadowed by the undeniable fact that it is the norm for the arts to lose money. There is no yardstick for judging how much lost money is acceptable in a given situation. Although this may soon change it has generally been true to say that an arts administrator in a jam will achieve more in an hour devoted to politicking for a bigger grant than in an hour spent improving the marketing of his organisation.

Emotionally, the arts world wants to achieve more in terms of audiences; it is full of individuals to whom the empty art gallery, the unsold ticket, is anathema. There are plenty of people who know that the way forward lies in the development of the marketing function within their organisations. But they cannot take the risk of spending more money on audience-building schemes, money which they do not have, money which does not appear in the estimates which have been vetted by the grant making bodies and upon the basis of which their grants have been decided. As the successful outcome of a marketing project cannot be guaranteed, what would happen if they tried and failed? Their end-of-year deficit would be larger than forecast and just look at those figures to see why! They have overspent their publicity budget!

Oh, how much we need some form of subsidy system that will under-write attempts to expand audiences! Oh, how we need a subsidy system that will encourage such attempts and reward those who make them succeed!

In theory the 'guarantee-against-loss' principle could be used but through mis-application this has almost degenerated into the direct grant, with recipients often working quite hard to make sure that enough is lost one way or another to take up the conditional sum offered. We do not want money so much as insurance schemes. In 1981 I proposed the idea of 'Artsbank', a way in which public and commercial money could be used to support arts marketing initiatives in the way that commercial banks support business ventures. The proposal was read by many people but, although it attracted much approval, nothing happened and it now rests in the Appendix section of this book where, apart from expanding on the argument contained in this chapter, it waits hopefully for its sugar-daddy.

Sponsorship of Marketing Schemes

In our original 'Subscribe Now!' proposals we drew attention to the potential which subscription campaigns had for commercial sponsors. A

subscription campaign tends to use sales material that is brighter and bigger than the average advertising leaflet and there are usually far more produced. Given that the average sponsor is looking for good exposure in terms of quality and quantity the subscription brochure should be a very appealing vehicle. The first to recognise this was Imperial Group Ltd. which backed one of the pioneer post-January 1980 subscription schemes, that of the Old Vic Company. A few months later the House of du Maurier announced its huge overall sponsorship of the Philharmonia Orchestra and with this came money for the orchestra's second subscription season. (It is worth noting that there was no sponsorship of the first subscription season into which the orchestra entered supported only by its self-confidence, and its belief in the idea brought about by the direct influence of Danny Newman and, to a lesser degree, ourselves.)

Two years later, John Player & Sons, the tobacco company that is a member of Imperial Group Ltd., took up a proposal that Hugh Barton and I had prepared on behalf of English National Opera and, grasping the opportunity with both hands, announced the sponsorship of subscription schemes for English National Opera, Welsh National Opera, Opera North, Scottish Opera and the National Theatre on tour; these sponsorships ran alongside an already comprehensive folio of arts support. But there, with perhaps the exception of a few other smaller schemes, this uniquely valuable form of sponsorship appears to have stopped. The theatres, far more in number than the major music bodies, with far more seats to sell and so with many more people to influence, have failed to attract sponsors to any significant degree. So their subscription schemes have been financed from a combination of their known cash resources and their self-confidence. We will never know how many brave schemes have not been realised simply because the anticipated risk was too high.

Commercial sponsorship has, of course, grown but, just like the subsidy system, sponsors have so far failed to respond in any significant way to the challenge of helping the arts organisations to operate in a business-like manner comparable to the sponsors themselves.

The Next Step

My 1979 seminar tour of Australia and New Zealand was at the invitation of Timothy Pascoe, a Harvard trained management expert and then the director of an organisation in Australia called Arts Research Training and Support Ltd. (known as ARTS). This body was formed in the mid-seventies on Pascoe's initiative and concerned itself with providing the existing subsidised system with a range of services including sponsorship consultancy. It did not focus only upon encouraging arts sponsorship and it saw my seminars on arts marketing as a natural part of what it was there

to do. This breadth of scope, which also included the provision of management consultancy and research services, shifted the emphasis from the mopping up of deficits through subsidy to the earning of money through improved management efficiency. Pascoe's view, which I share most emphatically, is that an organisation operating efficiently and selling what it has to sell at a price that is acceptable to seller and buyer is one which is most likely to attract sponsorship and is most deserving of support from the public purse.

In 1981 Timothy Pascoe was made the salaried executive chairman of the Australia Council, the equivalent to the Arts Council of Great Britain.

In 1983, Luke Rittner, director of the Association for Business Sponsorship of the Arts in the UK, was appointed secretary-general of the Arts Council of Great Britain.

In retrospect I think it would have been better for us all if we in Britain had followed the course taken by Australia and placed sponsorship in the wider context of what the arts really need. But it is not too late. Our ABSA will, I hope, go on doing well what it has always done well. Now we should consider the formation of an organisation to concentrate upon the marketing of the arts, an Institute or Academy or Association for this vital area; something to which independents like myself and those who work in the subsidised sector, can contribute and from which we can also benefit.

CHAPTER THREE

WHAT DO YOU MEAN 'MARKETING'?

I am ambivalent about the jobs I see advertised in our trade publications. There are vacancies for 'a Press and Marketing Officer', for 'a Publicity and Marketing Manager', for 'a Public Relations and Marketing Executive'. It pleases me to see that the existence of marketing is at least acknowledged by the use of the word but those job titles make me wonder if the people who wrote them have any real understanding of what the word 'marketing' means. Even when I meet marketing officers it takes only the briefest conversation to establish that their jobs are frequently concerned only with aspects of publicity. A few years ago, James Parker, who, like me, is in the business of audience building, sent me one of his promotional leaflets. On the cover it said:

**I was called
AN EXPLOITATION MANAGER
in the 50's**

**AN ADVANCE MAN
in the 60's**

**A PUBLICITY AND PROMOTIONS
MANAGER
in the 70's**

**and now it's called
MARKETING**

**However the job remains the same
SELLING THEATRE SEATS**

Those statements have a wry quality with which I can sympathise.

Merely renaming a job doesn't change it. It is what I think of as Marketing by Ritual: 'I dub thee Marketing Officer and from herein henceforth we market'. *Cogito es ergo es.*

Publicity is a vital part of the marketing function but only part. I do know of one person in the arts who is called a sales promotion manager and

on enquiry I find that sales promotion, no more and no less, is what the job entails. I have yet to meet a sales manager in the UK (I have met one in Australia) although I have met plenty of people whose jobs embrace that responsibility—even if they do not seem aware of it. (Stop Press: as I write I notice that the Crucible Theatre, Sheffield is advertising for a Box Office Sales Manager. Things are improving!) I have met many groups of people who collectively have marketing responsibility but do not behave as though they know they have.

I do not want to make too much of these semantic distinctions. I see these confusions of responsibilities and titles as being merely symptomatic of the present state of our development. It is important that we acknowledge to ourselves that we all have a long way to go before we are experts in this field. As a lecturer on arts marketing I feel compelled to start my sessions by undermining the implicit position of total expertise that teachers tend to have. When I used to teach mathematics and I came to the matter of, say, logarithms, I was reiterating a concept that had been totally thrashed out by someone else and had been thoroughly tested by generations of mathematicians; one may assume the posture of an expert when talking logarithms. When I teach the marketing of the arts I must preface my statements by explaining that 13 years ago the word 'marketing' was hardly ever used in the arts (indeed, I coined the term 'arts marketing' and began to use it on my professional letterheading in 1970). I go on to to emphasise that although I may talk with a great deal of confidence this is as much the product of my enthusiasm as anything else and what students are hearing from me is opinion based on experience. I illustrate my point by describing how, having written a book on arts marketing and lectured on the subject for years, the true importance of subscription-based marketing was not brought home to me until 1979. A member of the executive committee of Merseyside Arts Association, of which I was Director from 1968 to 1973, used to irritate me by his constant references to the German Volksbuhne system and the French Abonnement and it was not until 1982 that I saw a copy of a paper by Cecil W. Davies (*Theatre Audience Organisation—The Example of Germany*: published in 1972 by the Dept. of Extra-Mural Studies of the University of Manchester) that makes a number of very valuable suggestions on the subscription theme. When I lectured on the arts administration courses at the Polytechnic of Central London from 1971 to 1977 the head of marketing, Dr Carl Keil, often used to say that it would make sense to try to sell more to existing customers than to look for new customers. Under the influence of my missionary zeal I disregarded his wise words believing them to be contrary to the ideals of my profession.

Having so scourged myself in public I then go on to try to impress the students with the progress that has been made, and hope to convince them before they feel inclined to give it all up as a bad job.

I look at the task as pragmatically as I can and with the belief that most problems can be solved if you worry at them. Perhaps it is no more than asking Why? and How? This concert hall is full to bursting. This one isn't. Why? How? If that seems too simplistic then look at the way we solve other problems. The steps are fairly straightforward. First we observe. Then we analyse. Then we give names. Then we develop a methodology so that provided our analysis is the correct one we can approach all similar problems in the same systematic way. Because we have named the parts and have agreed the analysis and methodology we can discuss our problems with other people so that they may contribute to the solution.

If you accept that then you will understand why those job descriptions bother me. If we haven't even agreed the language we are going to find it heavy going. And we must agree the analysis.

The problem with analysis is that it is unusual to find just one way of looking at a set of circumstances that reveals all at a glance. We try to find the way of looking that reveals most and then we start looking from different angles to find more information that will build up a complete picture of how something works or how it is made. As we do this we try to ascertain the relevance of the information we obtain in relation to the reason why we are analysing.

Put a motor car in front of an intelligent person who has no previous knowledge of motor cars and ask him to analyse it. He would not at first be able to tell what was important to the function of the car and what was not, so that the cigarette lighter might seem as significant as the clutch pedal. He might try to analyse it according to the materials used so that he would list all the items made of metal, broken down into lists of steel parts, aluminium parts, brass parts and so on, then the items made of petroleum based products, then those made of glass and so on. He might analyse according to colour, listing the black bits, brown bits and so on. He might try size, big bits, medium bits and small bits. Obviously none of these analyses would tell him how the thing worked. If he were to start logically he would try to work out what this strange object was for and the presence of wheels and seats would bring him to the correct assumption quickly. If he then based his analysis upon the function of the component parts and related them to the assumed purpose he would quickly ascertain that some bits provided power, others transmitted power, others the ability to control direction, others protection, and others a whole variety of minor functions that are not as relevant to the purpose of the machine as the first.

Now that he has worked out the relevant functions he can then begin to see how they relate one to another and he is well on the way to an analysis that makes sense in relation to the purpose. If he chooses to give names to those functions and bits it will help him remember how the car worked when it has driven off, he can explain to someone else how it worked, if he

meets another car, even a very different looking car, he can understand it. He could even make a start on repairing one and, given appropriate resources, even to build one. If the motor car were to become an important part of his life he would quickly establish a methodology for sorting out motor car problems.

If we bring this approach to bear on the matter of the marketing of the arts we should start by asking what is the purpose of it all? Avoiding all the games you can play by asking what is the Purpose of Art, I start with the assumption that the arts are going to happen and that people like me have the job of bringing other people into contact with them. So, to me, the purpose is to bring people into contact with the arts.

In my 1976 book I offered a definition of arts marketing that owed much to my physics teacher at school who certainly knew how to make children memorise definitions. My definition leans for its style upon Archimedes' Principle:

> *The primary aim of arts marketing is to*
> *bring an appropriate number of people*
> *into an appropriate form of contact*
> *with the artist and in so doing to arrive*
> *at the best financial outcome that is*
> *compatible with the achievement of that*
> *aim.*

The first thing to notice about the definition is that it avoids reference to specific art forms. To me, any approach to arts marketing is worthless if it cannot be applied to all situations. Inevitably the contents of this book relate more to the performing arts than to what goes on in art galleries and museums but that does not mean the approach I advocate cannot be applied. My experience has been mainly in the performing arts but over the past few years I have found myself obliged to work on unfamiliar ground, such as magazine, cassette and book publishing, an airline—and even on one occasion yo-yos, and on another cough lozenges—and I have been able to handle the problems. The visual arts certainly present particular difficulties but that does not mean that marketing has no relevance nor does it mean that the approach cannot apply. So, the definition refers to the arts in general.

The definition also brings in the matter of money. One of the first and continuing objections to the very idea that the arts can be marketed (shudder, shudder) is the confusion in some people's minds between the marketing of commercial products and services which has, as its first intention, the making of profit and what we do in the arts. In its extreme form the confusion is expressed as follows, 'Marketing is about making profit. Profit is evil. Therefore marketing is evil'. Or it can take the form of

'Marketing is about making profit. The arts are not about making profit. Therefore the arts need not be concerned with marketing'. Worse still is the belief that audiences are collectively made by God and not by man and that interference in the divine process is as fruitless as asking the sky to stop raining: this is the 'marketing doesn't work' philosophy.

The arts are, from one point of view, no different from other vital but non-profit making concerns such as education, libraries, the National Health Service and so on. They differ from such comparable activities because most arts bodies are in the business of selling something and thus, from a marketing viewpoint, have more in common with, say, a transport system. We know that railways and bus services are absolutely necessary and we know that they lose money. Their loss of money is not so much to do with their inefficiency as the extremely high cost of providing them set against their finite capacities (that is, you can only put about 50 people in a bus) and the price that people are prepared or able to pay for the service. Those who run transport services do not set out to make a profit but they do try to achieve the best possible financial outcome.

It would be unrealistic to ask the arts to make a profit so my definition simply requires us to aim for the best possible financial outcome from the marketing project concerned. It could be that the best possible financial outcome is profit; it frequently is in the case of art forms where there is unlimited capacity and where the cost of producing more to sell is either constant or tending to get smaller as the volume gets bigger—and, equally important, where the demand is high enough to take up what is being offered for sale. Books, records, audio and video cassettes, prints can all satisfy these conditions and that is why people can get rich marketing them. But because the nature of marketing makes it a very uncertain business they can also make people very poor when they back the wrong horse. For the purposes of this book however, we should assume that most art forms cannot make a profit and we should base our theoretical approach to marketing on this assumption.

So, now we have a broad definition of arts marketing that should be universal in its application and does not ask the impossible. Where do we go from here? What analysis will be most helpful?

It is hard to arrive at the right analysis unless there is a good, typical, working set of circumstances to observe. My first experience of arts marketing was when I started to promote professional jazz concerts in Corby, Northamptonshire in the early sixties and at the time I was not even conscious that there might be some underlying principles involved in the process of running a club successfully. What I was doing was essentially *rough* marketing. I made an assessment of what people wanted, based on intuition and what other people were doing, and then selected a show that stood a chance of satisfying the want. My advertising material did its

humble best to make an attractive promise of what was to come and provided the basic information so that customers knew where to buy tickets, how much they were and where and when the show was to be held. I tried to get the local newspaper interested before the event and I tried to persuade them to cover it on the night so that people who had attended could compare their reactions with the journalist's and those who hadn't could read about what they had missed. Price was based on what other people were charging for similar entertainments and a few calculations on the back of an envelope told me how many people I needed to attract to cover our costs: this gave me a target which told me, as the campaign proceeded, how much more time and energy I had to expend (given that there was no more money to expend). I instinctively knew that I was capable of influencing the outcome and that even though there might be people 'out there' who might become my customers, I could not assume that they would just materialise on the night; my efforts were crucial to the process.

My later experience in helping to start and run the Midland, later the English, Sinfonia, and after that the Merseyside Arts Association, provided me with hundreds of different marketing problems. I began to realise that if I did not develop a systematic approach to the analysis and solution of these problems I would simply go under. In both situations I was under great pressure, from myself as well as others, to expand, to make progress, and we needed audiences and the income they generated. So I started to try to figure out how the process worked. What was it that made one poster better than another? How influential was pricing? Did the day of the week on which an event took place have any bearing on response? There were hundreds of questions to be asked and no firm answers to any of them.

The only guidelines were the old wives' tales of the 'all publicity is good publicity' kind, and the traditional practices that stemmed from the old style commercial theatre where you always produced so many double crown posters, so many hanging cards and so many leaflets—and where you had to have stars. Not the least of my problems was that I rarely had stars.

In the very early seventies I was asked to lecture to students of arts administration at the Polytechnic of Central London on 'Advertising the Arts'. The thought of having to present my muddled thoughts before keen young minds stimulated me to get down to the matter of analysing this process so that I could, at least, offer one sensibly constructed lecture. My analysis then, for all its (now) embarrassing inadequacies at least recognised that advertising and public relations were different activities and spotted the fact that making people want to do something was not the same as getting them to do it; in short, I defined publicity and stated its

objective and I perceived the separate, but vague outline of the sales function.

Any commercial marketing person would have hooted at my solemn presentation of these amazing revelations; I acted as if I had just discovered penicillin. But, at the time, this was advanced thinking and, to quite a few people, was even controversial. Why did no-one think to involve commercial marketing people, to seek their wisdom? From time to time they did but those that appeared on the scene did not have enough experience of the arts world to spot the essential differences. They all started with market research, it was market research that would tell us what the market wanted to buy and then all we had to do was supply it. You can imagine the reaction from people who knew that artists are often in the business of supplying what people do *not* want—or not just yet. There were flirtations with commercial marketers but they came to nothing and I became more convinced than ever before that it would be better for the arts world to develop its own approach. Naturally, I thought I would be the best one to do it and I have done it ever since.

The analysis I use today as my basic checklist when approaching any marketing situation has evolved from the experience of marketing the arts combined with the teaching work I have done since that first invitation. (It used to be logarithms, now it is arts marketing.) I see the function breaking down into a number of areas where decisions must be made and they apply to any event, or series of events, or any project where the objective is to bring people into contact, either directly or indirectly, with the product of artists. It does not just apply to loss-making activities, it is simply a way of breaking down any marketing problem so that a solution may be found.

Firstly, the areas where marketing decisions must be made:

THE PRODUCT

THE MARKET

SALES

SALES PROMOTION

FINANCIAL PLANNING

PRICING

PUBLICITY (advertising and public relations)

CHAPTER FOUR

THE COMMERCIAL APPROACH

Part of our problem in the arts is that we feel ourselves to be inferior to the commercial world because we do not make profit and we live off charity. Our view of the commercial world is one that seems to derive from films and television plays that portray all business as Big Business. The fact is that most businesses are quite small. We have tended to use this false view of the commercial world (and, occasionally, that contempt for the profit motive) as an excuse for ignoring what goes on there. When I overcame this barrier (a change of heart brought about by moving out of the subsidised sector some 10 years ago) I discovered that there were many aspects of 'the other world' that had a bearing on what I was doing and that if I watched what they were getting up to there was much I could learn.

The first thing I noticed was that most small businesses don't make a fuss about their marketing: it is accepted as being part of what they do just like making goods to sell, employing people and keeping accounts. They do not waste time wondering about the moral implications of trying to persuade people to buy things nor do they labour too long over their marketing plans. There is a sense of urgent pragmatism which makes them want to get out there into the market place to see how it works. Market research (the study of all significant aspects of the market at which you are aiming—the target market) is a luxury not often afforded. Having made a commitment, they then modify what they do according to the knowledge gained from practical experience. If the product seems to be costing too much how can the price be reduced? If the distributive trades are not very enthusiastic about the product can they be given extra incentives? If the sales force seems to be short on success can they be helped by training, by a better commission system, or is a new sales manager needed? When shall we make these improvements? Now!

I do not suggest that commercial concerns just leap blindly into new situations—no-one is going to risk money without a lot of thought—but the examination of an idea takes place in an atmosphere of pressure to get moving. Any proposal is related to experience so that the successful business is always tending to build on the successes of the past and new ventures are treated with caution.

So, when we look at this part of the business world we see much that is in common with our own situation in the arts and we can learn from the way in which problems are tackled. Most of us are all running small

businesses, after all. The sense of urgency derives from the need to make profit in order to make growth and somehow or other we, in the arts, where there is no pressure to make profit, must find a way of synthesising this forward drive and this, somehow or other, has to be thought of as part of the marketing function and hence part of our analysis. We must also learn not to be ashamed of ourselves for being small and having to make every penny count.

In the larger commercial organisation where resources are greater, it is possible to see the marketing function operating more clearly. The small company tends to make marketing decisions on the basis of experience, intuition, and trial and error, while the larger will be able to be more scientific in its approach. Market research, for example, will be much more in evidence and its findings will be very influential in how a product is developed for a perceived market, and how it is subsequently advertised. Advertising will be placed in the hands of a specialist agency that is capable of conceiving and executing campaigns that are tailor-made for the target market. Products and their advertising campaigns may be tested in a certain region before the company goes the whole hog on a nationwide campaign. There will be a whole department concerned with sales, with its own budget and personnel. Sales promotion will also have its own budget and, perhaps, a specialist agency employed to work solely on trade and customer incentives. Public relations for the company and its various products will also frequently be farmed out to a specialist company.

Notwithstanding the scientific approach that we observe we should also notice the tremendous importance the large companies place upon leadership and good, old-fashioned entrepreneurial flair. The board of a major company knows that no amount of science and system can guarantee achievement and it still requires a person or persons of talent to take these resources and integrate them into one forward-moving, success-orientated organisation. In this respect the large company is no different from the small and is no different from our kind of organisation. What so often distinguishes the successful company from the unsuccessful is the quality of its management—and that holds good for us too.

Above all, the commercial approach means being determined to succeed. Success means having a business that is growing and making profit: lack of success means unemployment. In the commercial world there is a large carrot and an equally large stick; provided one is kept aware of both, the drive to succeed is maintained. In the arts world the rewards of success are less tangible for the majority and failure does not always mean unemployment. Arts people work in a situation where success and failure are rather indeterminate points on a wide scale. If one does not set any objective beyond the achievement of a forecast deficit, then the thrust towards achievement will be at a minimum.

All arts organisations should, I believe, adopt the 'commercial approach' in its best sense which means knowing how to relate the principles of marketing to the immediate task in hand (and hence, knowing when corners may and may not be cut), setting ambitious targets and then going all out to achieve them. Apart from the obvious reasons for working in this way, it is, in my experience, much more fun.

CHAPTER FIVE

THE PRODUCT

Art—A Product?

The anti-marketers in our business don't like the word 'product' to be applied to the arts. I do. It is an all-embracing word meaning something that is produced which is exactly how the arts come into being. It also gives a more business-like character to our discussions. The use of the word does not mean that we do not respect the arts, it means that while we are thinking about marketing matters we put aside for a while our personal enthusiasms and employ a convenient, if somewhat clinical, communication tool. So, no apologies for using the word 'product'.

Them and Us

The reluctance to use words like 'product' stems from the belief that the arts are holy; it is this that isolates the makers of art from the rest of the world and so encourages people to see them as divorced from the marketing process. Of course the product of the gifted artist, no matter what the chosen art form, is a carefully conceived thing and there are many situations where the artist cannot function if he is forced to evaluate the likely public reaction to his work as he is producing it. There is a difference, however, between the work of the original creator, the composer, the painter, and the writer and the majority of people, who have artistic responsibility in arts organisations, and whose jobs involve either interpreting the work of artists or selecting the work of artists or both. The art with which this latter group is associated is not, in practice, as sanctified as it may appear to be nor as they would occasionally have us believe it to be. The music director of an orchestra, the gallery director, the director of productions of a theatre, dance or opera company, all have artistic freedom within the constraints of their position as employed persons, but they can be dismissed, and often are, for reasons which are to do with artistic matters. So to an extent, an extent which is relevant to the arts organisation wanting to improve its marketing, artistic freedom is something of a myth. It is limited freedom.

A complaint often heard in arts organisations concerns the way in which some people who have artistic responsibility cloak themselves in this mantle of holiness and decline any other responsibility. 'It is my job to

choose what we are to present and your job to find me an audience for it. If we enjoy success the achievement is mine. If we fail the fault is yours.' And they can get away with it because, as organisations, we are still not sufficiently orientated towards our real purpose, which is to bring people into contact with the arts. Critical achievement alone (good reviews but poor houses) is not enough if you are supported by public funds—you can do what you like if you are not.

All of which means that those who have artistic responsibility must be part of the marketing process, must *think* of themselves as being part of it and must be part of the organisation that handles it. It doesn't mean that they must produce an endless stream of pot-boilers, it means that they must make their decisions in the context of what their particular arts organisation is there to do. Artistic policy is where the process begins and discussion, liaison, and co-operation is how it continues.

The Authority of the Artistic Director

I have already referred to my work with the Churchill Theatre, Bromley. The experience remains in my memory as a perfect example of how people with artistic responsibility can make marketing work without compromising artistic standards. I do not believe that the scheme could have worked as it did without the leadership and determination of artistic director, Ian Watt-Smith, the support he received from his assistant director, Philip Partridge and the sheer devotion both to the subscription idea and to the theatre, of Sheila Dunn. (See Appendix B: Subscription at the Churchill Theatre, Bromley by Sheila Dunn.)

Christopher Bishop is the managing director of the Philharmonia Orchestra, which started its subscription scheme at the same time as the Churchill Theatre. The managing director has considerable influence over the artistic policy of the organisation. Many factors determine the artistic content of a year's programmes for an orchestra of such international standards and it is never possible to set out the perfect menu for one's guests (should one ever find out exactly what it is they want). All that Christopher Bishop and his council of management can do is to arrange the best blend of programmes, soloists and conductors and to ensure that everything is done to make the quality of the performance of the highest order. From this point on he is fully concerned with every stage of the marketing process, on a day to day basis and in the fine detail of every decision. As the marketing consultant to the orchestra I do not find this interest a disadvantage, indeed it would be hard to function effectively without it. Christopher Bishop, like Ian Watt-Smith, does not believe that his job is done once the artistic decisions have been made.

Apart from any other justification for the need to be involved we must remember that in any arts body the person with artistic responsibility has great authority with boards and executive committees and with staff. It is not, then, only a matter of providing the right artistic product and being involved with the decision-making processes but also of providing leadership and representation when major matters have to be considered by the governing bodies.

The power and authority possessed by artistic directors can work against the effective operation of the marketing function. When directors achieve eminence it sometimes seems as if it is a privilege for the organisations to be involved with them and it may be hard to sway them from goals which can derive more from their personal ambition than from a desire to make the organisation succeed. Such situations pose a serious problem for the arts body which, at one level, places great value on the talent of the resident artist and knows that without it the place would not be worth running, and at another level wants that same talent to work within the disciplines of the overall management so that there will still be a place to be run. No-one would want to deny the unique contribution made by the artist but it is unrealistic to ignore the fact that the artist may use the organisation for his own benefit for a while and then move on to greater things, leaving it to pick up the pieces that his ambition may have left behind. All of these considerations support the view that the people with artistic control must think of themselves as being part of the marketing process and not stand aside on the assumption that marketing is something that starts after they have made their artistic decisions.

What about Sam Goldwynism?

Sam Goldwyn, who knew a lot about marketing the cinematic art, took the commercial approach about as far as it could go. If he had felt that *Hamlet* needed a happy ending he would have had the whole *dramatis personae* live happily ever after without a second thought. Fear of Sam Goldwynism is another reason why some people don't like the idea that the arts can be marketed. They feel that once the marketing idea has gained influence the next step is to start changing the art to fit the immediate demands of the public. Even if one wanted to do that it is far easier said than done—we are never really sure of what the public wants anyway and I doubt if any market research could tell us in anything other than the broadest terms. The real fear, with which I sympathise, is lest we should start messing about with the art which has already been produced, which is the product of artists whom we universally recognise as being good, which we consider to possess a special and, if you like, 'holy' position. This has happened on countless occasions and in the main the results have been bad enough to justify the

fears of our nervous colleagues. If, however, the messing about is done by an artist of talent, then the outcome can be a new art product that can stand on its own feet to be recognised as something of quality.

The essential difference lies in who is doing the messing about, how good they are as artists and what motives they have; it is obviously a difficult area and for our purposes we can probably agree that whether we take the art as history has given it to us, or whether we choose to add to or subtract from it, it must remain the province of those with artistic responsibility and they, in turn, must be part of the marketing process. It is not for those who deal with the nuts and bolts of marketing to dictate to the artistic director.

One final point remains to be made on this controversial matter and that is to remember that whereas we, as marketing organisations, try to avoid changing the art product for the wrong reasons, we are continually exercising our power of selection and so behave in a kind of Sam Goldwyn manner. We may not give *Hamlet* a happy ending but we may decide against putting *Hamlet* on the stage and choose instead another play—with a happy ending. So we select our art product according to our artistic policy and our perception of what our public wants and/or should have. We also—let us not forget this—select those who are to do our selecting for us and we dismiss them if we don't like what they come up with.

On balance, I don't think we should be *too* critical of Mr Goldwyn.

Responding to Public Demand

We know that in practice most arts organisations do their best to strike a balance between what is artistically adventurous and worthwhile (and probably more of a box-office risk), and what is likely to receive a more predictably good response. Others follow an even safer course, sticking to known favourites. Some reject the traditional arts, opting for the radical approach of developing new arts and new ways of using old arts to meet what they perceive as being the needs of sections of the public in which they are particularly interested. Each approach is an attempt to respond to some kind of public demand as seen through the eyes of the organisation. It is guesswork, of course. It can be guesswork modified by the results of practical experience. Rarely is it based on the results of research, nor should it be. The whole art of programming for an arts organisation is based on a sensitive appreciation of who the market is, what it wants now and what it may be persuaded to want in the future and the relation of those perceptions to what the organisation is capable of delivering.

Some have devoted themselves to directing traditional art forms at new markets in an attempt to break down the barriers of attitude which still keep the arts from all the people: the concert in the factory, the play about

the mining industry aimed at miners, the concert of operatic extracts aimed at people who do not normally go to opera, and so on. Such attempts to tailor a product to fit an assumed market need, or to 're-package' it in a different, more familiar environment, are worth trying and sometimes they succeed. They appear to be less successful when the motive is not so much to build an arts-aware audience that is capable of enjoying itself on a wider front, as it is to convey a political message. Provided that any tendency to hide the political wolf under Granny's cloak is resisted then these moves are all to the good. (If you want to make political art then do it as such and be proud of it.)

It doesn't matter what art form, what audience is sought or what the motives are, the organisation that succeeds has developed the entrepreneurial ability to some degree. It is this quality that has traditionally taken the place of a scientific approach. It is the same quality to be found in the successful commercial organisation. If scientific research methods can be brought in to assist it is all to the good but at the heart of the organisation there must be this 'gut-feel', the instinctive sense of what kind of art is right for the kind of people you are best equipped to work for. It is this that must counter-balance any tendency to go off on flights of fancy that will carry you away from the audience you know and to which you can relate.

The Context

Those who work in the subsidised sector sometimes forget that there is a big commercial world out there that is ready and waiting to snaffle up any arts development that has good audience and profit potential. It has been this way in the theatre for ages (although the trend is reversing as economic pressures make it harder for the commercial theatre so that the subsidised theatre can begin to move into areas such as large-scale musicals that have been traditionally the province of the commercial world). This means that the subsidised sector is usually obliged to content itself with art forms which are not worth doing commercially and will probably always have to fight hard for its audiences. That is why there is a subsidised sector, after all—to ensure that 'uncommercial' art forms are not lost for all time.

It really doesn't matter who is to promote the arts provided that someone does it. What matters is that the arts are there so that the public may benefit from them. It is contrary to its purpose for a subsidised arts organisation to become so obsessed with gaining audiences that it shifts its artistic policy into areas where there are already commercial promoters willing and able to take the risk.

What Are we Marketing?

We are not marketing art, we are marketing the experience of art. Unlike other things that can be sold it is not a tangible item. It cannot be picked up off a shelf and this gives us a special problem. As we shall see when we come to consider the marketing activity known as sales, it is very important that customers who are already in a buying frame of mind should get what they want as soon as possible. In the performing arts all we have to offer is a ticket which is only the printed promise of an artistic experience. In most cases the ticket is sufficient because it confirms to the customer's satisfaction that the art experience is going to be delivered soon. The situation in a gallery or museum, where in most cases admission is free and tickets are not sold, is that there is no 'proxy-product' to offer and this partly accounts for the unusual difficulties these places have in persuading people to go into them.

Years ago, after I had given a lecture, an arts administrator showed me a small guide that had been produced to help arts promoters in their marketing. It was quite good on matters of publicity but when it came to the heading 'Tickets' all it said was, 'A ticket is a receipt for money paid'. Oh, no it isn't. It is much more than that. The ticket provides us with the means to make the art experience available now, in proxy form, in places where the public is able to buy it. The experience itself can come later when the promise is kept.

Availability

If we look at the commercial sector we find that very great emphasis is given to creating a high level of availability of the product. You cannot make something, price it right, make people aware of it and then expect them to come direct to the factory to get hold of it. Distribution is a critical factor and if it cannot be arranged then the project will be abandoned. The record industry gives a good example of the importance of distribution. Records are produced and are then sold through record shops. The number of record shop outlets is not large. When companies such as Music for Pleasure found a way of putting their records into High Street stores that had not before stocked records, they were able to achieve high volume sales. There were other factors, such as the budget price and a 'sale-or-exchange' arrangement with the stores, but it was the great increase in the number of outlets that made the difference. The whole mail order/direct mail industry has developed out of the realisation that availability of the product is vital, but that to create it through a large number of sales outlets is very expensive. Thus the direct response advertisement in national

media, and the directly mailed sales brochure, become the shop where the customer may make the purchase *now*.

There are plenty of examples in the commercial world where the product itself cannot be taken down from the shelf and sold immediately to a customer. Air travel, the holiday business as a whole, even the motor car trade where supplies may lag behind the demand. The businesses that know that they are in a buyer's market realise that they must work extra hard to make the customer enter into an agreement a long time before the goods are delivered. They thus try to build a system of many sales outlets, offer incentives for early purchase and aim to create the impression that they are operating in a seller's market ('if you don't buy it now, you might not get it').

Even today there are arts organisations that rely upon 'doors', the sale of tickets to people 'on the night'. This is the behaviour of an extremely self-confident organisation clearly believing that it really is in a seller's market. If, in fact, it is not in a seller's market (my own belief is that we are never in a seller's market—if we were then someone in the commercial sector would be doing it) then it is fooling itself and will come to grief.

A few years ago realisation of the true marketing significance of the ticket would be followed by a move to expand the number of ticket outlets. Step one was to try to encourage advance booking at the principal sales outlet, step two was to create more sales outlets. It made sense but the problem was the nature of those sales outlets. Travel agencies, libraries, small shops of all kinds were approached and often, because of the enthusiasm of the arts organisation's personnel, they agreed to take tickets or to operate a voucher system. But the foundations of these networks were built on sand because the outlets were not really in the business of selling this kind of thing and because it was not really worth their while to handle it. The extremely rapid development of computer technology has given new life to the idea of a network of sales outlets. Once the shop has decided to go into the business of selling tickets as part of a computer network it will gear itself up to do it properly. It may have made a substantial cash outlay in order to obtain the computer terminal and having given it a special place in the shop, and trained its staff to use it, it will regard all ticket selling as part of its business and will then take it seriously. It will state the terms of its business so that commission rates are fixed. From this point on, the performing arts body with something to sell will have an effective sales outlet. Such systems, if they are to be profitable, must have many computer outlets so that the arts organisation will be able to benefit from a much larger network than it could ever have organised for itself. The other main advantage of the computer system is that it knows exactly what the current availability of tickets is for any one of a large number of different clients and can state specific seat availability instantly. Real tickets can thus be

produced then and there, guaranteeing specific seats without reference back to the client organisation.

Riding alongside the computer development has been the increased appreciation on the part of the arts organisations of the value of the credit card, the telephone and the postal system, which together make the point of sale the home rather than the arts venue or a ticket selling shop (whether computerised or not).

At this time it is difficult to predict the next step. Ticket selling in the home, through direct mail and direct response advertising, is so simple, cheap and effective that it is a very serious rival to the computer based system. The introduction of the link from home to vendor through television using a direct purchasing system involving a credit card or direct debit method, which is taking place as I write, may well render the computer network system based in shops obsolete before it is fully implemented.

No Tickets to Sell

For those who have no tickets to sell—the galleries and museums—I can only say you have no choice but to do your very best to persuade people to want what you have to offer. You must make them want it so much that they will overcome all the barriers that come between wanting to attend and actually crossing the threshold and you must accept that because there are so many barriers you will lose a lot of customers.

Some art galleries and museums charge for admission but none that I know sell tickets ahead of time as though they were theatres. The reason for this is that we traditionally associate the ticket with the idea of limited capacity and we think of these places as having unlimited capacity. We know that when there is an extremely popular exhibition the capacity of the gallery suddenly becomes extremely limited and we have to queue to get in. It could well be only the fact that most exhibitions are not packed out that the organisers have not considered the advance sale of tickets very seriously. Indeed, the introduction of advance ticket sales would contribute greatly to the building of the impression that the gallery is having to ration attendance.

Why not make a charge? We have grown used to the idea that making something free increases its accessibility but all it really does is make it free. For people who are very short of money something that is free is more accessible than something which is not free but it does not necessarily persuade them to make use of it. The ticket increases accessibility far more than is achieved by making something free. Since the majority of people can afford to pay, does it not make more sense to put a price on the art experience, sell it through a ticket system and then offer reductions (down

to zero if you like) for people who cannot afford to pay? Some people cannot afford to go to orchestral concerts, the opera or to theatre and those organisations have found ways of helping those who have less money to attend. If you are offered a £2 ticket for 50p does it not appear to be a bargain in the first instance and, having bought it, are you not then unlikely to want to waste your 50p, particularly if 50p is a significant sum for you?

A long time ago, the government of the day influenced the then Minister for the Arts, Lord Eccles, to insist on charges being made for admission to certain galleries and museums. It caused an uproar and after a time the order was withdrawn. It was argued that it was morally wrong and it was also said that the cost of administering the ticket sales was larger than the revenue obtained. I often wonder what would be the situation today had those arts organisations been forced to go on selling tickets. Would they eventually have addressed themselves to the matter of the availability of their tickets and would we now see those tickets being sold alongside tickets for music and theatre?

Of course, charges are made for certain exhibitions today but the objective is only to raise revenue, not to increase attendance (although larger attendance may well be a result). My point is that if attendance at an art gallery or museum were defined by date and time, and even given a stated duration, it would take on the character of a performance—something that begins at a certain time and ends at a certain time—the idea of limited capacity would be suggested and so there would be *something* to buy and a reason for buying it *now*. ('If you don't buy it now, you might not get it'). The ticket would be more than merely 'a receipt for money paid'. The ticket would be a proxy-product and could be sold in advance, anywhere.

I offer this suggestion to those art galleries and museums which have made their exhibitions highly accessible and have found them to be badly attended.

A Funny Kind Of Product

It is a funny kind of product that we have to market. In most cases it doesn't actually exist until some time in the future and all we know of it is what we know of other similar things and what we have been told about it. The people who make it usually make it because they want to make it and not necessarily because lots of other people want them to make it. If we try to force them to do what we want the bad ones will probably give in and deliver something worse and the good ones will go somewhere else where they are not pestered. All we can hope for is that they will include the public into their considerations and will learn the pleasure that comes from watching an audience enjoying itself—it is an addiction that artistic

directors succumb to as readily as us. We can also hope that once they are addicted they will try to go on feeding the habit by shaping their programmes, not only to please their audiences with the familiar but to amaze them with the unfamiliar whilst recognising that what is to them, as creators, new and wonderful may be to those audiences no more than new and not necessarily wonderful. What we also want of these people is the recognition that what we do as marketers needs skill and talent too and that if we work together we may create something quite remarkable.

CHAPTER SIX

THE MARKET—WHERE IS IT?—WHO IS IT?

A Matter of Attitudes

There you are, sitting in your office, looking out at Mr and Mrs John Public walking by. There are millions of them. Somewhere amongst them is your audience for tonight, and tomorrow night and for all the tomorrow nights. Are they all potential customers? Could you pick any one at random, tell them about what is going on tonight and expect a favourable reaction?

You know the answer. The majority would show no interest at all in what you have to tell them. Somehow or other, in their progress from infancy to adulthood they have developed a set of attitudes, perhaps towards the arts in general or perhaps just towards your art form. On some subjects their attitudes will be very firm. Do you like holidays? YES. Do you like new clothes? YES. Do you like eating? YES. Do you like being poor? NO. Do you like bad weather? NO. Do you like bad drivers? NO. Do you believe in capital punishment? YES/NO.

On other matters they will be less firm because the subjects are not an essential part of their lives and also they may not have sufficient knowledge upon which to base an opinion. Do you like playing golf? I've never played it. How do you feel about tapioca? I can take it or leave it.

When it comes to the arts some people have attitudes that are as firmly established as those they hold towards bad weather or capital punishment; they may hate the arts or they may love them. There will not be very many who hold such positive views. The majority of people will not feel strongly either way because, like golf and tapioca, the arts do not really enter into their lives and they do not know much about them. What they do know they have picked up from newspapers, magazines, television, radio, other people and a limited amount of personal experience. This majority would not use words like 'hate' and 'love' to describe their attitudes; they are much more likely to say that the arts are not their cup of tea. If pressed, they might say that they think the arts are good to have in a civilised society, that they like a good play on television and they would not mind a couple of tickets for the Last Night of the Proms.

Some people will express more favourable sentiments towards the arts or towards a particular art form. Some are sufficiently well disposed

actually to attend arts events, either from time to time or even quite regularly.

Those people out there are not all potential customers; how could they be? Some of them really do not want what you have to sell; no matter what you say and do they will have none of it. They are hostile. Their feelings may be based on prejudice, misinformation or a rationally arrived at dislike. Their attitudes are very firmly fixed. They are not and never will be your customers and you had better accept it.

The majority will be the 'don't knows' and 'don't cares'. They are indifferent to what you have to sell. Within this sector there will be people who have the capacity to appreciate what you have to offer but are too busy, have never thought seriously about it, can happily live their lives without you. If you have time and money you may find ways of reaching these folk and persuading them to sample just a little. Their attitudes are not firmly set and so they may be changed—if you take the time and trouble to try to change them.

Then there are the people whose attitude is fundamentally favourable to what you have to sell and these are the folk who interest us. But where are they? Who are they? How many of them are there? If we look at the amount of space in newspapers and magazines, radio and television, devoted to the arts in one form or another we must conclude that there are quite large numbers of people who are at least interested in the arts. No-one has ever tried to put a figure on what proportion of the general public in the UK is 'favourably inclined' towards the arts. If we take but a superficial look at the the 'quality' Sunday newspaper readership in the UK we see that some 3 million copies of the *Sunday Times*, *Observer* and *Sunday Telegraph* are collectively bought every Sunday (April-September 1982 Audit Bureau of Circulation figures). There are 20 million households in the UK so we may conclude that some 15 per cent of the 'buying units' (e.g. families, couples, singles) are not actually repelled by the substantial amount of arts coverage given in these papers. (To put this in context, it is worth noting that the combined sales of the three main 'lowbrow' Sundays, *News of the World*, *Sunday Mirror* and *Sunday People*, total just over 7 million. The traditional middle-brow papers, *Sunday Express* and *Mail on Sunday*, sell a total of some 3.5 million. Thus, the combined sales of the quality Sundays, where the arts coverage is good, represent some 22 per cent of the households that buy Sunday papers at all.)

We also have the evidence of attendance at galleries, cinemas and performing arts venues, the purchase of 'good' books, records and tapes and the viewing figures for television drama. We do not need market research to tell us that these favourably inclined people are out there; these people are generally well-disposed towards the arts and some of them are well-disposed towards what we have to sell. We should be foolish to

imagine that this group of people amounts to more than a minority, but seen in terms of attitudes rather than behaviour (one may approve of it but not necessarily do anything about it), it may be quite a large minority and, I believe, sufficient to give us plenty of potential to be going on with. Market research in this field, which so often concentrates only on those who actually attend arts events, could help us more by giving us a clearer picture of those who might attend because of what they think about the individual art forms.

I find it helpful to think of this group of well-disposed people as consisting of 'Attenders'—those who attend a particular type of art activity once in a while (say, once a year at least) and 'Intenders'—those who, for any number of reasons, don't actually get around to attending—they just sit there thinking that art is a Good Thing. Obviously the Attenders have the highest amount of potential for us; we can find ways of identifying them, we can communicate with them directly, we can be much surer of their response when we offer them an art activity to attend, we can sell them more. The Intenders are certainly far more numerous but we do not know very much about them and, even if we can find ways of making contact with them, we are obviously going to have to work much harder in prising them out of their armchairs because, so far, no one has managed to do it. The Intenders do, however, represent a sector of high potential for us and we must always try to have them in our sights when planning campaigns. Collectively these two categories offer us a lot of people to aim at and if we could learn how to obtain a high level of response (that is, buying more and buying more often) from them, most of our problems would disappear.

As a practical approach to the matter of gathering together and building an audience for any art form I recommend that one thinks of the broad mass of people in terms of their attitudes and behaviour towards that art form. Some are Hostile (Hate the idea), some Indifferent (Couldn't care less), some are Intenders (We really must get out more), some are Attenders (Where are we going this week?). As a mental model it helps in determining the direction of any marketing strategy, it suggests targets and it assists in the process of communication. I think of it literally as a target, with the Attenders in the centre, the Intenders forming the next ring, the Indifferent forming the next ring and the Hostile the outer ring. It is a loose and unscientific way of analysing a market but, if you will bear with me through the course of the following chapters, you should find it a useful model and ultimately more practically valuable than waiting for the results of market research that may never be commissioned. Underlying the thinking is the belief that people with favourable attitudes towards us can fairly easily become customers, people who hold no strong opinions either way may one day have their attitudes changed and people who hate the whole idea are best ignored.

Aiming at the Attitude Target

When looking for an audience one must obviously aim at the centre of the target: the Attenders are the Gold. You must always be trying to hold the Attenders you have and add to their number. Growth in your stock of Attenders will come from those Intenders with whom you have managed to communicate, and have persuaded. Growth in the number of Intenders will come from the Indifferent whose attitudes you have managed to change.

What of the others? Are they to be ignored? If you are short of time and money, yes. In Chapter Three I challenged part of a speech made by David Pratley in which he said that marketing was about finding audiences from within the same social and educational group. In that you are most likely to find Attenders and Intenders amongst people of approximately the same social and educational background, his statement agrees with what I have said. But there must be some possibility of moving out to reach people who, because of their present attitudes, are indifferent or hostile to the art form that we are presenting. Since the entire non-commercial arts world is supported by public funds to which all contribute, is there not an absolute obligation to try to reach out beyond the people who know they want it and say they want it? The answer must be 'Yes'. Achieving this goal is easier said than done. It is a concern complicated by politics, by the missionary zeal of some people in our industry and by a widespread failure to understand how marketing works.

By now you will have discerned an apparent contradiction. I have said that those who are indifferent and hostile to our art product should be ignored and then I said that we should not ignore them. The essential elements that reconcile these two statements are time and money. The arts always operate under extreme pressure of time and money: the organisations are looking for audiences and the money that comes from audiences, now. For this reason they must accept that they are only likely to draw their audiences from people who are already favourably disposed towards them. Advertising, which is the bearer of information and our tool of persuasion, is almost wholly impotent in the face of hostility and indifference. Advertising, working in the short term, does not change attitudes, it can only exploit them. (Please don't object to the word, 'exploit'—exploitation is only bad if the motives behind it are bad.)

The only possible solution lies in learning how to change the attitudes of people. Marketing offers a way of doing this. It does not guarantee success, but the under-used and ill-understood practice of what is called public relations provides us with a tool that is capable of changing attitudes. It is an activity that needs time and money but it can change the way people regard things. It can provide correct information. It can clear up misunderstandings. It can explain. It can educate. Indeed, good public

relations practice merges into education so much that you cannot see the join.

The problem is that we generally believe the arts attending/intending public to be drawn from the middle classes and, if we go by readership of those Sunday papers, there is much to support this view. This is an unacceptable state of affairs to many. The problem that arises from this is that those who articulate the objections are not prepared to wait for a process of public relations/education to begin to work. The politician presses us for results now and, if we cannot produce our working class audiences now, wants to take away our subsidy or to interfere with artistic programming to try to make the art conform to the existing tastes of that sector of the public. The missionary zeal of those of our colleagues who believe so strongly that art is for all that they are prepared to thrust it down the throats of all whether they want it or not is another pressure we could well do without. In both cases it would help if those who demand action now would try to understand that if people do not want something they will have none of it (those 'lowbrow' Sunday papers achieve their high circulation by responding to what experience tells them their readers want and do not want) and if they want to change those attitudes they must first learn how to do it and, secondly, provide the funds and time necessary to do it.

But what is happening now? Are we to leave 85 per cent or more of the public deprived of these rich cultural experiences while we try to change their attitudes? Yes. The world is full of highly entertaining things to do and watch that are sustained by the massive support from sectors drawn from the 85 per cent or more. There is cinema and there is television, both of which offer pretty good art experiences that just happen not to be subsidised as well as plenty of straightforward entertainment. Sport. Gardening. Holidays. Walking. Drinking. When I consider those sectors of the general public that manage to live without the subsidised arts I am reminded of the song, *I Get Along Without You Very Well*.

It is more practical (and, I suspect, healthier) if we concentrate on establishing a strong relationship with those who already like what we do, and take a longer term view of the problem posed by those who don't. By this I mean that we want our organisations to grow and if we are to grow we must take steps to make our audiences grow—and vice versa. The present level of interest in the arts is too low so we must change it. We must develop a long term strategy to change attitudes. This approach is free of politics and emotion so we can concentrate on results rather than talk—or the creation of 'bringing art to the masses' schemes that are doomed to failure.

So, we always aim for the centre of the attitude target in any campaign. At the same time we plan to change attitudes over a much longer time-scale so that the centre of the target gets bigger.

Market Research

If we carry out a survey of people attending an arts event we can find out a lot of interesting things about them: where they live, their occupations, their age, their sex, and their educational background. We can also learn something of the 'reach' of our advertising, which media have successfully carried our advertising message. Formulating the questions and assessing the responses is a skilled job but it can be done and it has been done on many occasions. Once a profile of an audience has been obtained the organisation can set out to win over more people who are, in one or more ways, similar to those already making up the audience. At its simplest level the profile can be seen only in geographical terms; there is a significantly high proportion of the audience drawn from this area so let's concentrate our advertising here. Or in terms of media-reach; a lot of these people read the local evening paper so let's concentrate our advertising here.

I see two main drawbacks to market research in the arts. The first is that having the data there is the problem of what to do with it. Of the many surveys into arts attendance that there have been I am not aware of any whose results have had any greater influence than, perhaps, changing the use of media. The second is that the survey must inevitably concern itself with those who have already responded to the organisation's advertising; they are favourably inclined and clearly the advertising has worked. What such surveys cannot cover is those who are favourably inclined but for whom the advertising has not worked—or, indeed, those who are not even favourably inclined.

Unlike market research in the commercial world, these examinations are concerned with the response to a product, or range of products, that have already been determined by the artistic policy of the organisation. If one was really serious about using market research, and was prepared to act on its findings, one of the first tasks would be to see what a major section of the population thought about the product. We know that in the arts we cannot, or do not want, to start shaping our choice of product in response to this kind of evidence. So, we start off with a major handicap and it is one that market research cannot do much about.

With our short-lived products, with their unique status, we in the arts have evolved an approach that is pragmatic. We use the 'suck-it-and-see' method. We follow the line of a certain artistic policy and we assess the response. If we are satisfied, we keep going. If we are not satisfied, we make changes. What we are doing, in marketing terms, is 'test marketing'. One of the advantages we have over the business world is that we want to go on changing the product, it is part of the way we like to work. On the commercial side there is every possible reason for not changing; the product is developed until it is right for the market and it is not changed

until it starts to lose ground. Provided that we stay responsive and are willing to change there is nothing to be ashamed of in the way we do things; it makes very good sense.

If I could initiate my own market research I would concentrate simply upon the attitudes of the public. I do not know what percentage of the public is favourably inclined towards any of the art forms; I am forced to look at those 3 million quality Sunday paper taking households and assume that my audiences are in there somewhere. (They are also reading the quality dailies, of course, but one set of media is enough to be going on with.) I should like to know what people know about the arts, what they think about them and what prejudices they hold against them. If we had this kind of information about the broad mass of the public we could begin the process of changing unfavourable attitudes. Market research could help us much more in our public relations work than it ever can in our advertising.

Publicity in the Short and Long Term

Public relations is a wide field that encompasses much more than an educational role; its techniques can also be used to raise the level of awareness of an event or organisation in the minds of the faithful. PR plays an important complementary role to advertising in the campaign that sets out to motivate a potential audience. Publicity campaigns in the arts are almost always of short duration so that within the space of perhaps no more than a few weeks one must create a high level of favourable awareness (the other kind won't do) of the art product and within that climate of opinion deliver the pointed, persuasive advertising message. Very few in number are the Attenders who will attend everything you do; they have other demands on their attentions as well. The need to take positive steps in influencing the minds of the Intenders is even more pressing because they do not yet have the habit of regular attendance and if you do not work at making them aware of what you are up to they will pay little heed to your advertising.

The Objective of Publicity

When we use publicity our intention is to bring people to the point of wanting to do something. Possibly one of the biggest misconceptions about this marketing tool is the belief that publicity can make people do things. If you believe that publicity has the responsibility for making people do things then you will never recognise the importance of an equally important tool, that of the sales function. There are two steps in the process; the second step is the way in which we bring the motivated

potential customer to the point of actual purchase. It is not something that can be taken for granted. Just as we must consider in some detail what publicity is intended to do and how it should be practised, we must look very carefully at how we help the potential customer to consummate the desire that our publicity has created. In order to emphasise this point and to clarify it, the next chapters will deal with sales, sales promotion, aspects of financial planning and pricing and then we shall return to the matter of publicity to examine it in greater detail.

CHAPTER SEVEN

SELLING THE ARTS

'A sale occurs when there is a desire to buy and a desire to sell and a place or communication system linking the two. Make sure you behave as though you have a desire to sell. And sell now, not later—you may not have that customer later.'

Clearing the Obstacles

The previous chapter ended by saying that publicity is only supposed to make people want to do things and that it was the responsibility of something called sales actually to make them do it. For some people this immediately puts us in the shudder-shudder area; selling is a really dirty word. It conjures up the vacuum-cleaner salesman with his foot in the door, or the oily fellow in the back street car showroom trying to persuade you to buy that 'one-owner-a-retired-vicar-never-did-more-than-ten-miles-a-week-little-sparkler-she-is'. It really isn't like that.

We know that the desire to buy something is a volatile thing and if we do not catch it quickly it will probably evaporate. Sales is about bringing the wanting and the doing as close together as possible: it brings the psychologically committed customer to the point of physical commitment. That's nothing to be frightened of.

From a practical point of view sales is mainly concerned with the removal of obstacles. Often it need never go beyond that. The obstacles are the things that get in the way of a would-be customer who has responded favourably to an advertising message and wants to do something—go to your show, buy a ticket, enter your art gallery. The trick to learning what the obstacles are is to put yourself in the position of a would-be customer.

The customer sees an advertisement that makes him want what you have to sell. What happens then? He turns the page and in 30 seconds or less he no longer wants what you have to sell. This is happening to us all the time. We see advertising messages that turn us on for a few seconds and then forget about them. It happens to me every time I see a car advertisement but I am still driving my 1978 Renault. (Of course, the customer only responds this way if he is basically interested in what is being advertised.) There is not much that can be done about this high wastage rate beyond making the advertising message sufficiently compelling to hold the reader's attention for a long time so that it can sink in.

The first obstacle is thus the fact that the desire to have what is being advertised does not last for long and an advertisement is, after all, only a piece of paper, it is not the real thing. In order to get the real thing (or at least a written promise of the real thing) some action is required of the reader. If the action requires the would-be customer to make arrangements to have the children looked after while a special trip is made in the car to make the purchase, the odds are that it won't be taken. It's too much trouble. Or the Intender may promise that tomorrow is time enough to do something about it but when tomorrow comes, the advertisement cannot be found because the newspaper has been thrown away the night before. So, time is one of the obstacles; the time between wanting to do something and actually doing it. As the time passes so will the buying desire tend to evaporate. The advertising message must suggest that time is of the essence, that if you do not purchase now, you may not get it. You must clearly state a time limit, a date after which the desired thing is not to be had. If the option is left open, so that it does not seem to matter when purchase is made, the odds are that the option will not be taken up.

Another obstacle is information; either too little or too much. Once his interest is aroused the customer will have certain questions in his mind and before he can say to himself that this is something he must have, he will want some answers. If he has to take some further action to find the answers he may just not bother. On the other hand, the advertising message, in its desire to answer all questions before they are asked, may offer such a dense mass of information that the reader tires of the whole idea and turns the page.

Another is money. The product is just too expensive. Or the business of actually paying for the product may simply be too time-consuming because it involves getting in the car and going out on that special trip.

Murphy's Law applies to customers as much as to any other aspect of life; if a customer can find a way of not buying, he probably will. And bear in mind that we are considering here not the Indifferent/Hostile category but people who are well disposed towards the art form being advertised. Although these people may be regular attenders and may know your arts organisation and its products very well, their active response to one of your advertisements cannot be guaranteed. It is basic common sense to identify the barriers standing between those 'nearly customers' and their purchases and to reduce or remove as many as you can. This approach can be thought of as a passive kind of selling which is far removed from the hypeing, hustling selling associated with the traditional idea of the door-to-door salesman.

Passive Selling

We may define passive selling as what we do and how we behave when a would-be customer begins to approach us, either in person, by post or by telephone. The would-be customer is already reasonably well motivated through the publicity process and so we need to take no active steps to increase the motivation. A guiding principle of our behaviour is the removal of 'obstacles to purchase' and we can determine what these are by looking at the situation from the customer's viewpoint. Let us consider some specific areas where we can probably improve our passive selling.

The Box-Office/Ticket Agencies

The box-office should be open at times convenient to the customer; this may well involve opening during and even after an evening performance. The ambience of this crucial point-of-sale area should be pleasant and relaxed and good exposure should be given to the information the customer needs in order to confirm the purchase and to support the desire to buy—as well as encouraging further purchases.

Staff

Box-office staff should not be merely clerks, book-keepers and ticket-despatchers. Above all they are what would be called in any commercial situation, the *SALES TEAM* and they should be thought of, treated as and called that. The box-office manager is the sales manager and, as such, should be part of the marketing team. The sales team should consist of an adequate number of trained, informed and well-motivated people. Training should include the basic mechanics of ticket processing and box-office management and also the techniques that will enable staff to operate in an active mode whilst fulfilling their normal passive role. Adequate motivation may derive from a combination of proper remuneration and the effect of working as a member of a well managed team but there should be provision for the use of financial incentives linked to sales targets and achievements.

Management

The sales manager is responsible for day-to-day management of the box-office and the sales team, staff training, the setting of achievable sales targets (based on discussion with the marketing team of which the sales manager is a member) and staff incentive schemes.

Telephone Response

If telephone bookings are to be encouraged, there should be sufficient lines and adequate staffing. Response should be quick, efficient and courteous. A recorded message system should operate when the box-office is closed inviting the caller to leave name and telephone number for a call back when the staff are present. The telephone is an increasingly important sales tool, particularly when used for credit card booking, because it reduces the major obstacles of time and distance. If the organisation's publicity has stimulated someone to call to make a booking there can be no excuse for keeping the person waiting listening to a telephone ring out, or for answering the telephone (thus setting in motion the charging system) then asking the caller to wait, leaving them without service for a long period.

Postal Response

A traditional performing arts ticket-purchase by post requires the purchaser to possess two envelopes and two stamps at the time the decision to buy is made: one envelope and stamp to post the order and within the stamped envelope another, self-addressed envelope, for the return of the tickets. Within the seminars I conduct I usually find an opportunity to ask those members of the group with one stamp in their possession to raise their hands; in the past seven or eight years I have never found a group where more than half have stamps: these people could not, at that time, make a purchase by post. Of course they could go out and buy a couple of stamps, just as the customer I referred to earlier could jump in the car and drive off to make a purchase. The odds are that they will not.

The UK Post Office makes it very easy for you to offer your customers a Freepost address; all the customer has to do is write this special address on an envelope and post it without a stamp and you pay the Post Office. You need a licence (which, at the time of writing is £20 a year) and you pay 5p on top of the prevailing second class postage rate. The system does much to reduce this particular barrier but it is not perfect; the delivery service is only second class and, if a buying deadline is imminent, delays can bring the orders in too late. Using this service to assist book purchase by post I have found that when the postal service is under pressure the Freepost mail can take many days to arrive. Another disadvantage is that the Freepost address is not your normal postal address so, if a customer wishes to write to you on another matter, he must use the Freepost address (unless you have taken steps to provide the normal postal address as well) which can involve delay and makes you pay for his postage—which in this case you may not wish to do. There is also a general lack of understanding of the Freepost system amongst the public which could be improved if the Post

Office gave better publicity to it; most arts users of the system note a high proportion of customers still put stamps on their envelopes.

The Post Office Business Reply service allows you to provide the customer with a special envelope which carries your normal postal address and can be designated either First or Second class. You are also required to obtain a licence which currently costs £20 a year. Where you are advertising to your market by direct mail the inclusion of such an envelope will eliminate the disadvantages of Freepost and will encourage rapid purchase. A disadvantage is the cost of producing the special envelope to the Post Office approved design. If you are reaching your market by press advertising then obviously a Business Reply envelope cannot be used and Freepost is essential.

The same concern for the customer's convenience should apply to the return of tickets by post. Customers should not be asked to enclose a stamped, addressed envelope for the same reason as we do not ask them to pay the postage on their ticket order.

When tickets are returned they should be accompanied with a brief printed note thanking the customer and explaining what to do if a mistake has been made: it helps reinforce the bond that you are trying to build if the message can be from a named person in the sales team to whom the customer can refer if something has gone wrong in the booking.

Ease of Payment

Parting with money is always painful even when it is exchanged for something that is wanted very much and that is probably why credit cards have become more popular; not only do they delay payment (and in the case of Access/Visa type credit cards enable payment to be repaid in instalments if so desired) they seem to make the transaction less painful. The payment of money can put up two other barriers to purchase: the first is the problem that arises when a customer wants to buy from a distance, the second is when the sum of money is higher than the customer would like. Any system that facilitates payment from afar and minimises the inconvenience or embarrassment of having to pay out a large sum of money, should be considered seriously. Credit cards, cheques, even Standing Orders at the customer's bank are systems that can be used. Where there is a substantial number of really regular Attenders, as in the case of a successful subscription scheme, then the introduction of personal customers' accounts should be considered; the customer orders tickets by telephone, post or personal visit and receives an account at the end of the month which is required to be paid within, say, four weeks.

Returns

This is a major problem for box-offices as they are presently run. The orientation of the majority of UK box-offices is such that the system is created and maintained for the convenience of the organisation and the staff. Where staffs are inadequate in number, as they usually are, this may be understandable but it is not the way it should be if one is to take sales seriously. A returned ticket gives the box-office something of a headache; it involves changing the book-keeping, messing about with seating plans and so on. Yet, looking at it from the customer's point of view, if money has been paid out and later something turns up to make it impossible to attend, what a shame it is that the arts body just refuses to exchange the ticket or refund the money. So much time and effort has gone into winning this customer and now, for reasons which are probably beyond his control, he is out of pocket, doesn't get the art experience he has paid for and probably feels quite badly about the organisation in consequence. I believe that if the sales team really values that customer it should try to find a way of accommodating his problem. A sales team would take that point of view; a typical box-office staff might not.

It becomes a particularly pointed problem if a subscription scheme is operated (see Appendix A: Subscription-Based Marketing) because then the organisation tries to persuade the customer to buy tickets 'wholesale' so that a whole season of regular visits are bought at once. The customer is also encouraged to buy far earlier than in normal circumstances so the risk of date clashes in the personal diary is much higher. With a customer who has overcome the barriers posed by the substantial time and money commitment involved in subscription, how can one refuse to exchange a ticket or refund the money ?

Active Selling

Active selling is the mode adopted when we contribute to the motivational effect of publicity. It means doing more than just removing and reducing the obstacles, it means using our resources (usually our staff) to inform and persuade the potential customers and to help them over the final hurdle of purchase, that painful moment when they have to part with the money.

The active approach must be handled with care because if it becomes too active and too pushy the customer will back off. We are addressing ourselves to Attenders and Intenders, people who probably have a good idea of what they will and will not buy. If we push too hard the result will be counter-productive. (See how important it is to keep focused upon the centre of the attitude target: if you start off believing that you can influence the Indifferent and Hostile you will be tempted into a much more

aggressive style of active selling which will not succeed with the outer part of the target and will alienate the vital centre.)
Here are some examples of active selling.

The Box Office/Ticket Agencies

Sales team members are in a very good position to influence customers who approach them. The customer may choose a ticket at a certain price but all seats at that price have been taken: a good member of the sales team will guide the customer into an appropriate alternative finding out how important is the seat location and what range of prices will suit his pocket. Often the customer will be happy to buy a more expensive seat if he is convinced that it represents good value. The sales person can offer informed guidance. While the customer is buying tickets for one event he can be told about other events and encouraged to buy now while he is here, or while he is on the telephone.

An Attender, identified by name, address and telephone number, is worth a hundred Intenders 'out there'. The sales person can use the opportunity of direct contact with a customer to ask for and note the name and address which can be added to the vital Attenders' mailing list, which is the heart of all advertising campaigns for the arts.

The sales team is often approached for no more than information but it may be fairly assumed that anyone who voluntarily enters a building known to house arts events is fair game (and will accept that they are fair game) for an overt but tactful sales pitch. If someone wants to know what is happening on a certain night, or asks when the run of a play begins, one can either mutely pass over a brochure or pass over the brochure whilst starting a conversation. Often it is enough to comment that booking has just opened, that ticket sales have been marvellous, that there are still some good seats left, and then suddenly there we have another Attender, with tickets in hand and name, address and telephone number duly recorded.

It takes time to change the orientation of a sales team from passive to active and it cannot be done by the simple introduction of an incentive scheme or by exhortation alone. There is nothing more frustrating than to be offered a prize and then to be unable to win it. Training is vital. The sales manager should try to set aside time, perhaps an hour a week, when the sales team can meet to discuss their techniques and, under the guidance of the sales manager, work out what methods are working best and what methods can be tried out. A tremendous amount of progress can be made through group discussion into which the sales manager inserts an element of structured training.

The transition from being a box-office staff to a sales team starts with the recognition of its true role and its clear identification with the sales

function. If it is openly acknowledged to be playing a vital part in the marketing process, if its opinion is sought and heeded, it will react to the respect that is being shown towards it and, given training, will deliver the goods. The move towards active selling then follows as naturally as tax follows income.

The Telephone

There are two kinds of telephone calls: those that people make to you (and so choose their time to call) and those that you make to them (when you choose your time to call). When people call the sales team and ask for information or want to buy tickets, they are open to the same kind of active sales approach as they would be had they walked into the building. Calling them in order to sell tickets is a different matter.

The general awareness that now exists in the UK of subscription-based marketing has helped us to concentrate upon many aspects of arts marketing, amongst them the use of the telephone as a medium for active selling. It has become a talking point and has run the risk of being seen to be one of those panaceas that the arts community is so fond of taking up. The telephone can be used for active selling but only in certain circumstances. Its use on a random basis, making calls to people of no known arts interest, cannot be justified on either grounds of time involved or cost. Double glazing or burglar alarms are something that any randomly selected householder may be persuaded to buy and so a telephone campaign for this purpose can be justified. If there exists a list of known, recent Attenders, with whom the organisation believes it has a reasonably close and friendly relationship (the subscriber is a perfect example) then the telephone can be used. Rare are the cases where one would attempt to contact thousands of people but if, for example, a campaign is well under way and the sales deadline is imminent then it is reasonable to start a programme of sales calls that are primarily intended to remind the customer of the impending deadline and to provide him with an opportunity to make a purchase then and there using a credit card, or to make a seat reservation which he can follow up with a postal booking.

Anyone who has used the telephone in this way quickly develops an approach that reduces the possibility of intruding upon someone's privacy and avoids wasting time. For beginners it is helpful to provide an outline script, listing the points to be made. It might follow this pattern:

1. Greeting.
2. Introduction of caller and organisation.
3. Explain purpose of call.
4. Check that timing is convenient. Arrange to call back if not.

5. Question: have you decided when you would like to attend? Have you decided if you want to attend? (How the question is phrased will depend on how active you want the selling to be.)
6. If response is Favourable—operate booking procedure.
 If response is Unfavourable—use the call to verify name and address and confirm that advertising material is still welcomed.
7. Thank you and Good Evening.

I have used the telephone as a means of contacting known subscribers within the final week or so of a campaign. I have done it myself, as part of an 'amateur' team, and I have watched a skilled professional team in action (the advertising sales team of *Classical Music* magazine which was hired, on a commission basis). Those who dismiss the use of the telephone as being an unjustifiable intrusion upon the privacy of the individual may be assured that very, very few of those called showed any sign of resentment; most seemed rather flattered that the organisation should take the trouble to call them and all conversations ended on a friendly note. Results, in terms of sales, varied according to the campaign concerned. Where there was no special incentive for existing subscribers to re-subscribe, the telephone campaign pulled in high sales figures; after the introduction of special sales promotions aimed only at 'our' people, the sales results from the telephone dropped heavily to the point where we could confidently abandon its use (because we had already seen a marked improvement in sales by post and in telephone calls made to us).

An interesting point about telephone selling campaigns is they are quite good fun to do and they can improve the morale of a sales team, particularly if a financial incentive is present. I shall always remember the sight of one of our *Classical Music* magazine salesmen as he found himself persuading a customer to buy £158 worth of tickets; his voice remained calm and relaxed while he waved his free arm around in jubilation and jumped up and down at the thought of his commission on that sum!

Personal Selling

Door-to-door selling on a random basis ('cold canvassing' is the term used which evocatively sums up the chilly doorstep confrontation) makes no more sense than random telephone selling. We know that the majority of people are simply not in the market to buy our tickets so unless we have limitless manpower resources it cannot be worthwhile. There may be some justification in forming a team to call on people in a neighbourhood simply to find out whether they are Attenders or Intenders, so that a good mailing list may be compiled, because the time involved per call is small and because the long term benefits of having that mailing list could be great.

But, usually there are better options open and this kind of activity is best left alone. (The *TMA Marketing Manual* Volume 3 published in November 1982 contains an excellent case study on the experience of the Greenwich Theatre in door-to-door selling, written by General Manager, David Adams, which describes how it was introduced and then abandoned.)

Amateur organisations have long relied upon personal selling but a different strategy is involved. Selling to friends is quite different from the cold canvass and, if it is only done once or twice a year, friends remain friends. The professional body has to sell throughout the year and it can rarely, if ever, count on the goodwill of people to sell on its behalf on a regular basis without payment.

The idea of employing people as 'representatives' has better potential. It is a part-time job that suits some people and it need not cost a great deal to operate. The payment of an honorarium plus expenses would often be sufficient reward for a person with spare time and income from another source. Representatives are used to disseminate publicity material in a location, to build up lists of known customers, to organise party bookings and generally to establish a presence in the community: it is obviously of interest to the organisation with a fairly wide catchment area with communities sufficiently small to make it possible for the representative to become known. Representatives will inevitably concentrate upon friends, friends of friends and work through a developing social and quasi-social network. A random approach should be discouraged (if they try it they will soon be discouraged anyway). To be effective, representatives must, although working alone, feel part of a team and so need the guidance of a manager and should meet other representatives and the in-house sales team regularly for briefings and training sessions.

Sales Material

Another example of the seminal influence of Danny Newman and subscription on our thinking here in the UK is the way in which it has drawn our attention to the importance of sales and, in particular, the need to transform our advertising material into sales material. This is not to say that we did not produce sales material before Danny Newman told us to, it is simply that we did not do it as a conscious part of our work in the sales field. We did it from time to time, and here and there, but we treated it as an option rather than an essential. Danny Newman showed us pieces of paper, multi-coloured, multi-folded, with pictures and words leaping out to grab our attention and make us want the product that they described so persuasively. All of these pieces of paper had something else in common: they made us want and they made us do. There was always an order form for postal booking and a telephone number to make purchase possible

now. The order form was not tucked away apologetically it was there large as life as the natural conclusion of the story he and his many clients had been telling. That emphasis upon selling as a logical step to follow the process of persuasion was what made his material sales material.

We now realise that whatever advertising we may plan we must always consider the sales implications; that is, we must ask ourselves how the turned-on would-be customer is actually going to lay his hands upon what he wants. If we cannot provide a quick and easy method then we might just as well abandon the advertising.

I shall return to the business of making sales material later. (See Chapter Fourteen.)

Wishing Won't Make It So

Very occasionally arts events really do seem to sell themselves. With comparatively little effort on the part of the promoting body, which has done no more than print a few posters and distribute a few leaflets, an audience emerges from out of the woodwork, clamouring to buy tickets. It doesn't happen very often in the subsidised sector although in the commercial entertainment world (which bases its assessment of quality entirely on the capacity of an event to 'draw') it is more common. The reason why this phenomenon occurs is easy to explain; through one means or another a sufficiently large number of people have been brought to the point that not only are they extremely aware of the event and the personalities involved, they have also reached the point where they want it so much that they will actively search for information on it (for example, they will buy a magazine in order to find the advertisement for it) and will be convinced that if they do not take special steps to secure their right to it they will miss it. So highly motivated have they become that they will overcome any number of inconveniences in order to satisfy their desire. Tell them that tickets are only on sale at ten minutes past two in the morning on the first rainy day in April and they will be there. Tell them that the tickets will cost them the price of a good big dinner and they will still be there.

The lucky organisation is in a seller's market, the principal characteristic of which is that it does not have do take any positive steps to sell—the customers do all the work.

This happy situation is the El Dorado of arts marketers but, unfortunately, the trail is littered with iron pyrites. We see a successful event and we look for its characteristics and we note that the promoting organisation appears to have done very little beyond behaving in a very confident manner. So, we think, if we want to be successful we must copy

them; so we behave in a confident manner and wait for the customers to do all the work. Sometimes it works. Mainly it doesn't work.

There is a difference between being in a seller's market and just behaving as though you are in a seller's market. It is very important that you know the difference and even more important that you do not try to fool yourself that you have a winner when all the indications are that you must carve that audience out of granite. One's own state of morale is an important factor in achieving success and it is quite common for the person running a campaign to believe so hard in the product that, at the time, it seems to make perfect sense to believe that everyone else will share that view. Don't let your enthusiasm run away with you because there is far more to the matter than feeling and looking confident.

Naming of Parts

It seems hard to believe that in 1976 the use of credit card booking was a controversial matter; now it is almost totally accepted. We have seen the general influence of the subscription idea upon printed matter and media advertising. There are training courses on direct mail and telephone selling techniques. All of them separate manifestations of a sales function that is not yet universally accepted as being an integral part of arts marketing, as part of the analysis, part of the methodology and, so far, it is unacknow-ledged even by name. We do not have sales teams, sales managers, sales departments, nor do we have sales budgets. Naming something is a way of recognising that it exists and making it hard to forget.

There is more to the sales function than merely acknowledging it by name. Once we understand its place in the process it begins to influence our decisions in other areas such as pricing, sales promotion and financial planning. Let us take, for example, the idea of unit pricing (that is, all seats at the same price). Without the perspective of sales it can be thought of as a nice, democratic, approach to pricing that you can take or leave depending on how nice and democratic you want to be. Bring the sales concept into the picture and it becomes a very good way of encouraging people to jump the hurdle of procrastination because if they do it now they will get a better deal. Unit pricing has more to do with selling than with anything else but it appears to the public that we are being nice and democratic so we win on both counts.

Financial planning involves the setting of budgets for expenditure: if we acknowledge that we operate the sales function and that it plays a major part in achieving our income, we will begin to accept that we have to spend money on things like bonuses and commissions, salaries, honoraria, fees for training, commissions to credit card companies and so on. The next step is to create a sales budget and from that moment on the sales function is

enshrined and openly acknowledged as being part of what the organisation does. I was once advising a local government department of leisure on how it could implement an arts provision system. Up to this point the treasurer's department had regularly vetoed the use of credit cards and the distribution of complimentary tickets to shopkeepers who had displayed posters. I discussed this with one of the treasurer's senior officers and found that the reason for their refusal was simply one of accountancy; they had only a publicity budget and they would not accept that credit cards and free tickets were publicity—which, strictly speaking, they are not. 'Why don't you create a sales budget?', I asked and went on to explain what sort of things might be paid for out of it. I watched the scales fall from his eyes as he realised how much easier everything would now be for them. 'You mean, we buy the tickets from ourselves?' he said. 'We pay out from the sales allocation and pay into ticket income?' I then hit him with the same argument for sales promotion. He went away a happy man.

CHAPTER EIGHT

SALES PROMOTION

Sales promotion is the term used to cover all the techniques we employ to make what we are selling even more attractive, to increase the likelihood of purchase and to bring the moment of purchase as close as possible to the moment when the customer decides that he wants to buy. It is a way of smoothing out the obstacles in the path to purchase, or a way of persuading the customer to overcome obstacles that you cannot remove or reduce for him. There are sales promotion methods that we can use to make the customer loyal to us—to make him want to come back for more. It can be a way of encouraging customers to buy more (more tickets) or to buy more expensively (more expensive tickets).

Discounts, vouchers, prize competitions and draws, special offers and so on, come under the sales promotion heading. Once again, the introduction of subscription based marketing, which regularly uses such devices, drew our attention to the potential of sales promotion and helped knock on the head the thought that such methods were inappropriate in an arts setting—at least, in the minds of most practising arts marketers.

'Surely, offering someone 10 per cent off the price of a theatre ticket won't make a customer out of someone who cannot be bothered with theatre, nor will giving someone the chance to win a weekend for two in Vienna make them buy a ticket for a concert.' These objections are commonly voiced and used as arguments against sales promotion. They are valid. Sales promotion will not motivate someone who is Indifferent or Hostile to your art form, just as your advertising will bounce off the pachydermous attitudes of someone who just doesn't want to know. It can, however, influence the Attenders and Intenders.

If one accepts that time is a very important element in sales, that even the most highly motivated person may fail to buy because there is no particular reason to buy now it can be seen that if something extra is offered—provided the customer buys now, it will be influential. The customer reads the advertising message which describes the art event attractively and states the ticket price. 'Fine, that's nice—I'd like to go to that.' The message goes on to say that if he buys the ticket before the end of the month he gets a £2 voucher that he can use to reduce the cost of his next visit. Fine again. He gets more, simply by doing what he was intending to do anyway. 'The end of the month is only a week away—I'll telephone them now.' We know that he probably would have been side-tracked, or would

have forgotten. The voucher offer pushed him into buying. The voucher promoted the sale.

The subscription approach tries to persuade the customer to perform an unnatural act; it tries to make him buy a whole clutch of promises months ahead of when the promises will be kept. It asks for a large amount of money, usually *now* and it expects the customer to tie up a series of dates when he would probably rather leave his diary free. This customer likes many aspects of what is offered but there are some big disadvantages, perhaps, even probably, big enough to put him off. Then he sees the price it will cost him if he accepts what he presently sees as the disadvantages (he will probably change his mind about the disadvantages later): not £60 for his season of pleasure which is the normal box-office price, but only £45. £15 is a big saving, big enough, perhaps, to make him give it a try.

'But the deadline for purchase seems a long way off. There are two months to go before booking closes. Leave it until later, I'll still get my £15 off. Just a minute, what is this? A sticker on the booking form that says if I book by the end of this month I'll save another £2. £2 is £2 and I was going to do it anyway, so I'll do it tomorrow.'

'There is a letter here with the brochure. It says that booking opens today and tickets are allocated strictly on a first-come, first-served basis. This is a very attractive offer; I'll bet they are inundated with personal callers and telephone calls. With my game leg I really need an aisle seat in the stalls. If I call now I am sure they'll fix me up with a decent seat.'

And so sales promotion encourages a customer who sincerely believed that he would buy sometime or other into someone who buys now. It could be argued that this has cost the organisation first £15, and then another £2. So it has in a one sense but it has also brought it in £43 that it is sure of now and it has filled possibly six or more seats.

Price reductions can also be used to correct misjudgements in pricing. Decisions on how much to charge are frequently made months ahead of the events themselves and it could well be that in the desire to improve the yield from audiences, price levels have been pitched too high so that customers are declining. Provided that it is handled with discretion, a discount voucher might bring the price level back down to a level of public acceptance.

The cost of a sales promotion is not something to be disregarded. Discounts, price reductions no matter how disguised or dressed up, are items of expenditure and should be accounted for both in estimates and in final figures. It is harder to estimate these expenditures because they are linked to sales income (i.e. the more you take in, the more you spend) and common practice is to account for net income so that in the earlier case, only £43 would be recorded, rather than showing income of £60 and sales promotion expenditure of £17. This kind of expenditure should not be

glossed over: it has played its part in the motivation of the customer as publicity has done. Just as we try never to spend any more money than we need to spend on publicity, so we must try to contain sales promotion expenditure: we can only do this if we plan, monitor and experiment to see how little money is needed to lure our customer into purchase. (See Chapter Nine: Financial Planning.)

Some sales promotions need cost no money at all. Competition and draw prizes are comparatively easy to obtain from commercial companies (certainly, far easier than hard cash) in exchange for advertising space on sales material. I have negotiated many travel prizes, such as holidays in the Philippines and Vienna, and items such as cases of wine and food hampers. The same rationale will operate in the supplier's mind as in a sponsorship arrangement: the arts-going public constitutes a market of interesting potential and if the cost is not too high then it is worth exploring.

Do these 'gimmicks' work? A discount must be influential to someone who is teetering on the brink of buying, but a chance in a draw? A competition? Surely not? It is hard to make a really convincing argument. My feeling is that in a campaign where you are trying hard to excite customers, where you are attempting to build up a whole package of 'reasons why', something like a holiday prize can add to the glamour. It is not worthwhile if the prize cannot be attractively illustrated. One line of type saying 'Win a holiday in the Bahamas in our easy competition' is not likely to enhance your offer whereas a full section, in full colour, showing palm trees and lovely beaches will. Some people say that if there can be a connection between the prize and the art events themselves, that is better. So, for a music subscription offer, a visit to the Bayreuth Festival might be better than that holiday in the Bahamas—but I am not so sure. Our customers may be unusual in that they like the arts but they are still members of the human race and like good holidays, good food and wine and all the other pleasures. An association between the arts and simple, if expensive, pleasures is probably enough.

But do they work? If we keep at the front of our minds what the purpose of sales promotion is, that is to make what is offered more attractive one way or another, and if we use these pretty lures together with other, more powerful devices such as cash benefits and/or preferential seat booking, then they will play their part in the enhancement. If the competitions involve time and trouble on the part of the customer then, of course, the effect is likely to be counter-productive.

I must add that I have never yet felt so confident in these methods that I have ever recommended a client to spend money on obtaining prizes: I have only used them when it has been possible to come to a *quid-pro-quo* arrangement.

Let us now look in greater detail at the basic sales promotion techniques.

Discounting

When discounting remember always that your aim is to reduce the 'normal' price by no more than is needed to bring the customer to the point of purchase. There should be a reason for discounting, a reason that makes sense to the customer as well as to you, such as asking the customer to buy more than he usually expects to do, asking him to buy a more expensive seat, asking him to pay money further in advance than usual, and so on. The major risk in discounting, apart from being too generous, is to discredit your pricing policy so that a certain level of discounting is expected always; if this happens and you then choose to reduce the level of reduction there could be resentment and resistance to purchase. The trick is to keep on the move, switching from one discount approach to another and from one sales promotion method to another.

Also remember that the calculations you make in working out a discount approach are your business and it may not be to your best interests to show, for example, all the percentages. You may decide to show the customer what the basic box-office price is, what the reduced price is, and leave it at that. You may choose to list the actual savings. You may highlight the percentage reductions. It will all depend on what aspects of your sales promotion strategy you think it will benefit you to reveal. In the five examples of percentage-based discounting that follow you could say of the first, 'SAVE 25%!', and of the rest 'SAVE UP TO 25%!'. There is not a great difference between those phrases but, on the examples chosen, the financial difference in your receipts could be as much as £2325.

There are many basic discounting approaches; the examples that follow illustrate the use of constant and varying percentages. The box-office prices chosen are taken from a typical classical music subscription scheme where there are six seating areas all priced differently. This poses quite a difficult discounting problem because the reasons why people opt for different seating areas vary: some will choose the 'best seats', some the most expensive, some the cheapest, some the 'best value for money'. To what extent variations in discounting can influence people's buying habits in the very personal matter of ticket buying is hard to judge—all one can say is that the more eye-catching and truly significant the variation, the more likely it will be to influence your customers. You need time to find out how a specific market responds so that you can develop a strategy accordingly.

Percentage-based discounting

a Constant 25% reduction

Price	% off	New Price	Customer Saves
£61.00	25%	£45.75	£15.25
54.00	25%	40.50	13.50
47.00	25%	35.25	11.75
40.00	25%	30.00	10.00
33.00	25%	24.75	8.25
26.00	25%	19.50	6.50

Assume 100 seats sold in each price/seating area

Total value of customer savings (your expenditure) is £6525

This approach relates the customer saving directly to the amount spent and is generous/expensive. If the most expensive seats are hard to sell and the cheaper seats are in demand, then consider a Diminishing Percentage Discount scheme. If the opposite applies, then consider an Increasing Percentage Discount scheme.

b Diminishing Percentage Discount (Down from 25% in 2% decrements)

Price	% off	New Price	Customer Saves
£61.00	25%	£45.75	£15.25
54.00	23%	41.58	12.42
47.00	21%	37.13	9.87
40.00	19%	32.40	7.60
33.00	17%	27.39	5.61
26.00	15%	22.10	3.90

Assume 100 seats sold in each price/seating area

Total value of customer saving (your expenditure) is £5465

Here the customer saving is loaded in favour of the expensive seats and might be used if there is resistance to buying in this price/seating area. The 2% decrement brings the final percentage down to 15% which still offers the customer a good saving on the cheaper seats. On the notional sales of 100 seats in each area this scheme costs £1060 less than scheme (*a*).

c Increasing Percentage Discount (Up from 15% in 2% increments)

Price	% off	New Price	Customer Saves
£61.00	15%	£51.85	£9.15
54.00	17%	44.82	9.18
47.00	19%	38.07	8.93
40.00	21%	31.60	8.40
33.00	23%	25.41	7.59
26.00	25%	19.50	6.50

Assume 100 seats sold in each price/seating area

Total value of customer saving (your expenditure) is £4975

In (*b*) the percentage reductions were 'going with' the price/seating area reductions: here they are going the other way so that the effect is to level out the customer savings. There is only £2.65 difference between the highest saving and the lowest saving: in (*b*) the difference was £11.35. On the notional sales of 100 seats in each area the cost of this scheme is £1550 less than scheme (*a*) and £490 less than scheme (*b*).

d Diminishing Percentage Discount (Down from 25% in 3% decrements)

Price	% off	New Price	Customer Saves
£61.00	25%	£45.75	£15.25
54.00	22%	42.12	11.88
47.00	19%	38.07	8.93
40.00	16%	33.60	6.40
33.00	13%	28.71	4.29
26.00	10%	23.40	2.60

Assume 100 seats sold in each price/seating area

Total value of customer saving (your expenditure) is £4935

Here the decrement is 3% which brings the final reduction down to 10%. Like (*b*) it is loaded to encourage purchase of expensive price/seating areas. Unless there was a very strong demand for cheaper seats it might well be that the 10% reduction, which gives only £2.60 off a 26.00 purchase, would not be sufficient. On the notional 100 seats sold in each area, the cost of the scheme is £540 less than (*b*): perhaps the saving is not worth the risk of losing sales in the less expensive areas.

e Increasing Percentage Discount (Up from 10% in 3% increments)

Price	% off	New Price	Customer Saves
£61.00	10%	£54.90	£6.10
54.00	13%	46.98	7.02
47.00	16%	39.48	7.52
40.00	19%	32.40	7.60
33.00	22%	25.74	7.26
26.00	25%	19.50	6.50

Assume 100 seats sold in each price/seating area

Total value of customer saving (your expenditure) is £4200

In this case, with a 3% increment, the increases 'beat the tide' as it were, with the percentage reductions getting bigger as the price drops. The customer savings are actually larger in the middle of the price range although the differences are marginal (only £1.50 difference between the highest and lowest saving). The effect is almost that of a flat rate reduction.

(In the examples given, the figures do not take into account the requirements of a box-office accounting system, which may require every price to be easily divisible by the number of performances. In this case it is normal practice to calculate percentage reductions and then to 'round up' or 'round down' according to the box-office requirements. This is perfectly acceptable provided that the revised figures do not depart by more than, say, half a per cent (preferably less) than the published, headlined, discount offer. To announce '25% OFF' when you are, in fact, only offering 24.1% would not do: you could get away with it if the exact figure was 24.8%.)

Fixed Sum Discounting

This is simply the reduction of all prices by the same amount. If all your seats are the same price then a fixed sum reduction is the same as a constant percentage reduction: if they have different prices then the effect will be the same as a varying percentage reduction. When used by itself the main advantage is that it gives you something to shout about that is easily understood and can be very influential. '£1 OFF ALL SEATS TONIGHT!', 'SUBSCRIBE TO FOUR PLAYS AND SAVE £10!' Customers will only think about percentages if you encourage them to by displaying columns of figures showing all the percentages. If a theatre has four basic seat prices and on one night of the week offers a flat reduction of £1 off all seats, few people will complain that this is giving a higher percentage reduction to those who are buying cheaper seats, which, of course, it is.

A fixed sum discount can be used in conjunction with a percentage scheme and it is particularly useful as an 'accelerator', as a way of persuading people to buy even earlier (as in the case of our earlier customer with the game leg). One might use a percentage method to overcome a price obstacle (as in a subscription scheme) and a fixed sum reduction on top of that to stimulate immediate purchase.

Discounts By Voucher

The main problem with discounting is that we are offering our customers only promises. The voucher puts the discount into the customer's hand here and now, before purchase is made, even before purchase is seriously contemplated. A voucher cannot be used to carry the equivalent of a percentage based discount but if the reduction is for a fixed sum, then the method should be considered. So, instead of saying '£2 EXTRA REDUCTION IF YOU BOOK BEFORE . . .', you give the customer a piece of paper with a big £2 printed on it, all the information needed on how it can be used and you make it look as if it is worth £2.

The voucher may be posted out with the main sales material or given to customers when they buy tickets for other events. It is both a sales promotion device and a piece of sales material in its own right. It is tangible and it sits there ready to self-destruct on the day of expiry.

The voucher is also a particularly effective way of holding customers from one campaign to another. If the customer has been swayed by your combination of good publicity, sales and sales promotion, and has enjoyed what you have persuaded him to buy, then he should be ripe to buy next time. If you have used the opportunity provided by the first contact to give him a voucher valid for next time, he will have in his possession a reminder that there is to be a next time and a good financial reason for his being there.

In Chapter Seven I referred to a subscription renewal campaign using a team of people on the telephone and described how that approach to obtaining renewals was abandoned after sales promotion had proved effective. The method used was a voucher, sent back with tickets ordered in one campaign and valid for the next. We knew that some people would lose their vouchers so we agreed in advance that we would be tolerant—after all, we knew who they were, they were our customers. The vouchers were validated up to a date approximately five weeks before booking closed. Our 'old' customers used their vouchers, sending them in with their booking forms and cheques for the balance. After the expiry date of the vouchers we started the telephone campaign and discovered that customers who had not booked all appeared to have very good reasons for not booking and could not be swayed. (Before the use of the voucher a very large number of people

had responded as though they had simply overlooked the matter, they thanked us for reminding them and then, frequently, made their booking.) At the end of the booking period we found that not only had we obtained more renewals than ever before (that is, in proportion to the number of people who were on the file to be renewed) but 98 per cent of the renewing customers had done so before the expiry of the voucher. Unlike the former situation this telephone reminder campaign drew almost no sales. The voucher was only worth £2 whereas the average expenditure per customer was in the order of £35, yet the voucher was clearly influential.

Sales promotion methods must be versatile and capable of responding to the problems of today as well as being integrated into long term planning. There can be a whole variety of situations where sales suddenly need a boost and Diggle's all-purpose, ready-for-anything, go-anywhere, voucher is to be recommended. The voucher is clearly identified as being yours, with the name of the organisation, the logo, even a picture if it is appropriate, and a big £1 sign. Somewhere on the front is a blank panel headed 'Validity' and into this you may later print whatever information is necessary to relate the £1 voucher to the event needing the boost and the date after which it becomes invalid. On the back of the voucher you state the basic conditions; for example, the voucher cannot be exchanged for cash, you have the right to change the conditions of acceptance at any time, and so on. They may be used in quantity to encourage party booking: one might send out 20 at a time to party organisers in order to ginger them up a bit. If they are not used they will cost you nothing beyond the cost of printing them.

I once worked with a theatre that had the habit of telephoning local businesses when ticket sales were down and offering them free tickets. It helped fill the place but that was all. It had the adverse effect of making the theatre look as though it was in trouble. I overheard some of the telephone conversations and it was clear that the local businesses thought (and spoke) as though they were doing the theatre a favour in accepting the gift of a few tickets. We introduced the all-purpose, ready-for-anything, go-anywhere voucher and validated it for Monday and Tuesday evening performances of the next play, where sales were not good. This time the telephone call offered the local businesses not free tickets but a strictly limited number of £1 vouchers: they were asked how many were required and were asked to promise to return any that could not be used. What we were doing was putting a value on what we were offering. The business people took it quite seriously and when, for example, the local insurance company received its six vouchers and distributed them, the staff complained that it wasn't fair, there were more than six staff and what about wives and husbands? So the next thing was a respectful telephone call to the theatre asking if, perhaps, they might be sent another eight vouchers. Not all the vouchers were used,

Designed by Mentor Advertising

USE THIS VOUCHER AND SAVE £5
ON ANY TICKET WHICH EXCEEDS THIS VALUE.

Wozzeck
at the
Royal Opera House

Please present this voucher at the Royal Opera House
Box Office in Floral Street, Covent Garden together
with your booking and payment.
(One voucher only may be used per ticket)

TO

CL

Churchill Theatre
Privilege Voucher

**This Playgoer's Privilege Voucher, value
One Pound may be used in the purchase
of one ticket as specified in the
validity panel right.**

It may be used at the Box Office or for postal
booking. Please read the conditions overleaf.

**Enjoy a Live Show at Bromley's
wonderful Churchill Theatre.**

Churchill Theatre
Bromley
Kent BR1 1HA
Box Office telephone 01-460 6677/5838

Validity

du Maurier
Privilege Voucher
Philharmonia
Orchestra

**Subscription Season September 1982
to March 1983**

This voucher, value Five Pounds, may only be
used in accordance with the conditions specified
in the Philharmonia Subscription brochure. It may
not be exchanged for cash and it may not be
used towards the purchase of single tickets at
Royal Festival Hall or other Box Offices.

One voucher may be used for each Series Subscription purchased.

£5

See reverse side for entry form for Philippines
Holiday Competition.

Examples of vouchers. The Royal Opera House voucher for **Wozzeck** was printed in
a magazine. The Churchill Theatre voucher was used for general sales promotion.
The Philharmonia voucher was used to give an extra bonus to 'registered'
subscribers.

but those that were brought in more than bottoms to fill seats, they brought in money because the price of the tickets was around £2.50.

But what about the people who would have come anyway and would have paid full price? This is a common objection to sales promotion and there is an element of justification in it. With a voucher of the type I have just described, then it may be that people will not use it to reduce the price of what they would have bought anyway but might use it to buy a more expensive seat. The experience of the Philharmonia Orchestra has been that once a subscriber has been enrolled there is a marked tendency for him to 'trade up' in successive campaigns, 'spending', as it were, his saving on more expensive seats. The ultimate argument is that if there were enough people who were paying full price then you would not be using any sales promotion method at all. Sales promotion is a tool only to be used when necessary.

Seat Preference

The matter of where a customer sits is of considerable importance to him. During the moment of decision, when the choice may go either way, thoughts of seat location will almost always be present. If I go, will I get a good seat? If I want a good seat, how much (or how much more) will it cost me? If I cannot get a good seat, do I still want to go? There are two factors operating here, the desire for a good seat and considerations of cost. The customer's wish for a good seat is something we should now consider as a matter of sales promotion. If we can make it clear to the would-be customer that immediate action will greatly increase the chances of securing a good seat, then we are helping to overcome that particular sales barrier. If we can make some kind of promise that this customer will have priority treatment for a limited period of time, then he is likely to move faster, which is one of the sales promotion objectives. Subscription-based marketing makes great use of this idea. When you become a subscriber you become a very special customer and everything is done to look after your needs. Obviously you will want the best seat in the house, fortunately, we may define the best seat in the house as being the one the customer wants and so there are usually plenty of best seats and, as you are one of our valued customers we will do everything we can to help you get it. All you have to do is call or write to us *now*.

Group Bookings

The attractions of being able to sell tickets in bulk are obvious and most arts bodies have a concession scheme offering price reductions to groups. Unfortunately the schemes are often rooted deep in the history of the

organisations and are rarely taken out, dusted off and reconsidered. Somewhere at the back of a brochure there may be a line of very small type saying that a reduction of 10 per cent is available to parties of 10 or more. This is sometimes backed up by the organisation's PR person going out to give talks to groups within the community and encouraging them to form parties. Although there are a few exceptions, and we may include theatres offering Christmas shows amongst them, the group concessions are rarely taken up in quantity and are generally unsuccessful. This is due, I believe, to a failure to see these schemes as being methods of sales promotion and a failure to look at what is being offered from a customer's viewpoint. Even the word 'concession' implies the wrong relationship with the customers (it suggests that something is being yielded).

We know from experience that a typical ticket purchase will involve the sale of between one and four tickets, with an average of around 2.3 to 2.4. This means that a typical purchaser is in circumstances that make it unlikely for him to want more than four tickets for any one event. It is not appropriate to his situation for him to buy more, he only has one wife and a small family, or he only has a couple of friends who share his interests. For him to buy 10 tickets would involve him in a lot of extra work and, anyway, why should he? If it were suggested to him that he might try to round up just a few friends and then the ticket price would drop by a significant amount, then he might consider the proposition. Why should it always be parties of 10 (even 20 on occasion) and discounts of 10 per cent? Any group larger than four is well above average. Ten people take some organising but five is within the realms of possibility for lots of people and four even more so.

The problem also derives from tending to see this particular market as being made up of 'party-organisers'. There are such people. They organise trips in schools, colleges, Townswomen's Guilds, Housewives' Registers, Women's Institutes, Round Tables, Rotary Clubs and so on. They work hard organising trips to all kinds of places including arts venues but their time and energy is limited and they may not get around to organising, say, a theatre visit, more than once a year. Their value to us, therefore, is limited. Yet, every ticket buyer is a potential party-organiser if we redefine what we mean by a 'party'. If a party is five people it is much more achievable to the average purchaser: it is, for example, a typical family group plus a couple of friends, it is a married couple with their teenage son, their teenage daughter and her boy-friend.

If a good discount is then offered we have a real sales promotion. What is a good discount? In sales promotion terms it is a discount that strikes the customer as being significant, as worth having and strikes us as being affordable within the context of our objectives.

Suppose the ticket price for a show was £4. We might say that for a group of more than three the price of a fourth ticket would be £2, a fifth

ticket, £2 and so on. If we were concerned that people might band together to create ticket-buying cartels that might actually reduce our income (highly unlikely) we might put a limit of, say, six on the group size. In this way, a party of four would pay £14 (£12+£2) and would receive a discount of 12.55 per cent. A party of five would pay £16 (£12+£2+£2) and their discount would be 20 per cent. A party of six would pay £18 (£12+£2+£2+£2) and their discount would be 25 per cent.

This approach would tend to encourage whole family attendance and, because the limit is slightly greater than the average family size, would encourage groups made up from the family plus.

These discount values may seem high but they are no higher than those frequently offered to individual purchasers of packages of five or more play or concert tickets. Indeed, it is common to see sales material today in which subscribers are offered discounts of 25 per cent for a six event commitment and, somewhere on the back, lost between the Arts Council credit and the name of the printer, the same old 10 per cent offer for parties of 10 or 20 or more.

Remember that those party-organisers still exist, so do not lose sight of them whilst trying to turn every customer into a party-booker. Re-examine the incentives offered to these folk and come up with new ones that recognise the task they undertake, for example, in persuading 25 sixth-formers to give up an evening and to pay out good money not only for the ticket but for the coach or train fare, distributing and collecting parental consent forms, making sure that parents are waiting to collect them on their return, ferrying home those who forgot to ask their parents to meet them and making good the financial difference when two of them decide not to come at the last minute. Someone who does so much for your organisation deserves more than a couple of free tickets, which is what the 10 per cent reduction means in real terms to the teacher who organised that party of 25. Think not so much of those few brave souls who do overcome the obstacles but of those who are not yet doing so because it is a lot of trouble and there is no real incentive; find ways of motivating them and you automatically reward the others.

Just as with other discounts, remember to ring the changes from time to time so that they are not taken for granted, and focus them upon areas where your sales need promotion. If a certain seating area, or certain nights of the week, are not selling well, then tie the incentives to those.

Reductions for the Old, Young and Unemployed

The special consideration of sections of the community that are hard up for one reason or another, is a matter of duty for any arts organisation that receives financial support from the community. It is also a matter of duty to

try always to achieve the best possible financial outcome from any activity. Thus, if it your wish that no charge, or a reduced charge, should be made to a certain section of the community, then do so but not necessarily for the best seats on Saturday night. One of the few (probably the only) advantage of being unemployed or retired is that there is more time and as art does not vary much from Monday to Saturday, no harm is done if the reduction applies to weekdays and seating areas that are not in heavy demand.

Perhaps the biggest problem that arises from this situation is in openly identifying a customer as being hard up. The thought of having to join a box-office queue and having to produce documents to prove that you are unemployed is sufficiently daunting to put off most people. The all-purpose, ready-for-anything, go-anywhere voucher could be useful here. If one can find a way of distributing appropriately validated vouchers that can then be used instead of money, this will keep embarrassment to a minimum.

Any action taken will be governed to an extent by the number of performances that are available. A theatre, giving six evening and two matinee performances each week, and running each play for four weeks, will probably have performances where attendance will predictably be low. On these occasions there is perhaps no need to create special terms for people who are short of money and have time to spare: simply designating certain performances as being priced at a lower rate should be sufficient. If there is only one performance then some method such as the voucher should be tried.

The essential point is that although one may be charging very little for tickets because of the special circumstances, one should still approach it from a sales promotion viewpoint using the technique of discounting to guide people where your sales are less good.

Special Offers

So far this chapter has concerned itself with reducing the price of tickets in one way or another. In contrast, the 'special offer' almost always involves the customer in spending more money—but on a bargain which is only available to your customers. The most common example is the theatre/dinner package where for one sum of money the customer receives both ticket and sustenance. Another is the putting together of ticket and travel into one easily purchased package. With the Philharmonia I have selected one concert in a season and designated it the 'Subscribers' Bonus Concert', which is available at a fixed price on a first come first served basis only to those who subscribe to the season advertised; this has proved to be a very successful incentive.

The first intention of a special offer is to promote the sales of what you have to sell and if it does not achieve this it is probably not worth doing. It should enhance the subject of the campaign. An exception to this might be where your customers are seen as potential customers for something else, such as books, records, wine, even your own identified merchandise such as scarves, ties and so on. If this kind of special offer really is special then there is probably no reason why you should not make it, but be wary; people do not always welcome what they see as extraneous to what your organisation is there to do, they may even object to an offer that is too overtly commercial and then it really will backfire on you. Special offers that reduce the cost of the whole evening (which involves far more than the price of a ticket) will always be welcome: special offers that are very closely linked to you and what you do, similarly so. Otherwise, be careful.

Free Gifts

The same rule applies to the incentive of a free gift as to special offers; if it has an obvious connection with your organisation then it can most definitely enhance what you are trying to sell. If you offer customers a free programme or a free interval drink, that is a nice thing for them to have and it will certainly make them more responsive next time you want to sell them something (provided that the show they see is good). It is essentially a fairly weak sales promotion method, however, and it is rarely worthwhile devoting much time or money to it.

Competitions and Draws

I have already stated my own reservations on the potency of prizes as a way of promoting sales. Used in conjunction with other, more powerful incentives, however, they add to the fun and they show the arts organisation to be lively and alert to finding ways of looking after its customers. If you have decided to try using this kind of sales promotion and have been able to negotiate with a suitable provider so that a prize is available, you must then choose how you are to make use of it. Unlike any other incentive, the prize is not open to all; only the chance of getting the prize is open to all.

Prize winners are chosen by means of competitions or draws and it is unfortunate that in the UK the legislation governing the conditions under which you may operate either is quite complicated. The problem is compounded by the fact that there are rarely any prosecutions so one is regularly seeing organisations apparently breaking the law with impunity. Having taken legal advice myself I have arrived at what I believe to be a working understanding of the law and what is both permitted and capable

of being handled by an arts organisation that does not want to be paying legal fees every time it wants to give its customers some fun. Naturally, I would recommend that you ask a friendly solicitor to cast his eye over any competition or draw that you might arrange, but if you observe these guidelines it is very unlikely that difficulties will emerge.

The whole issue is governed by whether or not you are asking entrants to 'pay for the chance' of winning. If you are asking them to pay and are making this payment a condition of entry then you cannot run a draw: selection of a winner by means of random selection where entrants have to pay for the chance, constitutes a lottery in law and lotteries in this country are illegal except in certain restricted cases. In those cases (which could well include an arts organisation as a beneficiary) there are so many conditions with which to comply (such as registering under the Lotteries and Amusements Acts 1976 with the Local Authority and/or the Gaming Board) that you would never wish to bother.

It is not widely appreciated that if you offer free entry to a draw to people who first must have bought a ticket to one of your shows, you are making payment a condition of entry and it is not a free draw.

If the draw truly is free then it is legal and none of the tiresome conditions applies. But then, if anyone can enter, how can one use such a draw as an incentive for customers? The law does not apparently require you to inform the world at large of your draw, so, provided your sales material gives people the chance to enter without payment, that is sufficient. Thus, you may circulate the details amongst, say, a restricted mailing list of subscribers, who may or may not make a booking on this occasion, and provided they may all enter, you are in the clear. The law also does not appear to specify the degree of prominence you give to this option of entering a draw without payment so, provided you state it (where and how is up to you) you are legal. In practice you will find that very, very few people will exercise their rights in this respect and you will receive few, if any, entries from people who are not buying. This is due either to the British sense of fair play or the belief that non-paying entries go straight into the waste-bin.

If you want to restrict entry to customers only then you must run a competition. There are restrictions on competitions but they are quite easy to comply with. It is, for example, unlawful to offer prizes for forecasts of the result either of a future event or of a past event the result of which is not yet ascertained or not generally known. It is also unlawful to run a competition in which success does not depend to a substantial degree on the exercise of skill. The trick is to make sure that skill and knowledge are involved in the competition and then you restrict it as you will.

The great advantage of the draw is that it does not hold up the customer in his purchase. The whole intention of sales promotion being to

speed up the process it is counter-productive if one then offers an incentive which adds another obstacle to the course and, in most cases, a legally acceptable competition is bound to do this. In a competition there must also be a tie-breaker, a final challenge that will give the organisers a way of deciding a final winner if all other aspects of the entry are equal. This too will take up the customer's time. Nevertheless, competitions can be fun (I once asked the Philharmonia's subscribers to write down their ideal concert programme, naming works, soloist and conductor, and we were overwhelmed with a response that also provided valuable information on our customers' tastes) and you may want to run them. Make sure, then, that customers may send in their entries whenever they like (before a stated closing date) and not necessarily together with their ticket booking form.

Some Basic Guidelines on Sales Promotions

Although there may be exceptions the following conditions should generally apply to your sales promotion activities:

They should be date-limited. Sales promotions which apparently go on for ever become less effective and are taken for granted.

They should vary from one method to another and should use combinations of methods which change (e.g. Diminishing Percentage combined with Fixed Sum Discount; Increasing Percentage plus Voucher valid now or valid for a later campaign; Fixed Sum Discount plus Holiday Competition as an 'accelerator'; and so on. Try to avoid being predictable.

They must be easy to explain and easy to understand.

They should not involve the customer in so much extra time in complying with conditions that the impetus created by the sales promotion method is lost.

Whatever is offered must be significant to the customer.

They should generally be aimed either at the market as a whole or at a well-defined and discrete part of it in order to avoid resentment on the part of those who have not received the offers. For this reason, it is generally bad practice to launch an offer in the middle of a campaign so that late-comers appear to do better than early buyers.

They should always involve the organisation in the minimum expenditure that will achieve the desired results.

Their costs should appear in budgets alongside sales and publicity and income should not be 'netted down' to remove the need to show them as items of expenditure.

They should never be used in such a way that they make the organisation look desperate for business: they should always be used (or appear to be used) from a position of strength and only when necessary.

CHAPTER NINE

FINANCIAL PLANNING, OBJECTIVES, ESTIMATES AND BUDGETS

I have often heard it said, and have nodded sympathetically, that business should never be put in the hands of accountants. Two of my closest associates are qualified accountants and they say it as well, but they have both moved far beyond the stage of totting up figures and working out tax returns. The point made by these maligners of an old and honourable profession is that business is about expansion and if the objective of any organisation degenerates into the mere balancing of its books, then it will stand still and then diminish. The point is also about conservatism; what we think of as the 'accountant mentality' is a fear of risk and the unknown which results in always taking the safe option even if, later on, it proves to be far from safe. Expansion almost always involves risk of some sort, whether it be risk of money or risk of time—or even risk of reputation.

In the arts we are also running businesses and we are subject to most of the pressures faced by people in the commercial world. The pressure to be conservative in planning is, perhaps, even greater for us. When faced with the option of either taking a risk that might lead to greater achievement or greater loss or ending the year with the realisation of a planned deficit that will be covered by subsidy, most organisations will opt for the 'safe' alternative.

The arts are particularly bedevilled by one of the results of their public accountability. Because they receive subsidy and because they are non-profit-making (and frequently registered as charities) their ultimate control lies in the hands of people who have usually no experience in our kind of business. I do not mean the paid employees, I mean the executive committees, councils, boards and trusts, that have the final say on financial and other matters. They are frequently very bad at encouraging the expansionist approach and stifle the ambitions of the professionals who want to move things forward. In *Subscribe Now!*, Danny Newman cites the example of a board member who is, in his professional life, a highly successful businessman, yet, when he sits on a board of an arts body, leaves all his business acumen behind and takes a negative, conservative line which inhibits the organisation's ability to take initiatives. I have met this problem in the UK on many, many occasions and it is sometimes

79

impossible to overcome. I have sat in my office talking to the chairman of a theatre trust, with the theatre's artistic director and general manager. The director and manager wanted progress. The chairman, who was the financial director of a very large business concern, could only see risk and failure; he did not believe that success was possible.

To be fair to these board members, we should remember that they are usually legally responsible for the actions of the paid personnel and if something goes wrong they could be left holding the baby. Constitutions usually limit the financial liability of individuals but nevertheless, few people want to feel morally responsible for debts incurred by others and so will be cautious in the authority they delegate.

Danny Newman's great talent, which comes through in his book, is to inspire confidence even in the faint-hearted and to give them the vision of better things to come. *Subscribe Now!* is a book that should be read by everyone concerned with the arts, whether they want to use the subscription method or not, because its central message is about the drive to greater achievement. As a working consultant I often wish I had the courage to point my finger accusingly at people such as that theatre chairman and declaim in Newman-like tones, 'You, Sir, are you a man or a mouse? Do you want SUCCESS or do you want FAILURE? You sit there, a shining example of the success of private enterprise, and you deny these people the right to succeed in a public enterprise!'.

Although, as you will see elsewhere in this book, I believe the subscription method to be extraordinarily useful in straightforward marketing terms, it also has the effect of giving people sufficient confidence to overcome their natural reluctance to take risk. I have seen this work on so many occasions. Say to the board, 'Increase my advertising budget by £15,000, please', and the answer is a flat rejection. Sell them the idea of subscription, show them examples of where the method has succeeded, show them estimates of income and expenditure—where both sides of the equation are considerably higher than hitherto—and they may just buy it. I have frequently failed to persuade people to spend more money on 'conventional' schemes in order to earn more money, but when subscription is the basis of the campaign then it is often a different story. It is like faith-healing, which works because people believe that it will work.

So, when we are making plans for our organisation, we first need ambition; we must want to do better and to do so in more than artistic terms. We must want more people to experience what we produce and we must want to earn more money at the same time. Then we need confidence; we need confidence in the basic idea of marketing—confidence in its ability to effect change. We need confidence in ourselves and in those for whom we work and those who work for us. We need knowledge and experience to back up that confidence (heaven preserve us from the confident enthusiast

with neither!), and we need skill and imagination to help us deal with new situations and problems.

Because of the real danger that things might go wrong in this the riskiest of risk businesses, we also need special financial backing such as the insurance schemes that I referred to in Chapter Two, the idea of which is elaborated in the Appendix section headed 'Artsbank'. To be realistic we will have to face the fact that we shall probably continue to need that financial backing for some time yet and will have to go on sticking our necks out, substituting prayer for the helping hand that Artsbank advocates.

Our objective is to create the upward, widening spiral of economic expansion that yields growth and improvement in all the aspects of our work that are important to us. We must start this process by setting ourselves a target, something to work towards—an objective which, if achieved, will mean that we are bigger.

Setting the Objective

You could be planning just one event, or a series of events or a whole year's activities; you could be drawing up a Five Year Plan. Whatever it is, you must give yourself a financial target. If you have already been in business for some time you will have access to real figures that show what you have been spending and what you have been earning. Study these figures carefully, looking at them from show to show, concert to concert, series to series, season to season, year to year. Whatever your business is, there will be some convenient way in which you can break down the real figures so that you may assess your achievements, make comparisons, and discern trends. Before you can make up your mind where you want to go you must know where you are.

It could be that when you examine your figures you will conclude that you are doing as well as possible. You are selling all the art experiences that you can supply at prices which satisfy your requirements. You are content that you are spending no more than you need and that the money is well allocated. Having regard to your future artistic plans there is no reason why you should not continue to succeed and short of the collapse of civilisation, your life should be a bed of roses. How you react to such a blissful situation is up to you and your colleagues. Some may choose to accept it gratefully, knowing in their hearts that it probably won't last for long. Others might then cast their eyes inwards to see what improvements are needed in the organisation: is the staffing level adequate, are the salaries too low, is any special equipment needed? My own reaction, which stems from a deep-seated belief in the value of ambitious targets as a personal incentive, would be to look for necessary improvements and to try to finance them through

increased income. However, it must be admitted that there are occasions when an organisation reaches a level of maturity at which there is simply no point in trying to push it any harder; if prices are forced up there is the risk of a reduction in sales, if staff are asked to work harder and longer they may become less effective. Then one must leave well alone, whilst keeping a careful eye open for signs that the business is going off the boil, that having reached a peak of achievement it is now beginning to slide down the other side.

It is also possible for an organisation to mature at a level way below its maximum potential. Its books balance very nicely with income (from all sources, not just earned income at the box-office) equating with expenditure. This will satisfy the accountant but it should not satisfy you because your aim must be to sell everything you have to sell.

It is unlikely that you have reached your level of maximum achievement. When you have examined your figures, you will probably realise that you could have done better. The most common situation is for tickets to have remained unsold so that income was lower than it might have been. Another possibility is to have sold everything, but at prices that do not yield sufficiently high income to meet the demands of your budget taking into account the amount of subsidy available and any other income from, perhaps sponsorship, and so on. In this instance, one might reasonably look for economies that could reduce the level of expenditure and so bring it into balance with the total income. If economies cannot be made—and usually in the arts world they cannot because almost everyone operates at breadline level—then the task is to raise the level of income.

Let us therefore assume that your scrutiny of the real figures reveals that your earned income could be greater and this could be achieved either by selling more at your present price level or by getting more money from the current level of sales. For your future plan, whether it be the single event or a range of events spanning a long time period, how much more do you want to earn? How much do you think you could achieve? If you are selling roughly half of your products and earning, say, £50,000, could you contemplate selling half as much again and earning £75,000? It may be too ambitious and you may have to drop your sights but, just for a moment, let us consider the implications of trying to increase income by £25,000.

Your previous, real, figures show you that by doing what you have been doing and spending what you have been spending, you are very unlikely to see that increase of £25,000 happen out of the blue. Now you must ask yourself, and everyone else involved in the process, what must be done to achieve this increase. These are some of the questions which should be raised and some of the implications that would follow:

Can we improve the attractiveness of the product? (Yes, but it would probably cost more money.)

Can we beef up our advertising? (Yes, but it would cost more money.)

Can we increase awareness of our organisation and what it does through public relations? (Yes, but we would need another member of staff and that would cost more money.)

Can we improve our sales function? (Yes, but we would need another member of staff, another two telephone lines, we should have to allow for the costs of using a Freepost address and we would have to make structural changes to the box-office—all these things would cost more money.)

Can we introduce some vigorous sales promotions such as discounts or a voucher scheme? (Yes, but they might cost us more money especially if they do not work and our existing customers take up the offers and so reduce the income we get from them.)

Can we increase our prices? (Yes, but there might be a fall-off in attendance that could leave us no better off financially and with smaller audiences.)

You can see the problem. Most of the suggested changes would involve a commitment to greater expenditure now, whereas any improvement in revenue still lies in the land of maybe. The other changes do not necessarily involve immediate outlay but they carry with them the possibility of reduced income which is just as bad. This dilemma is not peculiar to the arts; every business faces it almost every day. You cannot guarantee success and yet commercial businesses, large and small, do make progress by taking risk and reaping the rewards. Many fail but that does not stop thousands of individuals from trying to succeed. 'But,' says the arts organisation, 'we do not have the money to pay for the changes in what we do and how we do it. We are not commercial businesses with millions of pounds slopping around our ankles.' As I wrote in Chapter Three, most businesses are quite small and they do not have lots of money with which to finance their expansion; if they want money they go to the bank for it and pay for the privilege of borrowing what they need. Money is one of the resources businesses need and if you want some you have to go out and buy the use of it for a while.

It is not easy for an arts organisation to borrow money because it may find it hard to provide a lender with collateral or financial guarantees (which is why the Artsbank idea is so important), but, if there are not sufficient funds in hand, it is still worth a visit to the bank manager. If you have banked with him for some time and, if you are using the bank's facilities on a fairly large scale, the manager might be able to help with an overdraft over a few months. He is likely to want to see your figures and your plans for expansion and he will certainly want to know what you will

do if your schemes come unstuck; how will you make good the debt? This requires you to plan carefully and to explain your plans very clearly and is a useful exercise in itself. It is always a good idea to put down in writing exactly what you want to achieve and how you intend to achieve it. An alternative to the bank might be to take the written plan to your usual source of subsidy to see if an underwriting can be obtained. We know that arts councils, regional arts associations and local authorities find it extremely difficult to handle such applications but things are changing, albeit slowly, and if there were more well-conceived and explained plans of this nature put to these bodies they might well start to find ways of supporting them. Another source of help could be through sponsorship by a commercial organisation; in general the companies prefer to make a finite financial commitment and the possible return of money in the middle of a financial year can actually cause them accounting problems, so you might end up with money that does not have to be returned.

It is possible to finance expansion out of existing budgets provided that they are not too small. It can be done by very careful phasing, breaking down the programme into smaller, manageable units each of which represents a mini-marketing scheme. It could be a year's programme for a theatre, split down into four parts, each representing three months' trading (or it could be done play by play). The money that is available to be spent on direct marketing activities could be divided up so that in the first three months there is perhaps 45 per cent of the year's budget available. This is the 'suck-it-and-see' approach which gives the organisation time to assess what effect the extra expenditure is having and, if it is not generating more money than the extra that is being spent, allows time for cutbacks to be made to bring the figures back to the forecast level before the year's end. If the plan is working, then the budgets can be maintained at the new, higher, level. Careful monitoring is vital with this method because if you are in a financial straitjacket, with no possibility of extra money, you must be able to make on-course corrections during the year to avoid that embarrassing imbalance that leads to ugly scenes at the AGM.

However you approach the matter of your financial underwriting, you must try to keep your concentration on your target and remember at all times that this is what you must achieve. All the pressures on you are to be cautious and if you are weak-willed you will be overwhelmed by the thoughts of what might happen if things go wrong. Think of it this way: out there in the future is that extra £25,000 which you are going to achieve— you will finance the achievement of this money out of the money itself. You may decide that you need to spend £20,000 in order to raise your income by that £25,000; that is all right, you will be £5000 better off at the end of the year. You must thrust your hand into the future, grab £20,000 off the pile, bring it back to here and now, and then start to spend it effectively.

When you read that kind of advice in print it seems almost reckless but it is no more than a colourful way of describing what people do in the commercial world and the arts business all the time. They may borrow money (because that 'future' money does not exist yet) or they may indulge in frantic exercises of robbing Peter to pay Paul, but they are still really spending money that they do not yet have and if they fail, they have to pay it back one way or another. Apart from the exercise of skill and judgement which reduces the risk level, the other part of the trick is to relate the size of the risk to the size of the whole operation. Thus, if you are running an arts organisation with an annual turnover of £5 million, a gamble on increasing revenue by £15,000 is no great problem; failure means a hiccough in the system, no more. The gambler who puts everything he has on a horse, no matter what the odds, is asking for trouble because he cannot afford to lose.

So, choose your target income and then plan how you are to achieve it.

Estimates

Estimates, whether they are of expenditure or of income, are not real figures, they are guideline figures, they are what you believe you will probably spend and earn during the period of your forecast. They are not sacrosanct. They are not carved in tablets of stone to be obeyed without question.

If what you are doing is subject to the scrutiny of a controlling committee such as you may find in a local government department of arts, leisure, recreation and what-have-you, you may find that estimates are elevated to a holy status in the name of public accountability. The estimates have been considered and approved and now, by God, you had better stick to them. What this means is you must spend no more than has been agreed. If, by chance, you earn more than has been agreed that will be all right. But, if you think you might achieve more than has been agreed, by over-spending, then you can't do it and if you do, you are in trouble. This is the situation that can be found at both national and local levels of government when what are known as 'cash limits' are applied. It may make sense if a department is simply in the business of spending money, such as on roads, or the fire service, but if it is in a trading situation, such as the arts and entertainment, where growth is life, it is simply stupid.

We are all of us, no matter how entrepreneurial and adventurous, nevertheless respectful of our estimates. What is the point of drawing guidelines if you ignore them? What we should respect is not so much the detail, or the totals of planned income and expenditure, as the *difference between them*. If we are in a potentially profitable situation then planned income will exceed planned expenditure and the difference between them is the profit. If we are in a loss-making situation, typical of the arts, then the

reverse obtains and the difference is the deficit. No one minds if profit is greater than forecast, no one minds if deficit is smaller than forecast.

Let us assume that we have a planned expenditure of £10,000 and a planned income of £8000. Forecast deficit is obviously £2000. Suppose, as we began to progress through the trading year, that we began to discover opportunities which could increase our audiences and our income. It might be a celebrity performer suddenly found to be available whose fee is high but whose drawing power is high as well. It could be an unusual advertising opportunity or an interesting sales promotion idea. Any of these could push expenditure up beyond the £10,000 and carry with it an increase in income. At the end of the year we might find that we had spent £20,000 and had an income of £18,000. The deficit is still the same. The grant requirement is still the same. The difference is that we have been more successful. Our business is about people and money and this example illustrates one way in which our business is different from commercial business. In a commercial situation there is no point in increasing expenditure if, at the end of the day, the profit is the same. To us, where significant increases in income are almost always derived from increased attendance, the bigger the financial 'envelope' in which we operate, the better it is.

The correct way to approach the use of estimates, the way that respects the value we place on people as well as money, is to operate what is known as the 'Gap Principle'. It is obviously very important that a forecast deficit, which is going to be covered by a grant, should not be exceeded; this is the 'Gap' between forecast expenditure and forecast income. As the year begins and progresses, our intention is to increase income beyond what has been forecast, to spend what we need in order to effect this increase, but to maintain—or to reduce if humanly possible—the Gap, the deficit. To put it another way; if you spend £1 more than you have planned to spend, then it must come back to you as increased income—preferably bringing some friends with it.

Careful and regular monitoring of your financial progress is essential if you are to operate the Gap Principle. As your financial year proceeds, reality is imposed upon the 'unreal' figures of your estimates and they must be continuously modified to take account of what has really happened. It is a good idea to break the year's work down into, perhaps, a dozen convenient 'mini-estimates' based on either a month's trading, or suitable groupings of events, into which you put the year's various allocations of expenditure and anticipated incomes. The items of planned income and expenditure are split up according to how you expect the year's work to run so that if, for example, you think there will be a relatively heavy level of expenditure in March and a relatively low level of income in August, you

adjust the mini-estimates accordingly. Obviously, the totals in the mini-estimates will equal those of your year's estimates.

As the year begins, you match real figures with those of your first mini-estimate. If they are roughly the same you need take no action. If expenditure is roughly the same but income is higher, you might decide to use the increase to finance some extra money earning activity and so make adjustments to all the remaining mini-estimates. If income is lower, you might then choose to compensate by reducing the planned expenditure in the remaining mini-estimates. You follow this through the year making on-course adjustments as each period of real figures is completed.

This is no more than basic good domestic financial planning and book-keeping as it stands, but the method can also then be used to operate the Gap Principle. If you wish to increase an item of expenditure it can be added into the mini-estimates (preferably early in the financial year so that, if the plan does not succeed, you are able to make adjustments to compensate) and spread over as many mini-estimates as the campaign suggests. You may, for example, decide to launch a special campaign in June which will incur extra expenditure over June, July and August but extra income will not start to flow until August. In this case you would increase the expenditure items over June, July and August and would increase the income item from August through until whenever you believed that the effect of the new campaign would be exhausted. If, at the end of September, you found that the new income was not as high as planned you would have to act, either by reducing the remaining expenditure items, or by spreading the new income items further into the future to give the campaign more time in which to work. Throughout these adjustments the final, forecast deficit figure, the Gap, should never be greater than originally planned.

Seen from this angle, it can be appreciated just how short the working year becomes and how difficult it is to work within the constraints of the system of subsidy. If one is running an ordinary business, the end of the financial year is important for a number of reasons but not so important that it can dominate the trading and the planning in its final two or three months. There is, thus, no reason why an expansionist programme cannot be launched in February and continued through until June with the financial year end (most frequently the end of March) being merely the moment when the business takes a quick look at itself, freezes that moment so that everyone can have a good look, including the tax-man, and carries on. Where one's figures must be scrutinised by Local Authorities, Regional Arts Associations, the membership at an AGM, the Arts Council and other interested bodies, it does not do to end the year with one's figures pessimistically at variance with one's estimates.

Each organisation approaches its process of estimation in a different way. Whatever the method, the pressure, the drive towards expansion, must be maintained. Merely to adhere to estimates and to achieve the planned deficit is not enough. Even if, at the end of the year, it is realised that in spite of effort upon effort the forecast deficit has been achieved, it is not so bad provided the organisation has fought. If income has been increased, albeit matched by increased expenditure, that is better than placidly following a path that has been set down by a system that always seems to value caution above all other things. It is perhaps no more than a matter of morale.

Beware of the other side of the planning coin, the tendency for caution to lead to a reduction in the size of the organisation's work. It works like this. Income starts to fall short of the forecast. Compensate by reducing expenditure. Many expenditures, because they are committed months ahead, cannot be reduced. Expenditure on direct marketing activities are most vulnerable; they are reduced. The result is a further fall-off in income. Compensate by reducing expenditure. The result is a further fall-off in income. Compensate by reducing . . . The phenomenon may be termed the 'Vanishing Up Your Own Deficit' syndrome.

Budgets

If we examine the figures of a typical arts organisation we would see that under the heading 'Expenditure' there are three basic classifications:

Product *the cost of making or hiring the artistic programme.*
Administration *the cost of staffing the organisation.*
Publicity *the cost of whatever the process is that attracts people to the Product and persuades them to buy it.*

Under the heading 'Income' there are two basic classifications:

Box-office *income derived from audiences*
Subsidy *income derived from public funds*

There are, of course, other items that could be included such as income from sponsorship, income from charitable donations and other income that is derived from audiences, such as bar and restaurant receipts, merchandise such as records, T-shirts, posters and so on. There are other expenditure items as well, such as bank charges and accountancy. The ones I have listed are the most significant.

When these expenditure headings form the framework for estimates, as they do in the large majority of cases, they inhibit the work of marketing because they do not acknowledge the existence of two important marketing activities—sales and sales promotion—and they do not give proper

recognition to publicity as a combination of advertising and public relations. How advertising and public relations are to be described in estimates is not so critically important provided the organisation understands the proper practice of each and allows for adequate financing for both. The absence of sales and sales promotion allocations is usually due to the practice of 'netting off' any such expenditures against box-office income before it is recorded. By this I mean that if an organisation sells tickets worth £1000 and has, for example, discounted them by 20 per cent, it has only received £800 in cash and so might only record the £800 as an item of income. In fact the organisation has spent £200 in order to sell £1000 worth of tickets. If the book-keeping does not show the expenditure of £200 then it is unlikely that the estimates will. This is very bad practice and could be compared with 'netting off' the entire publicity budget against box-office income. The organisation might, over a year, have spent £30,000 on publicity of one sort or another and achieved a box-office income of £100,000. Following the first example, it should then logically show no expenditure under publicity and record an income of £70,000. To take the matter even further, one could argue that there would not have been any box-office income without artistic product and without an administration so they too should be deducted. The arts organisation thus presents its figures in two lines, estimated deficit and real deficit.

It is also bad practice because it can lead to unchecked expenditure. In Appendix A, Subscription-Based Marketing, I give the example of a theatre which offers its subscribers a 30 per cent discount, the cost of which, if it achieves its objective is £48,600. Such a theatre might well have a publicity budget of £30,000 as the example just given. It is very easy to pick a sales promotion idea out of the air, to produce a slogan like 'See Two Plays Free!', and then ignore the financial implications until the end of the financial year. The whole purpose of using estimates is to provide guidelines which, before the year starts, summarise as well as possible, all the expenditures that contribute to achieving the planned income.

Including budgets for sales and sales promotion also reminds the organisation, including its controlling body, that they are there as tools to be used. Remember the case of the local government treasurer's department (Chapter Seven) that could not approve the use of credit cards because they had no budget for the commission. Once these items appear in the figures they are there to stay, to be thought about, argued over, evaluated and their value as creators of income implicitly acknowledged. The justification for spending the £30,000 lies in the belief that it generates income. So it is with sales and sales promotion and it should never be forgotten. We do not spend money in these areas for cosmetic reasons, we spend it because we intend to increase income.

Apart from ignorance, the practice of excluding these items probably also stems from the fact that it is not easy to budget for expenditures that are usually directly linked to earned income. If the earlier organisation had not sold its £1000 worth of tickets it would not have spent £200 on sales promotion. Publicity expenditure is easily determined in advance. The estimates say there is £30,000 to spend and so, plus or minus £100 or so, at the end of the year £30,000 will have been spent.

This situation obtains in the commercial world as well. If you have a sales team, you must budget for its expenditures. If you are going to give your product an extra boost through, for example, a dealer incentive, you must budget for it.

While you are introducing the two new items, take the opportunity to express the publicity expenditure under the headings, advertising and public relations. In most organisations public relations does not amount to much more than maintaining contact with the media and perhaps giving a few talks to local groups, so its expenditure is limited to the salaries and expenses of staff plus the cost of the occasional press conference. As such these costs are usually set off against the general publicity budget. It may well be that in the first year of operating a full budget schedule there is small chance of expanding the public relations work but put it in anyway, give it its own status and budget, however limited, so that its existence is acknowledged. Advertising, which now takes on a fairly precise meaning if this book's message is accepted, will take the lion's share of what was formerly the publicity budget.

The real problem comes when we have to introduce these budgets for the first time. How big should they be? I come back to the publicity budget which, because it has always been there and because there is an established pattern of expenditure, is a relatively easy item to allocate. This year we spent £30,000, so how much do we think we should spend next year? What did we spend it on? So many brochures, so many posters, so many radio commercials, and so on. They have all increased in price and, because we want to try a special scheme we must allow for more of everything. Let's put £37,500 into the estimates and see how the figures look. With sales and sales promotion we have nothing to guide us, particularly if we have not been actively operating these functions.

The only sensible way of approaching the problem is to work out a marketing plan for the forthcoming year that makes use of the tools in your marketing tool-box. Look at the product which is likely to be offered. Look at the pricing situation. Look at the level of income which the economic circumstances are likely to demand that you must achieve. Then, regard the three direct marketing activities which are there for you to use, publicity, sales and sales promotion, and plan how you would like to use them. These are the answers to the questions that were posed under Setting the

Objective earlier in this chapter. You would like to introduce an incentive scheme for sales staff based on commission—draw up a draft scheme that pays, say, an overall 10 per cent to the team once it exceeds this year's total (later on you can break it down into monthly or weekly targets based on your mini-estimates because you do not want your sales staff to be waiting until ten months of the year are passed before they see their commission). You would like to try a new party booking scheme with the 'party' redefined so that it makes sense to the average customer. Suppose you attract 500 parties during the year, each of, say, four people with a 50 per cent discount on the fourth person in each party. How much would these schemes cost if your not-very-ambitious target was to be achieved? How much extra income would it yield? Will you now need more publicity money to make sure that your customers know about the new party booking scheme, or can you cover it with your existing publicity budget?

Your estimates will be very, very, rough indeed because you have no previous history on which to base them, but it does not matter too much because you have your system of mini-estimates that allows you to make on-course corrections and, if you have basically the right schemes, your extra expenditure will only occur if you have extra money coming in. In the first year it is probably wiser to try to stick to schemes that only cost money if extra money is made and then, provided you have freedom to operate the Gap Principle, you can introduce others, where the expenditure is predictable and not related to income on a sliding scale, when your confidence and experience have improved.

The process of building budgets into a really useful set of estimates, with an ambitious but achievable target income, can take a long time as you juggle with too many imponderables for comfort. Once it has been done, and a year's trading experienced, it gets easier.

So, the arts organisation that wants to budget for marketing now has six expenditure budgets where before it had only three. They are:

Product
Administration
Advertising
Public Relations
Sales
Sales Promotion

CHAPTER TEN

PRICING

Charge As Much As You Can Get

If I were to say that in the arts we should always charge as much as we can get, there would be protests. More of that damned Diggle commercialism! We should always charge as much as we can *get*. If we charge more than people will pay then we get nothing and that is very uncommercial.

Our objective is always to 'arrive at the best financial outcome' and that means, on one hand that we spend no more than we need and, on the other, we try to earn as much as we can from the sale of our product. Because we are supported by public subsidy we also have an obligation to the community at large and so, within our plans, we must make provision for those who want what we have to sell but cannot afford to buy it at prices that are acceptable to the majority. The mistake which is sometimes made is to behave as though the *whole* community cannot afford to pay our prices and so to keep prices far below the level of general public acceptance.

Common sense and day-to-day experience tell us that demand (that is, the level of sales) is governed by price. If prices rise there is a tendency for demand to fall and if prices fall, there is a tendency for demand to rise. They are not, however, directly linked according to some immutable arithmetical law, which means that it may be possible to increase prices up to a certain point without there being any fall-off in demand at all and you may quite easily find that if you reduce prices there is no increase in demand. Because our concern is always with people and money we must aim for a situation where we are drawing the maximum amount of money from the maximum number of people, subject only to the requirements of the artistic product that is being marketed (e.g. it might make economic sense to present the Royal Opera on Salisbury plain before an audience of one million but the performance would suffer).

Consider the simple graph (Fig. 1) where we have a number of hypothetical price options open to us (on the horizontal scale) and a series of hypothetical purchases (on the vertical scale). The points on the graph show how the demand might vary according to price, so that with a price of £1 we can see that there are 400 purchases, at £2 there are 350 purchases, at £3 there are 300 purchases, at £4 there are 250 purchases, at £5 there are 200 purchases and at £6 there are 150 purchases. If a crystal ball was provided with this copy of the book (now, there's a sales promotion device!), and

these results could be predicted, which option would you go for, which would be most successful?

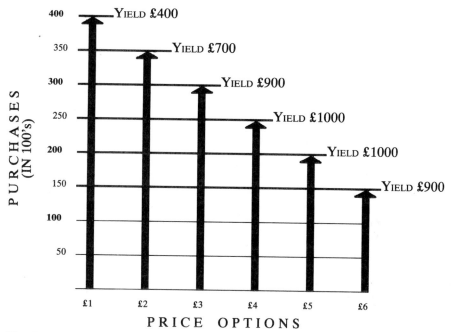

Fig. 1

Because the Full House is the holy grail of all arts marketers, because we exist to please as many people as possible, we are under great pressure from others and from ourselves, to choose the first option with 400 people paying £1 and giving a cash yield of £400. But should we accept this as best? What if £400 is just not enough? We do not live in a world where the prices charged to us for materials, labour, fees and so on, are lower just because we are working in the arts. If we priced at £3 our yield would be £900 from 300 people. There would be 100 people fewer but we would have £500 more. Suppose the entire cost of mounting the event was £500; then the first option would show a loss of £100, whereas the second option would show a surplus of £400. That surplus could then be used to make possible more shows and so benefit more people. Ultimately, going for a higher price could mean that you were more fully achieving the objective of maximum money and maximum people. (This assumes, of course, that you are able to operate the Gap Principle.)

This argument could be taken further, to make the £4 option acceptable even if it means an audience reduction of a further 50 people because the cash yield is £100 more and the venue would still be 62.5 per

cent full. When you reach the £5 and £6 options then there is no improvement in yield and probably few people would attempt to price at that level.

Evaluating the Demand/Pricing Decision

Consideration of the demand that might or might not result from a change in pricing is hypothetical and because so many factors unrelated to price influence the size of an audience, we mainly price according to what we have done in the past and what we think the market will bear for any show. We naturally and understandably avoid any approach that is more mathematically based. However, once a price change has been introduced and the resultant demand recorded, no harm is done if we try to work out a basis for evaluating the results of our change of policy. If one is in a fairly stable situation, where it is possible to compare like with like (as in the case of a theatre running in repertory) and where financial and attendance records are kept for long periods, some simple system of weighing one set of results with another can be helpful.

Success in our business involves money and people, so any evaluation must take both into account. My colleague, Tony Gamble (one of those redeemed accountants I referred to in the previous chapter), suggests that one might allow an arbitrary cash value to every customer and that this extra valuation be added to the cash yield. So, if 400 people paid £1 to attend, the cash yield would be £400 but one would then add, say, £1 per head, to reach a final evaluation of achievement. The result is the sum of £800, which means nothing in terms of what you can put in the bank, but it gives you a standard for comparison. The £1 is just a guess, it is a way of giving some value to an attendance so that comparisons can be made and, if it is increased, it is a way of weighting the importance of attendance in your evaluations. In the table shown in Fig. 2 I have taken the demand/price figures shown in Fig. 1 and chosen 'customer factors' of £1, £2, £3, and £6. For each price option I have then added to each respective yield the audience 'value' based on the four different customer factors. This gives us a 'final value' for each result: (see Fig. 2).

In the first table, with a customer factor of £1 (where we are giving minimum value to the attendance) we can see that the £4 price option yields the best results in arts marketing terms. The £5 price option achieves the same cash yield but the final value is less.

A customer factor of £2 (we are putting greater value on attendance) shows that we might again opt for the £4 price because it offers the maximum final value and the best cash yield.

At £3 (we are putting even greater value on attendance) the table tells us that £3 is the best price.

PRICE OPTION	NUMBER OF PURCHASERS	CASH YIELD
£1	400	£400
£2	350	£700
£3	300	£900
£4	250	£1000
£5	200	£1000
£6	150	£900

Figures in the top table are taken from Fig. 1

Customer Factor: £1

CASH YIELD	"AUDIENCE VALUE"	FINAL VALUE
£400	£400	£800
£700	£350	£1050
£900	£300	£1200
£1000	£250	**£1250**
£1000	£200	£1200
£900	£150	£1050

Customer Factor: £2

CASH YIELD	"AUDIENCE VALUE"	FINAL VALUE
£400	£800	£1200
£700	£700	£1400
£900	£600	£1500
£1000	£500	**£1500**
£1000	£400	£1400
£900	£300	£1200

Customer Factor: £3

CASH YIELD	"AUDIENCE VALUE"	FINAL VALUE
£400	£1200	£1600
£700	£1050	£1750
£900	£900	**£1800**
£1000	£750	£1750
£1000	£600	£1600
£900	£450	£1350

Customer Factor: £6

CASH YIELD	"AUDIENCE VALUE"	FINAL VALUE
£400	£2400	£2800
£700	£2100	**£2800**
£900	£1800	£2700
£1000	£1500	£2500
£1000	£1200	£2200
£900	£900	£1800

Fig. 2 *Relate the figures in the lower four tables to the data given in the top table*

The £6 customer factor (where we are very heavily weighting the value of attendance) tells us that £2 is the best price because it gives the best final value and the highest cash yield.

I must emphasise that this is not an accepted way of evaluating results; it is only an idea to play around with but it does seem to clarify a confused area of thinking. If one has recently introduced a price increase which has produced more money at the box office but a smaller audience this method makes it possible to compare events before and after the increase. Of course, the size of the customer factor is crucial. There are two considerations that might influence the factor at which this is set: the per capita subsidy that the organisation is receiving and the cost to the organisation of winning a new customer. If each person who attends is being subsidised to the extent of £5 then it could be argued that the value of a new customer is £5 and this might be taken as the customer factor. If, by looking through the figures of income and expenditure over the previous year it can be seen that each customer has cost £1 in direct marketing expenditure (and given that the organisation is properly geared up to making every effort to keep that customer) then this sum might be added to the per capita subsidy based customer factor to give one of £6.

There is much to be said for this idea. It provides us with a badly needed way of measuring achievement and it could even be used as the basis for allocating subsidy; it could provide the rationale for giving extra financial support in areas where lack of cash was believed to be the main cause of low attendances and a way of fairly assessing the results. But it is only an idea and it needs much more thought. In the meantime we must go on charging as much as we can get.

Commercial Pricing

If we have been working under the same circumstances, offering roughly the same kind of product over several years, we will probably have come to know what the market will stand in terms of pricing. If we are just starting we have a greater problem; all we can do is to look around for similar situations, to see what other organisations are charging for similar events, and to follow them. This is one of the ways the commercial world approaches pricing.

There are two basic ways of pricing a product if one is working commercially. One, which is used when there are other similar products on the market, is to pick a price which competes with prices currently being charged and then to create the product so that profit can be made within that limit. If the product is significantly better and different, the price might be higher than the prevailing norm and the product would then compete on the basis of being of higher quality. If the product is essentially the same as

others, it obviously makes sense to try to price it lower. The other approach is to work out how much the manufacture and marketing of the product would cost, to add a profit margin and then to put it on the market at that price; if there are no similar products around and hence no norm of market price acceptability then time will tell if the product can be marketed profitably.

Either way, sales promotion is a widely acknowledged method of increasing the product's chances of selling through the modification of price and perceived value. Wherever there is competition, sales promotion—the special offers, discounts, competitions and so on—is used to enhance the product's attractiveness over and above that of similar products. Sales promotion can be used to ease the path of the new product where the market is uncertain and where resistance is anticipated in the face of something new at a price that may seem high. A good, short-term, price reduction ('good' meaning good from the *customer's* viewpoint) will encourage the first-time buyer particularly in the case of goods such as food, drink, tobacco, detergents, toiletries etc., where regular purchase is involved. Sales promotion is always there to be used as a strategic tool.

Our Approach

Our approach to pricing is a sort of combination of the two commercial methods although we do not have profit as a goal. Our financial planning gives us a monetary target and our job is to achieve it; the target derives in part from an evaluation of the cost of making (or hiring) and marketing our product. So we are basing our pricing partly on the cost of the product. At the same time we recognise that there are many similar products to ours on the market so we compare the prices that our target suggests with those other prices and we adjust our prices accordingly. There is no essential difference between our approach and that of the commercial world.

However, we do not always recognise fully the part that can be played by sales promotion as an adjunct of pricing. If, for example, we choose to increase our prices and we fear resistance from the public we can use sales promotion to soften the effect. Suppose circumstances forced us to put up a price from £5 to £7; this is sufficiently large an increase to make us anticipate a reduction in sales. Instead of boldly introducing the new price at the agreed date, we might bring the new price in much earlier but combine its announcement with a special discount or voucher scheme worth £2 in the first stage, then £1.50, then £1. Bearing in mind the importance to us of keeping our regular customers loyal, we might even have a special scheme for them which extends the discount beyond the date of introduction of the new price. In this way the new price becomes accepted in the mind before it is a burden on the wallet. If we can go on

finding new propositions to put to our public that will keep the price per art experience at the old level in return for buying more of them, then we could well find that sales income was increased although a proportion of our audience was still paying the old price.

What Of Those Who Cannot Afford To Pay?

Go back and have another look at Chapter Eight: Sales Promotion. It is far better to ignore the hard up when making pricing decisions and then to return to them with appropriate sales promotion methods to bring the price down to match their capacity to pay. Pricing policy should not be based on the assumption that everyone is hard up.

Price Increases

Nobody likes price increases. Once you have established a price or range of prices they become, in the public mind, equated with value. The link between value and price does not always have a rational basis so an unexpected, significant variation is likely to promote an emotional response—'If that's the way they are going to behave then they can go to blazes!'. What is value, anyway? Is a book worth £10? It may only have cost £3 to produce but the customer does not know it and so, given that the book meets his needs, it is worth £10. Is this theatre ticket worth £6? It actually costs £12 but the customer does not know this and so, if he likes the show, it is worth £6. If you suddenly ask the book customer to pay £14 or the theatre customer to pay £10, they will both object to the change in the price/value ratio and it does not really matter what the reasons for the price increases are. How can something be worth £10 today and £14 tomorrow? It does not make sense—to the customer—even if it makes perfect sense to your organisation with its sales targets to achieve.

If you have to put up your prices, the answer must be to do it little but often in such a way that no increase is so large that the customer is outraged.

I have found subscription to be wonderfully useful in making price rises palatable. The Philharmonia Orchestra, playing in the Royal Festival Hall, London, must price its tickets according to levels agreed by the London Orchestral Concert Board so that there is parity between the major London orchestras. Ticket price levels have increased steadily (although not, in my view, excessively) since the Philharmonia introduced its subscription scheme in 1980. We have found that by varying the numbers of concerts in the groups of concerts offered to subscribers, and by varying the discount levels, we have been able to make the price increases almost undetectable whilst the number of subscribers and the income derived from

them have increased considerably. I would add here that the influence of the London Orchestral Concert Board has made it impossible for the Philharmonia to give in to any temptation to put its prices up so that it may then reduce them through subscribers' discounts. This approach is fraught with danger because if the subscription offer is not taken up, one is then left with single tickets to sell at a price that is significantly higher than the norm—and you may not sell them.

There is another reason why regular, small, price increases are better than one big one; they yield more money, sooner. Consider the four cases illustrated by the graphs in Fig. 3; they all concern a situation in which the ticket price has to be increased from £2 now, to £5 in three years' time. It is assumed that in each six month period there are x number of sales and that there is no fall-off in demand when prices are raised. Note that in none of the cases is the £5 price actually charged within the period; the organisation has to be ready to introduce this price at the end of three years.

In Case 1, the price has been raised steadily, every six months, throughout the three year period. This means that in the first six months, the x number of sales have each yielded £2 so that income for the period is £2x. In the second period of six months, the ticket price is £2.50 so the total yield is £2.5x. Total income for the period is:

$$£2x + £2.5x + £3x + £3.5x + £4x + £4.5x \qquad = £19.5x$$

In Case 2, the organisation has chosen annual increases, moving up in increments of £1 at a time. The number of sales in each year is thus 2x and the sales income for the three years is:

$$£2 \times 2x + £3 \times 2x + £4 \times 2x = £4x + £6x + £8x \qquad = £18x$$

In Case 3, the organisation waits for 18 months before increasing the price to £3.50 and then goes up to £5 after a further 18 months. The total sales income is:

$$£2 \times 3x + £3.5 \times 3x \qquad = £6x + £10.5x \qquad = £16.5x$$

In Case 4, no action is taken until the last minute with the £2 price being held throughout the three years. Sales income is:

$$£2 \times 6x \qquad\qquad = £12x$$

These figures do not look significant until one gives a value to x. If these cases referred to a typical theatre, the number of tickets that could be sold in a six month period could be, say, at six performances a week over 26

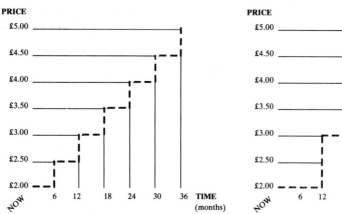

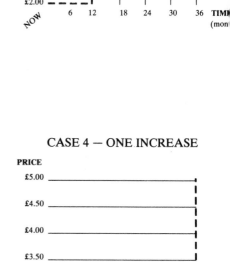

Fig. 3 Price Increase Options Over a Three Year Period

weeks with an average attendance of 500, 78,000. So, with x as 78,000, the sales income alternatives would yield:

Case 1	78,000 × £19.5	= £1,521,000
Case 2	78,000 × £18	= £1,404,000
Case 3	78,000 × £16.5	= £1,287,000
Case 4	78,000 × £12	= £936,000

The difference between Case 1 and Case 4 is £585,000 over the three years. Even the difference between Case 1 and Case 2 is £117,000 over the three years. It is easy to see how much more money will be taken by using the 'small but often' approach to price increases and, if you accept the argument that the method is less likely to arouse the ire of customers, there is less risk of sales falling off. Case 4 offers the extreme example and shows what might happen to the organisation that is either fearful of putting up its prices or holds them down out of some strange belief that by doing so it will influence the course of the nation's economy. If this organisation's customers are sold tickets at £2 for three years more and are then asked to pay £5 they will not appreciate the argument that they have been treated kindly over the period; they will react along 'go to blazes' lines.

Price Sensitivity

I have already touched on the concept of price sensitivity, which simply means the extent to which demand (that is, the level of sales—I repeat this because it is important to see demand as something which actually manifests itself as a purchase rather than an inclination or a desire to purchase) varies according to the way prices vary. At the start of this chapter I said that there is obviously a tendency for demand to fall as prices rise, and vice-versa, but this did not happen according to any fixed rule. The extent to which demand varies with respect to price is called 'price sensitivity' and it simply means that if a small change in price causes a large change in demand, we think of the situation as being very price sensitive. Air travel is a good example of extreme price sensitivity; on routes where there is heavy competition the airlines compete by discounting and sales can be won or lost in very large numbers by variations in the order of £10 or £15 on prices that have been discounted down from perhaps £800 to around £400.

The public's response to the arts and their pricing is peculiar and often unpredictable. It is probably because the expectation of value is very closely tied to the price, particularly amongst the majority of arts-goers who are not keen students of form. Thus, the higher the price the better the product is thought to be; if this price is within the purchasing power of the potential customer then the high price can actually be a beneficial factor in

motivation. If the price is higher than the potential customer can afford, the expectation of value will not be diminished—the person will simply not buy. Charging very much less can easily make people believe that the quality is less and so it will be rejected. Most arts administrators have had experience of the free event, made free to make it accessible perhaps, which fails to attract an audience. Free events succeed where there is no doubt at all as to the quality of the event. Where low priced events succeed it is because the organisation has successfully managed to present itself as being a reliable promoter of 'good stuff at popular prices'.

'Quality' is, without doubt, far more influential in a potential customer's mind than price, provided that the price more or less falls within the current level of acceptability. A theatre ticket at around £5 or £6 is acceptable if the show is believed, or known, to be good. Top line opera will go for £10–£15 a seat quite easily and very much more if it features internationally famous singers who carry with them a reputation of quality. Given, then, that what is to be sold is believed to be good by the interested public (the Attenders and Intenders) the arts are generally not particularly price sensitive and so price increases, along the lines described, can be introduced if the financial planning requires it.

The Publicity Factor

Publicity, in its attempts to make people want to buy our products, must convince the interested public of the quality of what is being promoted. The public is used to extravagant claims being made by advertisers and is sceptical. Advertising must do more than present events as being new, worthwhile, interesting, and exciting; it must have *credibility* so that the potential customer does not even begin to ask if the event is worth the money being charged but takes it for granted. Value for money must be an implicit message. Public relations must present the promoting body as being implicitly a value-for-money-high-quality-trust-'em-with-your-life organisation and enhance the event in the same way. One reason why promoters value 'stars' is not just because they are famous, it is because they are usually (not always!) accepted as being of high quality and their presence adds credibility to the whole affair. It is not surprising that an unknown artist or a new organisation has a hard time of it; the ticket price may be no higher, usually it is lower, than something well established but there is no guarantee of quality, so the price is irrelevant. This is why an arts organisation launching a subscription scheme to a wider, new market of people who may not know it, often seeks the endorsement of someone who is famous so that there is a believable statement of quality. What the endorsement states is 'You may not have heard of it but I know it well and, believe me, it is good'. It sometimes works.

One Price Or Many Prices?

There are two basic ways of pricing a set of seats in order to achieve the target created by the financial planning process. One is to price them all the same. The other is to offer a variety of prices. Each method has its advantages and disadvantages.

Multiple pricing is particularly useful if the overall amount of money to be raised from sales is high. If a hall has 1000 seats and the sales target is £8000 then obviously each seat must produce an average of £8 and it may be that the organisation does not believe that it can persuade 1000 people to part with £8. The hall might then be divided up into five sections, each of 200 seats, with the sections being priced at £4, £6, £8, £10 and £12. On sell-out, the yield is £8000. The problem is that in order to create the lower prices there must be some counter-balancing higher prices and it may be that at the higher end of the range, the price will go higher than an acceptable level.

If it is thought that £12 is too high then other re-arrangements are possible to achieve the same end. A hundred seats could be priced at £4, two hundred at £6, three hundred at £8 and four hundred at £10: the yield on sell-out is still £8000 and, by lowering the top price from £12 to £10, it is possible that the chance of achieving sell-out has been increased. Of course, there are now rather more seats to sell at what is still quite a high price of £10.

Difficulties arise from this approach to pricing which requires the would-be customer to make a decision that is not entirely based on reason. How does a person decide how much is to be paid? Faced with five options, ranging from £4 to £12, does the person follow habit and buy at the top price? The bottom price? Or does he buy at the price suggested to him by the box-office? Or does the seat location play a more influential part in the decision so that price does not matter so long as he sits in the right place? What is his reaction if the chosen seat or the chosen price is no longer available? Does he then tend to buy more expensively or more cheaply?

I do not understand (I suspect that no-one does) what goes on in the mind of a person faced with a variety of price options. I suspect that our customers approach the moment of purchase wanting to experience what they have seen advertised and what they have heard about from other people. I also suspect that they want the experience to be as good as possible and they probably relate price to the quality of the experience they expect to have—but not too carefully. I believe that there are occasions when 'only the best will do' and there are people who take pride in always buying the cheapest seat (they are not, I believe, always the poorest people).

Looking at the matter from the viewpoint of the sales function (where it is important to remove the obstacles that come between a would-be

customer and a purchase), a range of prices must, in itself, constitute a hurdle, another decision that has to be made.

When there are different prices the organisation is making an implicit statement about the value of what is being sold. There is an implied relationship between price and 'how good' the seat is; this is frequently very ill-founded. In our hypothetical concert hall, where we have chosen prices and seat allocations entirely on the basis of arithmetic, the only basis for the quality/price relationship is likely to be in the distance of the seat area from the front of the hall. It is probably the case that seats at the front are better than seats right at the back, but what about the front row of the £4 seats, is it really £2 less good than the back row of the £6 seats?

If quality is a significant factor in whether a person will pay a price or not it must be better for there to be some rational basis to account for the differences in price. Thus, in a traditional theatre, where there really are differences in the quality of the experience being sold (e.g. cramped seats at the back or bad sight-lines) it is reasonable for there to be differences in price but these should be as few as possible. Otherwise, it is far better to concentrate upon the quality of the event itself, rather than to draw attention to the varying quality of the seating through a complicated pricing structure.

One major virtue of multiple pricing is that it does make it possible to increase yield without increasing prices. By varying the seat allocations within a range of prices, the yield (which we hope will be the same as the financial target) can be increased within reasonably generous limitations.

Multiple pricing increases the difficulty of financial planning because the pattern of buying cannot easily be predicted. The cash yield from a 50 per cent capacity hall where customers have bought from the cheapest price upwards will obviously be less than the yield from the same capacity where customers have bought from the top price down. Administrators come to terms with this by referring to achievements in terms of 'audience capacity' and 'financial capacity' so that a 50 per cent house, for example, may produce 45 per cent or 55 per cent financial capacity.

From the performer's point of view, a hall with price variations where customers have gone for the cheapest seats first and have bought less than capacity, will have empty seats exactly where they are not wanted.

I have heard the argument that multiple pricing is necessary in order to provide expensive seats for the rich and cheap seats for the poor; this may make some kind of sense. Indeed, I am sure that where there are wide differences in price, wealthy people will tend to buy expensive seats and poorer people will tend to buy cheaper seats. What I find difficult to accept is how the person pricing the hall knows how many poor people and how many rich people there are who will respond to his particular proposition. And does it not depend on the scale of values of the customer? A less well

off person who values his music or his theatre highly may well choose to buy an expensive seat.

Unit pricing, which simply means charging the same price for all seats, is appropriate when the average seat price (which becomes the price to be charged), determined by the number of seats to be sold and the financial target, falls within the level of acceptability and (most commonly) when there are no significant variations in seating. This basis of pricing removes any suggestion that what you have to sell is variable in quality and makes the proposition put to the public much more straightforward. It also gets rid of the idea that you have one product for the rich and one for the poor; the ideal must be to have one product at one price.

Most things which are sold are sold at just one price and the means of the purchaser are not taken into account at all. Driving lessons, hair cuts, shoes, meals—their prices are fixed according to the basic commercial rules. Where there are variations in price there are clear variations in quality. Thus there is the very expensive Citroen car and the very cheap Citroen car; the product is tailored to the means of the market, not the price. It is only in the arts and entertainment world where we create the illusion that quality is directly linked to price as though they were marked on two axes of a graph and the relationship expressed in the form of a line on that graph.

Even if there are variations in seating quality, unit pricing can be used; by putting the same price on seats that are known to be of varying quality you can help to accelerate purchase, one of the basic sales factors. Unit pricing is a special form of sales promotion, therefore, because it is offering special benefits to those who respond quickly. It is similar to offering a discount to those who book before a certain date. This beneficial effect holds true whether or not there are significant variations in seating quality because people have their own seating preferences and like to exercise them independently of thoughts of price. But what of the customer who buys late? He has paid the same price as the person sitting up there in the front row, is this fair? It *is* fair and it will usually strike that customer as being fair. People will almost always accept that if they are at the end of the queue they run the risk of getting the scraps.

Once it is made clear to the public that all seats are priced the same and will be sold on a 'first come, first served' basis, they are much more likely to act on their buying desire. At the Churchill Theatre, Bromley, where unit pricing was introduced on my recommendation, we were able to say to our potential customers, 'The best seat in the house is the seat you want—and you can have it if you book now.' This acted as a remarkable accelerator.

It is, of course, possible to create a 'rush to purchase' with multiple pricing but it takes time to establish. If you can succeed in creating the feeling that a seller's market is operating, people will hasten to secure their

seats at whatever price level. Unit pricing makes it possible to build the impetus from the very beginning because people do not have to be persuaded that a sell-out is just about to happen; they want the pick of the seats and they know that they must be quick about it.

If unit pricing has a disadvantage it is that it makes price increases very obvious indeed because they cannot be disguised by changing the seat allocations within a range of prices.

Try Both At Once

The two approaches to pricing are not incompatible. It is quite possible, for example, to offer a multiple price choice to single ticket buyers and a unit price to subscribers. This becomes a sales promotion, yet another benefit offered to those who buy wholesale. The Churchill Theatre scheme had one set price for Monday to Thursday and a higher set price for Friday and Saturday; the subscriber, buying tickets for six plays, was asked to pay just one fixed price and could choose a subscription for any night—another slogan used was *Any Seat in the House, Any Night of the Week.*

The London Choral Society, another client of mine, used a completely conventional multiple pricing policy for its Royal Festival Hall concerts but offered subscriptions at one fixed price. Potential customers were told that allocation would start at the top price and work its way down through the ranges. Because there was a point at which the cost of the subscription became greater than the individual costs of sets of tickets in the cheaper ranges, there was a pre-stated limit—1000—on the number of subscriptions that could be sold. It was, in fact, a disguised diminishing percentage discount scheme.

I have used unit pricing for the 'bonus concerts' of the Philharmonia Orchestra in the Royal Festival Hall. These concerts have the usual range of prices but are offered to subscribers at one price, well before the box office opens. Thus, in 1983, subscribers were offered tickets for the Philharmonia with soloist, Mstislav Rostropovich, at a flat £5 when the normal price range went down from £9.50. They were later offered a bonus concert with Carlo Maria Giulini conducting Bruckner's eighth symphony for £5.50 when the top price was again £9.50. In both cases, the unit price offer, with its obvious financial and seat location advantages, accelerated purchase of the ordinary multiple priced subscription series because you could only take up the bonus concert offer if you bought a subscription.

Multiple Pricing: How Many Seats At What Price?

If circumstances make multiple pricing desirable, what is a proper basis for making seating/pricing allocations? I have already said that there usually is

a relationship between demand and price so, on that basis, one should allocate a relatively small number of seats at the highest price and go on increasing the numbers of seats in each price bracket. But, we also believe that the perception of 'quality' is almost always more significant when making the decision to buy than price, provided that the overall range of prices falls within the currently acceptable norm. On this basis we might reasonably allocate a higher number of seats at the higher price levels. We also know that when we vary prices away from the mean we get on a price see-saw; for every lower price we create in order to stimulate demand there must be a compensating higher price which will tend to restrict demand. Confusing, isn't it?

Because I do not know much about the relationship between demand and price and because I do not know how people will relate their perception of quality to the price charged (which, after all, may easily change from show to show and will be influenced by my success on the publicity front), I price so that the largest number of seats carry my 'average' price tag—that is the price that results from dividing the number of seats into the cash yield that financial planning has provided as our target. Then, the seat allocations become smaller as the price goes up and as it goes down. The 'see-saw' effect is still operating but I am, at least, limiting the number of seats subject to its influence.

If we return to that hall of 1000 seats and a required yield of £8000, my solution might be to price along these lines:

100 seats @ £12 = £1200
200 seats @ £10 = £2000
400 seats @ £8 = £3200
200 seats @ £6 = £1200
100 seats @ £4 = £400

Total: 1000 seats yield £8000

But, then, I might look at those figures and think that the range is too extreme. I am offering an art experience on one hand at £12, and on the other, at £4—but it is the same show. So, I might consider:

50 seats @ £10 = £500
150 seats @ £9 = £1350
600 seats @ £8 = £4800
150 seats @ £7 ·= £1050
50 seats @ £6 = £300

Total 1000 seats yield £8000

This is looking better. Before there was an £8 difference between top and bottom price, now there is only £4. But, I still do not like the look of

these figures. If I am to present a glowing promise of high quality to people who have not yet bought from me, how can I say that it is worth both £10 and £6 even if it is an improvement on £12 and £4? And, isn't £6 rather high, anyway? But that is off-set by the reduction in the top price from £12 to £10. This cuts no ice with someone who is only going to buy at the lower price, what is it to him if the top price comes down? Let us consider:

100 seats @ £9 = £900
800 seats @ £8 = £6400
100 seats @ £7 = £700

Total 1000 seats yield £8000

This more closely matches my ideal of offering one product at one price and is but a step away from unit pricing. At what point would one make the change? If there were 100 seats (or thereabouts) that were really superior and there were around 100 seats that were less than good, I would probably go for the final alternative, with three basic prices. If there were no really significant variations—and distance from the stage is not always a significant variation—I would still be happier about charging one price for all seats.

Back to Financial Planning

But what if that one price of £8 really seems too high? Or that limited range of £9, £8 and £7, is just beyond what the market will stand? What do we do then? There is only one thing that can be done and that is to go back to the financial planning stage and re-work the figures to produce a more achievable target income. It could be that the artistic product that is being planned is simply too expensive for the present moment. You will not improve the situation by piling on more expensive seats at one end and cheaper seats at the other.

But What If You Don't Sell Them All?

This is the really important question. Pricing decisions are educated guesses and these figures we have just considered are all based on the belief that we will sell all we have to sell. The average price which formed the pivot of price variations was arrived at on the assumption that all 1000 seats would be sold. If we started with the assumption that we would only sell half our seats, the average price would be doubled, to £16. Our multiple pricing must then give us prices both above and below the mean of £16. The resultant price range would probably be beyond the limit of acceptability. We then find ourselves in the dangerous waters of the self-fulfilling

prophecy. If we start with the belief that we will only sell half our tickets we are forced into making decisions that make it very likely that we will sell only half our tickets.

As a general principle, pricing must be based upon the anticipation of a reasonably high degree of success. It is closely linked to the need to drive forward to success that is the underlying theme of this book, the need to expand, to create the spiral of success breeding success. Therefore, aim high in terms of sales, assume that you will sell at least 80 per cent of what you have to sell and then work to achieve it. If you are currently achieving 80 per cent then aim for 90 per cent. If you are full up, think of ways of increasing the cash yield from your audiences. Whatever you do, do not stand still!

Immediately we hear the voices of pessimism. 'We have never sold more than 50 per cent of our tickets so it would be foolish to assume that this will change. If we now base our pricing on a forecast of 80 per cent sales, should we not then reduce our prices in order to achieve the same target income? How do we know that the number of tickets sold will increase? If we only sell 50 per cent we shall end up with less money.'

Pricing is not the whole of the story. If an organisation does no more than increase the size of its sales forecast and reduces its prices accordingly, then, quite possibly, it will sell no more and will take no more at the box-office. If it changes from multiple to unit pricing and does no more, the result might be no different. If it increases its targets and changes its pricing policy as part of an overall marketing strategy that involves improvements in publicity, sales and sales promotions, and the product that it offers, then it has a good chance of success. Price reductions do tend to increase sales but use must be made of them in the advertising message or they must be expressed in the form of well advertised sales promotions. And, of course, there is no absolute rule dictating that prices should be reduced as sales targets (in numerical terms) are increased. No-one ever objects to sales income forecasts being exceeded.

Some Guidelines

Pricing decisions can easily tie you up in knots so it is as well to follow a few simple rules:

Charge as much as you can get.

Aim for the maximum amount of money from the maximum number of people.

If you have to choose, more people is more important than more money.

Reduce prices, either directly or through sales promotion methods, if it will increase the number of sales.

Charge one price whenever possible.

If multiple pricing is necessary, offer as small a number of options as possible.

Increase prices through several small increments rather than one big one.

As soon as you achieve your target, set yourself another, higher, one.

CHAPTER ELEVEN

ADVERTISING

What Advertising Does

The job of advertising is to make people want what you have to sell and to make them want it so much that they will voluntarily take whatever action is necessary for them to get it. The job of sales is to remove as many barriers as possible between the would-be customer and the moment of purchase and to clinch the deal. The job of sales promotion is to enhance the product's attractiveness by increasing the perceived value of what is being offered for sale. An old saw of marketing is that sales promotion pushes the product towards the market while advertising pulls the market to the product.

Advertising is making promises, convincing promises. At the time you start the process of telling people about your product, the product—which is really an art experience scheduled for the future—does not exist. Even if a show has been running for weeks, the product as it relates to new customers, does not exist. It can only exist when it is being experienced by the customer. Therefore, all that can be done to make the potential customer interested in this particular art experience is to describe it to him in such a way that he will want to buy it, ahead of time, before he actually experiences it. The experience has to be promised and the whole point about promises is that they are to be believed when they are being made and then they must be kept.

Description is a vital part of the promise making. The product has to be described in such a way that it is attractive to the potential customer. This means that whoever is doing the describing must be selective in the information presented (Here we go—the first ugly signs of the dishonesty inherent in advertising. Rubbish—all description is selective.) so that what is perceived by the customer will be seen as favourable. Selectivity is also very important in terms of how much description is offered; too much information is both difficult to communicate and difficult to assimilate. The describer must also have skill and talent in the art of description.

The fact that what is being advertised is an experience rather than something tangible does not necessarily mean that the advertising message has to be an explicit description of the experience; this aspect of the message can be implicit. Thus, the advertiser describes the event in favourable terms, makes a promise that it is good and worth experiencing, and the

reader relates it to himself, making his own evaluation as to whether he wants to experience it or not and how good he thinks it is likely to be. Obviously, the more the advertising message can relate to the reader's tastes, the better.

To Whom Do We Advertise?

If you refer back to Chapter Six: The Market, you will see that I said that in the short term we should concentrate our efforts upon those whose attitudes are favourably inclined to what we have to sell. Not just those who are presently buying and have a history of buying but those who think well of our particular art form, who read about it, talk about it but who never, or rarely, get around to doing anything about it. I recommended that you should think of your community in terms of its attitudes towards your art form. The four basic attitudes can be thought of as a target (see Fig. 4).

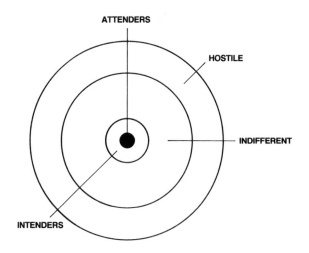

Fig. 4 The Attitude Target

For the purposes of advertising, those who are indifferent or hostile are so unlikely to respond that they can be ignored. I went on to say that public relations was the appropriate instrument to use in the matter of changing attitudes. Our kind of advertising, which works under extreme constraints of time and money, cannot hope to create need where none exists, it can only succeed where there are no major psychological barriers.

There must also be some geographical limitation to what we see as the community within which our market lies. This will be defined by who we are and where we are as well as the obvious physical characteristics such as transport services and the presence or otherwise of motorways. Our view of where the market is may also be influenced by the existence of other, similar arts organisations; we may adopt a competitive policy towards them or not. The geographical limitation is important because the cost of advertising is usually related to the spread of a market as well as to its numerical size and it is often cheaper to communicate within a geographically compact area.

By far the most important consideration is this view of the market in terms of its attitudes. In the arts world the pressure on us to seek out new audiences comes from without and within and it is vital that we see the potential for growth now as being amongst the Attenders and Intenders. If we do not accept this then our advertising messages will either be aimed at the public as a whole ('aimed' in the sense of the message content and style), in which case they will be bland and almost meaningless, or specifically directed at those who do not care for, or positively dislike, what we have to sell. Our intention in advertising is to motivate those who already attend, to attend more often and those who attend rarely, if ever, but think of themselves as 'culturally aware', to cross the first barrier. The first barrier may be no more than apathy, or a lack of belief in arts advertising messages, or a failure to realise that their domestic circumstances (such as having a young family) have changed so that they are now free to enjoy themselves more (the children are old enough to be entrusted to a babysitter now) or the thought that the arts are too expensive. There may be no real barrier at all; it could be that no-one has ever directed an advertising campaign specifically at them. It is from the Intenders that new audiences will be drawn. I believe that the potential from this category is very large. There is a saying in the marketing world, 'for everyone who buys there are thousands who nearly buy'.

The potential for growth within the attending group is rarely appreciated. Elsewhere I use as an example a theatre that regularly attracted an audience of 500 and over a six month period achieved 78,000 attendances, or 156,000 a year. If we assume that, on average, a customer attended, say, three times a year, we could say that the theatre had an audience of some 52,000 people. If the theatre had a capacity of 700 seats it would be playing to just over 71 per cent 'audience capacity'; if it could persuade that audience of 52,000 people to increase their attendance by 1 more in the year the number of attendances would rise to 208,000 and the audience capacity would rise to over 95 per cent. This is one of the bases of the subscription idea, to increase the frequency of attendance from those who are already buying.

But that's not right! That's not fair! That is denying access to the arts to the community! If you fill the theatres, people won't be able to get in. It is elitist!

Rubbish! The theatre box-office is still open to anyone for business. The ticket price is still the same—and subsidised to bring it down to within a very broad level of acceptability. There is plenty of information about where the theatre is (it's probably right on the High Street and hard to miss) and what it is doing. If a theatre full of regular attenders is elitist then I'll stick to the dictionary definition of 'elite' which is 'the best'. Once someone voluntarily walks into a theatre, or any place where there is art and entertainment, they define themselves as 'the best' and that is how I'll treat them. People are kept out of our art places more, much more, by *their* attitudes than those of the people who run the places. We who market the arts do sometimes show an off-putting face and part of this book deals with how to encourage those who are unsure of themselves when they make their first encounter; but the real problem is one of public attitudes.

This view of the direction that advertising must have is not a political one (although it is quite likely to be attacked on political grounds). It is based wholly upon the belief that in the face of entrenched antagonistic attitudes, this kind of advertising is impotent. One can use advertising techniques as part of a public relations programme which will inform, educate and may eventually shift people's views but product advertising—telling people about the show that is going to happen in a few weeks' time—just won't work with folk who do not want to know. Our job, as arts marketers, is to succeed and so we must use methods that will work.

How Do We Communicate With Our Market?

It is interesting to see how, in the UK, our way of communicating has changed over the past 12 years or so. Now there is much more interest in direct mail methods—the advertising message in the envelope directed at the individual in his home. The poster is rarely relied upon; it may form part of a campaign but few will hope to fill a hall solely on the strength of large bits of paper stuck up on walls. Leaflets, measuring 8″ × 5″, printed in one colour, have (to an extent) given way to large, glossy, multi-coloured, multi-folded, brochures that often look remarkably similar to the brochures of Readers Digest and the Automobile Association. The use of local commercial radio and television sometimes features in campaigns. There is large scale newspaper advertising. All of this is evidence of a desire to do better and of thought and energy being expended. It does not, however, necessarily mean that there is a universally accepted rationale behind what is going on.

The problem of communication with our market is made far easier once. we accept the market as defined by behaviour (they are already buying) and attitude (they approve of what we are doing). Choosing the channels of communication (which are called 'media') becomes a matter of deciding on which media will reach our market most economically (i.e. the maximum number of 'our' people reached at minimum cost and with minimum waste), which media are capable of carrying our persuasive advertising messages and which media enable the motivated customer to respond with a purchase.

What Are We To Tell Them?

This is product advertising and the main burden of our advertising message is the product. It may be one event or a series of events; what we have to communicate is information about this product, information which is most likely to motivate the people in the community that we regard as our market. The problem with information is that there is always far too much of it and, in this task of communication via a medium, too much information kills effective communication. To advertise, to convey the promise persuasively, we must select one clear, uncluttered, hard-edged, image of the product that is most likely to interest and excite our market.

Remember how this market is defined. With the definition in mind we can make some assumptions about what the market already knows about our product and products like it. An idea, when transmitted, reacts upon what is already present in the mind of the receiver. The more information that is already present, the quicker will be the take-up of the idea. This 'level of awareness', which is bound to be present in our market (because we have virtually based the definition of our market upon it), makes our task of communication much easier. We can 'speak' very economically. We do not need lengthy explanations. We can use symbols which are meaningful. So, when we decide what we want to say about the product, we can be even briefer and to the point and will communicate more effectively.

Not all the awareness that is present in the minds of our market will be favourable to a specific product. People may love classical music but detest certain pieces (or artists). It can thus happen that the advertising message for an event may be very well expressed and directed but when it arrives it bounces off the attitude that has hardened towards aspects of your programme. Nothing can be done about this; wastage of this kind is inevitable.

In the commercial advertising world they sometimes speak of the 'unique selling proposition' that is the heart of the campaign. This means the 'clear, uncluttered, hard-edged image' that I referred to earlier and it means an image that has been selected because it stands the best chance of

making people want the product and which is capable of being communicated through the chosen media. My use of the word 'image' should not be taken to mean simply a picture; I use it rather in the sense of a 'way of looking' which, when it is communicated, will involve the use of pictures, colour, words, shapes of words, arrangements of shapes of words and pictures and colours and any other element, such as music or movement, to convey it. The unique selling proposition, which is often reduced to U.S.P. for convenience, is a very useful concept and it should be in the forefront of your mind when you are planning advertising.

Without the U.S.P. concept and without a clear definition of the market, what is being transmitted becomes a vague, shapeless, information-laden, mass which, in its efforts to tell everything to everyone tells nothing to anyone. It is the difference between a snow fall and a snow ball.

If this idea is still not clear, take time to look at the advertisements produced for the commercial world by their advertising agencies. They are not all good but mostly you will find that this principle of simplicity and clarity and direction, is manifested. If the product is a car that is cheap to buy and to run and is tough and reliable, the car will be shown in such a way that these features are illustrated with a very carefully selected picture and backed up by words used with great impact and brevity. The car may contain a family. Because the car is cheap the family will look like a family of modest means (not poor, but not rich either). The setting may be rugged countryside and the car may be going uphill. The first words you read will be something like, 'The Workhorse'. This may seem confusing. They are trying to get across several ideas, cheap, tough, reliable; how can this be a unique selling proposition?

There may be several components to the idea that is to be communicated but when the advertisement is complete and ready to show to people, it is essentially a very simple, direct idea of the car that is received by the reader. It is the totality of the information, the gestalt of words, picture, relative sizes, shapes, colours, and relative positions, that comes through to convey the essentially simple concept. The U.S.P. is what comes out of the advertisement and what goes into it but it is not necessarily the bit in the middle.

The same holds good for arts advertising. When I started to specialise in subscription-based marketing, someone said to me, 'Now you are trying to sell six plays or 30 concerts at one go. How can you create a U.S.P. out of that lot?' It never struck me as a problem. What is to be sold, and hence advertised, is subscription; everything else is supporting information, just as the car advertisement will carry a mass of supporting information about the size of the boot, the cost of a sun-roof and so on. One uses the details of

the plays and concerts and expresses them with words and pictures, so that together they give one, highly desirable impression of what is being sold.

The U.S.P. is the part of the advertisement (here I use the word 'advertisement' to mean the advertising message rather than the medium; it does not mean only a piece of space in a newspaper or a television commercial) that is the main motivational element but, of course, there must be more. The reader needs more information. Where is it? When is it? How much is it? Are there any special reasons (i.e. sales promotions) why I should buy? How do I get it? How easy is it to get? When must I buy it? This is the business side of the advertisement and it is very important but it is not more important than the image of the event, the U.S.P. It is said that an advertisement carries information that seeks you (the U.S.P.) and information that you seek (once your interest and buying desire has been stimulated by the U.S.P.); the U.S.P. must have the lion's share of the available space.

Second in importance to the U.S.P. are the sales aspects. As people are drawn into the idea of wanting the product they must be presented with the means of purchase, clearly, easily, compellingly. Advertising that only carries a message to create the buying desire is doing half the job. This consideration will influence your choice of media into favouring those that are capable of carrying the sales message in an easily perceived and remembered way. The sales information, afforded proper priority, is what turns a piece of advertising material into sales material.

How Truthful Should We Be?

If you tried to be really truthful in advertising, you would never finish the job and even if you did you would never be able to communicate the real truth because there is too much of it. Truth is what you know to be true. With the arts event that has not yet happened there is a lot that is going to be true later on but you do not know what it is going to be. All you can do is assemble in your own mind the factual information that you know to be true and to develop a U.S.P. that you believe will be true. You will have to select some truths above others because they are more relevant and more interesting and so you could argue (if you were bloody minded) that by not telling all the truth you were being untruthful, or at least were offering a distorted view.

It is a futile exercise. When you plan an advertising message you know when your enthusiasm has taken you beyond the limits of truth and legitimately encouraging language. If you do not know, then ask a colleague for an opinion. If you exceed certain limits you could be liable under the law. If you raise expectations which are not ultimately fulfilled by events the results will show at the box-office later on.

The basic advice is to get the facts right, choose the facts which will be most encouraging to a potential audience and then tell the story persuasively. Because facts in the arts (such as who is going to do what) can change, make sure you put a disclaimer somewhere in the text to remind people that artists and programmes can change and that what is advertised is offered on those terms.

How Do We Tell Them?

We have in mind a profile of the people we are addressing and we have selected media of communication that will reach them (see the next chapter on Media. We have analysed what it is we have to sell and refined it into a communicable, persuasive idea. We have integrated the sales aspects into the message. What we must consider now is the way in which we use the media to transmit the idea and information. The first, and most important, matter is the 'language' to be used.

What Language Do We Use?

When you speak to people, you speak in the language they understand. So it is with advertising only the language you use consists of more than words. 'Language', in this sense, means all the devices you use to convey meaning: 'pictures, colour, words, shapes of words, arrangements of shapes of words and pictures and colours and any other element, such as music or movement'. In short, everything that is perceived by the viewer or listener.

In the past, when many believed that all people, irrespective of their attitudes towards an art form, their age and their financial position, were potential customers, the matter of what language to use was a very confused area. Some, in their search for the 'new' audience, deliberately tried to speak in a language that, it was hoped, would be meaningful to people who had not experienced the artform before. It might have been the language of pop music, pop television, or even the supermarket. It was the 'Hi there, guys and gals, we've got a really wonderful show for you tonight!' approach. It rarely resulted in new audiences and it often offended the audiences that existed already.

The arts administrators and artists who regarded their arts as being rather precious (who were, and still are, the ones who dislike the idea that the arts can be marketed and even shudder at the word 'marketing') loathed this approach to language. They felt that it was just not appropriate for their market and even degraded the product that they valued so highly. They were, and are, basically correct. Crude, strident, even patronising language is wrong for most existing arts audiences and, if it is used, it upsets them and makes them question the whole credibility of the organisation.

Those arts administrators were right about the language, wrong about the marketing—wrong to associate the marketing idea with an insensitive use of language, although their views have often been well founded on cases where the only apparent change in marketing has been in the language used.

In the majority of cases one can put this use of inappropriate language more down to enthusiasm and lack of experience than to anything else. It is a mistake most of us, and I certainly include myself, have made.

Acceptance of the idea that the market lies amongst those who are already well disposed towards the arts and therefore have some knowledge of them, answers totally the question of the language which should be used in advertising. This does not mean that language should be boring, or muted, or esoteric, or economic almost to the point of non-existence; it simply means that when an advertising campaign is being realised it is aimed, in terms of language as well as media, at those who are likely to buy—the Attenders and Intenders.

The different art forms tend to impose their own limitations on language, and so do the organisations that promote them. Thus, most theatres can be vigorous, humorous, overtly friendly, colourful, pictorial and so on, in their language, because the products usually have these characteristics and the audiences comprehend the language and are comfortable with it. Classical music, for all its variety, is a more serious business and its very nature makes it demand a 'cooler', more economic language although there is still plenty of room for improvement on the language currently used by most music organisations which mainly manifest all the signs of acute inhibition caused by fear of alienating their existing audiences. Although many would disagree with me, I believe that the art galleries, as they are today, are using the appropriate language for their markets. They use illustrations which serve as symbols for the particular exhibition and they choose titles which attract interest as well as describe. Opera allows for more 'theatrical' language; ballet, less so; modern dance, more so.

All arts marketers should look hard at the language they employ in their advertising to see if it can be more accurately matched to their market. Fear of saying the wrong thing often leads to saying almost nothing at all, which is just as bad as using an inappropriate language. More colour, more vitality, more excitement (more evidence of creativity, might I say?) are all well within the limits of tolerance of existing markets from whom we hope to draw increased attendances. The trick is to know when to stop, when the limit has been reached.

Subscription-based marketing techniques as we now know them, have provided us with plenty of examples of advertising language used in the United States of America, Canada and Australia. When the subscription

idea was new to us, we copied the language and, in particular, the words that matched the tastes of other people. Often, I suspect, only the language was copied as though by yelling, 'Dial The Hot Line Now!', or just by using full colour printing, customers would be made to reach for their cheque books. It is a more subtle matter than this. There are many aspects of overseas subscription methods that we should copy but the language is something else and we must tread carefully. What we must copy is the colour, vitality and excitement of the advertising language whilst remembering that countries and cultures are different and words, above all things, have the capacity to alienate as well as attract.

Language, then, is something we must give thought to and learn to use. If we are to be good communicators, capable of speaking to many different groups of people, then we must learn many languages. We speak the languages through the use of words (Copywriting) and visual images (Design); both are covered in greater detail in the chapters which follow.

The Advertising Campaign

There are four elements in an advertising campaign: the people to whom we are speaking, the message we are to communicate, the media which will carry the message and the skills we need to use the media effectively. This is most easily remembered as a diagram (see Fig. 5).

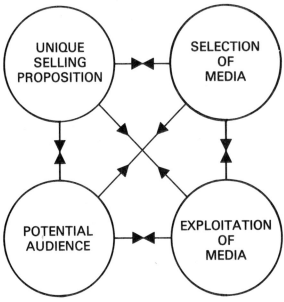

Fig. 5 The Four Elements of an Advertising Campaign

Damn You, Vance Packard

In the mid-fifties there was published a book called *The Hidden Persuaders* by the American, Vance Packard. It was about the techniques used by the American advertising industry to find out what people's deepest, most secret, needs were so that they could be commercially exploited. It painted a picture of a society that was constantly being manipulated by Big Business for its own ends. It did not do the image of advertising very much good.

The book has had such an influence on the thinking of people that even today, people who have never read it will trot out its warnings and its gloomy forecasts as though nothing has happened in the past 30 years or so. To persuade people of anything is thus wrong (even though they are usually trying to persuade me that I am wrong); to make them want something which they do not, at this precise moment, want, is wrong. Advertising is evil. Over the past 12 years or more during which I have lectured to what, I suppose, must have been thousands of people, there has always been a small but vociferous, element of people who have attacked what I have to say on the grounds that advertising is wicked and should be stopped. It has been argued that the arts, being more precious than anything else, should not be besmirched by this immoral practice. Even amongst people who do not hold such extreme views there is still the suggestion that advertising is a bit *infra dig* and should not be necessary in a proper world.

Packard's book was written within a year or so of the development of what was termed 'consumer orientated' marketing in the United States; this was a concept that came from the motor car industry originally and marks the start of marketing as we know it today. Essentially the idea is simple. You find out what people want and produce it for them. This marked a change in orientation for, prior to this, industry tended to produce goods for which experience or guesswork told it there would be a market; it was the era of the entrepreneur. But it was a risky business and in the highly competitive world of the motor car industry where a new product represented millions of dollars worth of investment, it made sense to try to find out what people wanted before designing and manufacturing a new car. At the time psychology was all the rage (in this country there was William Sargent's book *Battle For the Mind* about the techniques of brain-washing which seemed to complement Packard's book very nicely) and, just as the psychiatrists were queueing up to sort out America's mental health, the psychologists were there ready to tell industry not just what people wanted but what they needed. 'You see, he may say he wants a red car but what he needs, what he really needs, is an extension of his penis. So give him a long car, it doesn't matter what colour it is.'

It did not last very long. It was a fashion that went along with collars that buttoned down and very neat haircuts for men. Also, it does not appear to have worked very well and that must have contributed to its downfall. I cannot offer any guarantee that now, 30 years or so on, there are not, in the cellars of the multi-national companies, teams of psychologists slaving away over programmes to determine what it is that we all need, rather than merely want, but I do not believe that it works like that. We have market research which asks questions of people, gives them things to try out, asks for their reactions to packet design, advertisements and so on, but we do not even have so very much of that. Where research takes place at all it is at a fairly conscious level and does not try to delve too deeply into the tangle of people's unconscious. And marketing is still predominantly based on the give-it-a-whirl-and-see-how-it-flies principle and entre-preneurialism.

So, all that is left are the lingering suspicions aroused by *The Hidden Persuaders*, firmly rooted in the consciousness of western civilisation and particularly in the minds of those who like a good conspiracy theory and those who never grew up to use their eyes and their minds. And the suspicions get in the way of the innocuous task we have of persuading people to want and to buy things that we know to be quite good.

Damn you, Vance Packard.

(Note: do not let this deter you from reading the book. It is *very* interesting!)

CHAPTER TWELVE

MEDIA

Media, are our channels of communication and, as such, play a vital part in the advertising process. Our job is to choose media that will reach our market most economically (i.e. the maximum number of 'our' people reached at minimum cost and with minimum waste), that are capable of carrying our persuasive advertising messages and which, whenever possible, enable the motivated customer to respond with a purchase.

We must now stop thinking of the market as being a combination of the Attenders and Intenders, and think of them as two separate groups which must be approached in different ways from a media standpoint. The Attenders are people that we can contact individually because, if we have been doing our stuff, we have found ways of recording their names and addresses. The Intenders are out there somewhere but we do not know exactly where. We can expect a high level of favourable response from the Attenders; it will cost us much more to make contact with the Intenders and the resultant response and income in relation to cost, will be far lower.

The two groups have a great deal in common, of course, and that is they are to a greater or lesser degree, familiar with what we have to sell and therefore our 'language' of communication can be very similar, if not the same. This is very useful to us.

Direct Mail

Direct mail is a medium of special value when dealing with the Attenders and it can be useful for searching out and communicating with the Intenders.

Direct mail, to a list of people who have distinguished themselves by buying our kind of art product in the recent past, will always satisfy the three criteria above, by which we select media. Advertising/sales material, sent directly to named individuals who are known Attenders, will always result in better, more cost effective, response—provided, of course, that the product, the pricing, the sales promotion (if applicable), and the sales aspects are all well conceived and integrated into a good campaign and expressed well.

If we cannot identify people individually then we are forced to mail to very much larger numbers in order to reach those who are likely to respond; these are the Attenders whose names we have not managed to capture and the Intenders. In order to hit the sparrow we must use a shotgun.

Direct mail, when given specific targets of high sales potential, can almost never be bettered in terms of costs and resulting sales. If the targets are not specific then there are other media options that should be considered.

The subscription campaign probably illustrates the point best of all. Once a subscription scheme is under way, the subscribers constitute the most responsive of any mailing list. Out of a list of, say, 1000 subscribers it is quite common to receive ticket orders back from 500 or more of them. You may have to mail several times to them because people do not always respond immediately to your carefully thought out imperatives, but the response level can easily be 50 per cent or more—I have known cases where it went as high as 85 per cent. In North America, where they seem to be able to create the atmosphere of a seller's market much more frequently, response levels in excess of 90 per cent are common. On the other hand, a mailing to 1000 people, who are not known purchasers and who have been chosen by virtue of their education, social background, area of residence, profession, or any other criterion that strikes you as relevant to a possible interest in your art form, is unlikely to yield more than 1 per cent response and most usually it will be even less than that.

The cost factors in direct mail are:

cost of the envelopes and their contents
cost of inserting contents into envelopes
cost of postage or distribution

(Note: the term 'direct mail' is usually taken to mean putting envelopes containing advertising/sales material through people's letterboxes. It does not necessarily mean sending the envelopes by post. There are companies that specialise in door-to-door distribution and the Post Office has its own Household Distribution Service which does the same thing, without the need for paying current postage rates. Cost per item delivered is considerably cheaper than postage but the items cannot be individually addressed. Private companies usually charge much less than the Post Office but vary considerably in reliability; to date, the response rate from direct mail items delivered in bulk to the darker recesses of the hedge bottom has proved to be low.)

All of these cost factors increase with quantity. Only the cost of 'originating' the contents (that is, designing them and making the artwork ready for printing) is a constant. There will be some reductions in the unit cost of each printed item and in the cost of envelopes as the quantity increases but the total cost will still be a function of quantity. Direct Mail, which is aimed at a broad section of the community in order to communicate with a few is expensive.

Cost alone should not daunt the ambitious arts marketer. What must be done is to relate cost to the income that should result. A mailing to 100,000 people, allowing for any special Post Office rebate, might cost £25,000 (to cover envelopes, contents, inserting contents and postage). If 1000 people respond with orders which are worth, on average, £50, then you have £50,000. You will have spent 50p for every £ of income. If the 1000 people will be new to you, over and above what you would have attracted using your everyday methods and spending your basic budgets, and if you are allowed to operate the 'Gap Principle', then you might go ahead on a gamble of this magnitude. It is a gamble because you do not know that 1000 people will respond; the 1 per cent response rate that direct mail experts often predict is only a statistic (and one based upon the sales of items of far more general appeal than any of the art forms) and you may be the unlucky one to attract a 0.01 per cent response. So much depends on what you put in those envelopes and where you deliver them.

Contrast this with a direct mail campaign aimed at only 1000 known, regular customers. Your outlay might be as low as £1000 (origination costs will now represent a much higher proportion of your expenditure). If 500 respond with orders of £50 average value, you have £25,000 and each £ of income has cost you 4p. Of course, this too is a gamble. You do not know that 500 people will respond but because you have already successfully sold to them and given that there has been no major artistic disaster that might have made your customers wish they had not bought, the odds are very much more in your favour.

I should add that this substantial difference in response rate is more than adequately borne out by the experience of many arts organisations in recent years. With my own Philharmonia campaigns I have found it possible to produce very large returns indeed from the list of previous subscribers, people who will spend on average £65 or more in response to a mailing that has cost a relatively small sum to mount. In contrast, the cost of gaining a new customer is so high that only the belief (supported by evidence) that once 'caught' a significant proportion will buy again, can justify the risk and subsequent cost. Indeed, I have seen several cases in the arts world where each £1 of income from new customers has cost £1 and even more but it has been justified by the belief that next time it will cost only pennies to sell to them.

You cannot sustain and expand an audience simply by selling to existing customers. You can, of course, sell them more, which is the basis of subscription, but there are limits and your list of customers is constantly subject to what Danny Newman terms, 'transiency and mortality'. Your list is always getting smaller so you must add new customers to it.

The strategy, then, is to assemble a substantial mailing list of known purchasers with whom you communicate at a personal level. You sell as

much as you can to these people with every mailing. Another argument in favour of subscription is that it makes a sale worth having. If the 500 customers in the former example had each only bought £2 worth of tickets the resultant £1000 would just have paid for the cost of the mailing; you would have spent £1 to get £1 and then you would have had to do it all over again, straightaway, for the next show.

Building the list will tax your ingenuity because for most arts events, customers are used to buying anonymously, experiencing the show anonymously and then leaving anonymously. There was never a stronger argument for changing box-office staff into a sales team (see Chapter Seven: Selling The Arts). Most box-office staff find it hard to concentrate on gathering in names and addresses of customers. A sales team would find it second nature. This may sound glib. Any group of people under pressure to take money and sell tickets is likely to err in this respect but if the staff numbers are adequate to the task and the task has been defined as including the gathering in of names then they can do it if they believe that it is part of their job. It is a matter of attitude and training and the understanding at senior management level of the real importance of building the list.

The great advantage of encouraging customers to buy by post or telephone, which are by now (it has not always been so) the standard methods of purchase in direct mail, is that names and addresses are provided automatically. Even if a customer comes to the box-office as a result of receiving a mailed piece of advertising/sales material, it is quite natural to ask for the application form to be completed there and then. Then you have them.

Adding to the list, attracting new customers is, in my experience, extraordinarily difficult and risky in financial terms. Direct mail on the big scale, that is in numbers in the order of 50,000 or 100,000 or more, is one of the methods that can be used. The development of the 'ACORN' market segmentation system (ACORN—A Classification Of Residential Neighbourhoods) is an attempt to reduce the random element. Its underlying thesis is that there will be a relatively high correlation between the buying patterns of people and the type of neighbourhoods in which they live; this will relate to the purchase of items such as cars, household goods, clothing, holidays—and the arts. These areas can be determined by analysis of existing mailing lists of known purchasers. The system can produce the postal codes within these areas and so it is possible to concentrate a direct mail campaign upon those that are most likely to yield a higher response. (A comprehensive description of the system is to be found in the *TMA Marketing Manual* Volume 2.)

The ACORN system is probably the most sophisticated basis for a mass direct mail campaign and we can see in it the logical development of many of the rule-of-thumb approaches used in the arts world hitherto. The

most elementary is to say, 'distribute these in the best parts of town'. Another is to take the envelopes prepared for a mailing to known customers and to put them in piles according to address areas; one then distributes the mass mailing to the areas where the piles are highest.

I cannot disagree with the logic of ACORN and similar, if cruder, systems, but the cost and risk factors disturb me to the point where I am extremely reluctant to commit the funds of my clients to them. Direct mail to very large numbers of people whose only connection with the arts lies in the fact that they live in the same areas as other people who attend arts events, is but one method of dealing with the sparrow and shotgun problem. The medium appeals to me because of its capacity to carry potent advertising/sales packages, with relatively small limitation on size, weight, colour, number of items, and so on but I believe there is another option, far more restrictive upon the advertising/sales message, but if used with skill, capable of reaching the target market, persuading it to want to buy and then to go on to buy.

Nevertheless, the techniques of direct mail should be studied because often it is the only way to make contact with new people. (The *TMA Marketing Manual* Volume 1, has a section devoted to it.) The commercial practioners have developed the methods extensively and have been generous in their willingness to share them with the arts community. What I fear most, and it is based on direct observation, is that arts marketers will hail the medium as the new saviour and will adopt it without reservation and, perhaps, without the necessary skills just as, in 1980 and after, the idea of subscription was pounced upon as the new miracle formula which would guarantee instant success even if you were not particularly well experienced in basic marketing. The expert thus describes one direct mail campaign involving an envelope with a sales message printed on the outside, a personalised sales letter printed in two colours, running over four sides (with a PS message because 'that's what people read first'), a full colour printed brochure and a Freepost envelope. The arts marketer then rushes to do the same, forgetting that what has been described may already have become a cliché and the people he is trying to seek out with the mass mailing are probably more sensitive to hackneyed language and style than almost any other sector.

To sum up. The success of direct mail will depend largely on the potential of the list of people to whom the mailing is addressed. It will also depend upon the offer that is being made and how persuasively it is expressed. If the list is of people known to be recent customers for the product, the response rate could be good with a high ratio of income to cost. The need for high income as well as good numerical response makes it advisable to create packages of things to sell so that one purchase covers many tickets. When the list is more general the numbers of people to be

contacted in order to produce a satisfactory response must be far higher, usually in the order of a hundred or more times that of the first kind of list (which is sometimes known as the 'hot' list). There is rarely, if ever, a better way of advertising and selling than by direct mail to a 'hot' list. If the more general mailing is envisaged it should be weighed against other alternatives, amongst which is what is known as direct response advertising.

Direct Response Newspaper/Magazine Advertising

The use of newspapers and magazines to tell people about entertainment and arts events is as old as the media themselves. In a situation where there is a healthy demand for a product, the provision of basic information such as its title, where it is, when it is and how much it is, may well be enough to produce queues at the box office. The cinema, in its earlier heyday, offers a good example of this. Pop music events, some commercial theatre, music events involving star names and popular programmes, will also be able to generate enough interest to add to the existing level of favourable awareness to make a sufficient number of people want to attend so much that they will voluntarily overcome the usual obstacles.

This book, with its concentration upon the rather more difficult marketing problems to be found in the subsidised sector, cannot encourage the assumption that the seller's market exists. If it does from time to time that is splendid, but to base a marketing approach upon it would be naïve. So, an advertising campaign which makes the assumption that people need only to be given the basic information for them to rush to the box-office is (or should be) rare. It is possible, through the use of intensive short term public relations techniques, to create a tremendous sense of excitement about an event (that is, to put the 'favourable awareness' into people's minds like an injection) so that the complementary advertising can be less potent and less sales orientated. This kind of public relations (see Chapter Sixteen) is, however, a very uncertain business because it depends on the co-operation of journalists and radio/television producers; I should always prefer to back advertising where I can control the outflow of information.

Newspaper advertisements, which do not provide an immediate path to purchase, must be far less effective than those that do; just like leaflets which devote most of their space to the persuasive advertising message and then say, 'Tickets available from the box-office'.

The use of the medium in this way, that is, with the means of purchase integrated into the message and given due emphasis, is called 'direct response advertising'. The method of response may be by post or by telephone. For those who choose to book in person, the box-office is still there waiting to receive them, and so its opening hours should be included

as well. A more detailed coverage of this can be found in Chapter Seven: Selling the Arts.

The main drawback of direct response newspaper advertising is that much more space is required in order to carry the advertising message and the means of purchase, which is usually a coupon to be completed and returned. More space means more cost. Newspapers, in the main, only permit black and white advertisements and where the full colour facility exists, it is usually very expensive. If we contrast this medium with direct mail carrying highly potent advertising/sales material in the form of multi-coloured brochures, sales letters, and pre-paid or Freepost envelopes, it comes off very much as second best. If we examine the cost in relation to the number of people reached, however, it becomes a more attractive medium.

In Chapter Six: The Market, I offered some observations on the readership of the 'quality' Sunday papers, saying that the *Sunday Times*, *Observer* and *Sunday Telegraph*, with a combined circulation of some 3 million, all had a substantial amount of arts coverage. I concluded from this that the readers of these papers were obviously not repelled by this coverage. We might also assume that some of the readers were actually very interested in the arts features. One could even go so far as to say that if anyone was seriously interested, or even interested just a little, they would probably read one or more of these papers. Thus, unlike the readership of, say, an evening paper in a provincial city, some rough conclusions can be drawn about those who read these three Sunday papers, that is, quite a lot of them will be Attenders and Intenders. (Of course, these well disposed folk read other papers, daily papers, as well and the same argument obviously applies.) In terms of targets, therefore, these newspapers will enable us to communicate with a broad mass of people amongst whom there are likely to be potential customers. Disregarding cost for a moment, these media appear to offer serious competition to the direct mail medium, whether the distribution is based on an ACORN analysis or not.

Over the past three years, the *Sunday Times* and *Observer* have offered regional circulations in their colour magazines. This means that although the bulk of the magazine is the same nationally, there are advertising sections that can vary according to the different regions. These editions cover the London and South East area, the South, Midlands, Lancashire, Yorkshire, East of England, Wales and the West, North East, South West and Scotland. To date, the *Sunday Telegraph* does not offer regional editions.

The *Radio Times* and *TV Times*, both of which have readerships that might be assumed to include our targets (the *Radio Times* more than *TV Times* because of the general character of BBC programmes and the inclusion of radio programme information, including Radio 3) both

publish regional editions. *Radio Times* has 12 different editions, *TV Times* has 13.

It is interesting to look at some examples of the regional circulations of, say, the *Sunday Times* and *Observer* and to see what their advertising rates are for a single page mono (black and white). Circulation figures are approximate and based on telephone enquiries to the advertising departments of the papers. Rates are as at August 1983.

SUNDAY TIMES

Region	Circulation	Cost per page (mono)
London/SE	510,000	£3900
Midlands	185,000	£2255
Lancs	130,000	£1890
Yorks	93,000	£1790
Scotland	99,000	£1660

OBSERVER

Region	Circulation	Cost per page (mono)
London	300,000	£2260
Midlands	113,000	£1130
Lancs	84,000	£ 960
Yorks	60,000	£ 775
Scotland	65,000	£ 860

So, if our wish is to communicate with a large number of people in London and the South East which is more likely to contain our target market than the same number chosen at random, it would cost us £3900 to put one page of our information before roughly half a million of them (via the *Sunday Times*). The page size is fairly large, 221mm x 273mm, which gives us quite a lot of space to work in. It does not provide the freedom of, say, an A2 sheet of paper, printed on both sides, folded into a brochure, but it is adequate for many situations.

Within such a page area it is quite possible to display details of up to six events and to do it in such a way that each event is described attractively and comprehensively and for the whole collection to be seen as a highly desirable unit. There is space in which to highlight special sales promotions and to include all the necessary booking information. Expressing what seems to be essentially brochure-type information on one relatively small piece of paper, requires ingenuity but it can be done.

Disregarding the cost of originating the advertisement, which would not be very expensive, if the average value of a purchase was £50, one would

Philharmonia Orchestra: Direct Response Advertisement used in the *Sunday Times Magazine* (London/SE edition).

need 78 responses to cover the cost of the advertisement, or 0.0153 per cent of the readership.

The direct response advertising approach need not be restricted to national newspapers. The readership of a regional paper will not be so well targeted in terms of its readership but it is read by many thousands. The *Liverpool Echo*, a regional daily, has a circulation of more than 200,000 (that is, more than 200,000 copies are sold—the readership will, of course, be much higher) and charges £2495 for half a page, a size which is considerably larger than the full page of the *Sunday Times Magazine*. The *Gravesend and Dartford Reporter*, a weekly, has a circulation of 25,560 and charges £676 a page. (July–December 1982 figures). Both papers will put an advertising/sales message before a very high percentage of their respective communities.

A word about advertising rates. If you are going to try direct response advertising for the first time and have chosen the newspaper or magazine, remember that the asking price (that which appears on the rate-card) is not necessarily what you have to pay. Rates are frequently negotiable but reductions will not be offered unless you make it very clear that you are looking for a good price. Advertising salespeople are there to sell and if they have to offer a discount to sell, they will—just like you.

Be careful about other ways of using this kind of advertising. Some people find that they just cannot fit into a newspaper advertisement all they must say about their events; this is particularly true of subscription schemes. An option that seems to make sense is to produce a really excellent piece of advertising/sales material, which is intended first for the Attenders, and then to advertise this brochure in the newspaper. The response, then, is to telephone or write, for the brochure. It appears to work in the travel business but I have never known it to work in the arts. I have tried it and I have seen other people try it but, no matter how well the story is told, and how easy it is to respond, those unidentified Attenders and the floating Intenders, do not get sufficiently animated by the thought of a brochure to do anything about getting a copy.

Where complexity is the problem—too much to tell and too little space—it is better to choose something easier to describe and sell. The *Sunday Times Magazine* advertisement for the Philharmonia Orchestra, illustrated in this chapter, covers just three concerts and does not mention subscription at all. The concerts are part of a larger season all of which was covered by a brochure which was mailed to the Orchestra's own subscribers and to which the response was very good. The advertisement is a distillation of the brochure. The product is simpler, the price range less (as we had already sold most of the more expensive seats, there was no point in advertising them). It is easier to communicate and so it sells better. I must add that this approach was developed over a number of campaigns at the

beginning of which the newspaper advertising carried all the goods we had in the store. As time went by we found that the response to our advertisements (which were intended to bring in new customers) was diminishing. The 'simplified' approach was developed as a reaction to falling sales and the belief that if we were to attract the Intenders we should aim the message more obviously at them. Hence the 'Bizet Tonight?' headline and the very simple style.

Sometimes I think of the business of attracting new customers and then holding on to them as being rather like stocking a fishpond. With every campaign one tries to find new customers and once caught they go into the fishpond where they swim around until you want to catch them again. They are so easy to catch once they are there that it is worth a lot of effort and financial risk to go out fishing in open waters, time and time again, even if sometimes the returns are small. One is adding to the stock all the time. If only they would breed!

Inserts

An interesting way of overcoming the space and colour limitation imposed by Direct Response advertising is to use the newspaper/magazine medium simply as a vehicle to carry your own sales brochure; this way you get the best of both worlds. Most media will accept 'inserts', as they are known, and the rates can be relatively low. Where the circulation is very high, the cost of the additional printing can become a prohibitively high factor; for example, to run a brochure insert in the Midland edition of the *Observer Colour Magazine* would require an extra 113,000 copies to be printed and the cost of this would probably exceed the cost of one mono page several times. However, these media will often accept fewer inserts than their whole circulation and so it is often possible to use them. Another useful fact is that when a publication does not print regional editions, and most do not, it will often accept inserts on a regional basis. *Punch* magazine, for example, publishes nationally but will accept inserts in its London and South East England distribution; it claims to sell 21,000 copies in this region and charges £22 per 1000 inserts (August 1983). Thus, for £462 plus the cost of printing an extra 21,000 sales brochures, one can put the sales message before a group of people that might well contain a higher than average distribution of Attenders and Intenders.

This approach was used by the Old Vic theatre company in its first subscription drive in 1980. Its brochure was included in part of the London circulation of the *Observer Colour Magazine* and the results were said to be very good indeed.

The Advertising/Sales Brochure

There must be many readers who have reached this part of the chapter horrified by the sums of money mentioned and the scale of the circulation figures of newspapers and direct mail campaigns. Of course, these figures are large by the standards of most arts organisations but this does not mean that the principles are any different or that one should dismiss the ideas. What is important is how one chooses and uses media. My essential point has been that the identification of a group of known customers is vital because, whatever the scale of the operation, these people will buy more consistently than any other group and they will be cheaper to contact. Adding to this group need not involve mass direct mail operations or direct response advertising.

I also want to emphasise the importance of the target market in any media choice. Arts organisations are still advertising diffusely, speaking to everyone but communicating with few. One can choose media that are in themselves highly targeted (such as direct mail to a hot list) or one can use more generally distributed media that are targeted in terms of the message they carry and the language they use, where wastage is anticipated and planned for (such as direct mail to people who live in a certain area). There must be a target and there must be a planned way of reaching it.

The small organisation will produce its sales brochure for distribution to its own hot list. It may be modest in its appearance but it will tell its story and it will be aimed at those who know something about the art form. Growth in audiences will depend on how imaginative the organisation can be in putting that sales brochure into the hands of the right people. We know that it is almost impossible to capture the names and addresses of all customers so concentrate on the future performances. The sales brochure must be there, well displayed, passed out to those who enter, present on the seat when they enter, inserted in the programme, announced during intervals, offered again as they leave. The sales brochure should be passed over with tickets bought for the next performance. It should be on the tables when people look in for a cup of coffee. Wherever there are customers there should be sales brochures.

In Appendix A: Subscription-Based Marketing, I give an example of a special effort (the 'sales party') to distribute sales brochures and, at the same time, to provide an atmosphere in which sales are most likely to occur. The bringing together of known customers and their friends in a social context is an excellent, low cost, way of using the sales brochure medium in a well targeted way.

Posters

For organisations that have their own premises such as art galleries, cinemas, concert halls and theatres, posters provide an excellent way of creating a high level of awareness of a forthcoming event. The medium is large and is a perfect canvas for conveying the U.S.P. in a colourful, exciting way. So good a canvas is it that it can become an art form in itself and its real function overlooked as the designer goes to town on producing something that is more for him than for us and our customers.

The main disadvantage of a poster is that it does not provide an opportunity to buy now. It is also a less personal form of contact. The piece of paper in the hand, whether it is a brochure or a magazine advertisement, is in one-to-one contact and is read in a very different way. The impact of a poster can be improved by its location—in a theatre foyer or outside a concert hall will be far better than on a bus shelter—but the medium is intrinsically incapable of conveying detailed information (it can carry it but it cannot communicate it).

But, a poster is a marvellous way of shouting a brief and exciting message. Its colour, use of large type, brilliantly clear and vivid illustration, can make a great contribution to an advertising campaign. Printing costs are usually tolerable because quantities are relatively low. If you have good places to display them, posters should be used to complement the other media used in the campaign. Rarely, if ever (perhaps if one is in a real seller's market) should a campaign be based upon posters alone.

Radio

Commercial radio is a medium very similar to the poster in terms of its ability to convey a brief message very strikingly but without offering the means to buy immediately. Radio advertising is usually heard in the home or the car. In the home, where there is usually a telephone nearby, it is possible to make a telephone enquiry or booking; the radio advertisement offers an improvement on the poster in this respect. A radio advertisement, like a poster or like any other form of advertising, must always give the customer something to do, and the telephone is the obvious method for response. An address for postal response is very much second best with a medium like this where the message lasts for only a few seconds and then vanishes into the ether.

Again, like the poster, radio can be a very good complement to other media and particularly so where the event lasts for some time, such as an exhibition, or a fair. Then the immediate message is for people to get up and go now. 'There is no need to buy a ticket; just go now.' For future events, where ticket purchase in advance is needed, it may be possible to keep a

box-office open over the period of a radio campaign so that the message is, 'The box-office is open now so go down there and book your seat today.' Obviously this can only work cost effectively within a fairly small locality where the trip to the box-office is not too far.

For larger campaigns, where the budgets permit it, a central telephone booking service such as that operated by the company Teledata in London, is a way of overcoming one's own staffing problems. There is one number (in this case 01–200 0200) which through heavy exposure on radio and television has become very well known. Behind the number there is a large staff which is briefed as to the event, ticket information, and so on. Bookings can be made using credit cards.

Commercial radio advertising is rather like advertising in a newspaper where there is no particular editorial bias towards the arts or your art form in particular. People are not usually listening because they want to hear classical music or serious theatre or exhibition reviews. There may be some arts coverage but it will tend to be so small that it will be heard more by accident than design. A commercial radio advertisement for a concert located in the middle of a 'phone-in' programme on community policing is not likely to be heard by too many potential customers. How good it would be if the such advertisements could be heard during the interval of a BBC Radio 3 classical music broadcast!

In terms of its intrinsic qualities, radio is a totally different medium from any other. With only sound to work with, and sound that lasts for a very short period at that, it can only use the spoken word, music and sound effects. The spoken word, without accompanying visuals, has its own 'typography' in that it can use volume, accents, voice quality, inflection and changes of pitch, but it is still a strictly limited medium and can rarely do more for an arts event than contribute to an overall level of awareness.

Television

As a device for communication, television fires on all six cylinders offering moving images, colour, music, the written and spoken word and duration. It can thus speak in almost any language and can project the most persuasive messages. Like radio it can speak to the millions amongst whom there are the few that will have some interest in what we are talking about.

Also like radio it cannot provide the means of purchase beyond giving a telephone number or an address—but there are developments afoot that may make direct purchase in the home, via a small keyboard and using credit systems, possible within a short time.

No medium makes the arts organisation more aware of its lowly place in the ranks of advertisers than television because, above all other media, it is really expensive. Even if advertising time were given free of charge there

are few who could afford the cost of exploiting the medium to the full and justifying the cost of doing that against the target incomes that are normal in our business.

There are occasions when arts events are advertised on television but the medium is never (as far as I am aware) used fully. A static image in colour plus the spoken word, is really no more than a talking poster that may be seen by many but only for a very short period. When compared with the 'real' television commercial—and the comparison *is* made by those who watch a short clutch of advertisements between programme segments—the typical arts advertisement comes off a poor second best.

Television companies, from time to time, try to encourage us to advertise and offer special rates. When considering these proposals, see this kind of exposure as being, like radio and posters, a way of supporting and enhancing a campaign that is using more direct, more sales orientated and hence more cost effective, media. If you have a very large number of tickets to sell and hence a large target income, you may feel inclined to try this medium but do not make it the only string to your bow and watch out for the costs that arise in the production of even the simplest of advertisements.

Forming a Media Schedule

The purchase of media time and space, which includes print, will take up by far the largest amount of your publicity budget and so the choice of media is very important, not only because of what you want to achieve in terms of income but also because of cost. Media are chosen according to:

Selectivity: how accurate the medium is in reaching our target market—the Attenders and Intenders.

Intrinsic Qualities: how well the medium can carry your advertising message and the physical limitations that it imposes.

Sales aspects: whether the medium can provide the purchaser with a fast and easy means of response.

Cost: seen in relation to selectivity. Also, whether the cost is affordable in the light of the target income, no matter how selective the medium may be.

Origination cost: how much it will cost to translate your advertising message into a form that the medium can carry, that is design and artwork charges in the case of advertising/sales brochures and newspaper/ magazine advertising, and other items such as photography and studio/agency charges for radio and television.

The media schedule, the list of media to be employed in a campaign, is compiled with the intention of achieving the maximum income for the minimum expenditure.

CHAPTER THIRTEEN

DESIGN

Working With The Designer

Having made all the basic advertising decisions (what we want to say, to whom we want to say it and the media we are to use to carry our message) we now move into the area of 'media exploitation'—the skills that are involved in the process of communicating our advertising/sales message via the chosen media. Because radio and television so rarely feature in our media schedules this chapter on design (and that which follows on making sales material and copywriting) concentrate on the printed media. Unlike most of the subjects covered in this book, design as such need not be considered in specific relation to the arts and, as it is something well covered by other books, my treatment of it will be from the point of view of the user of design and the services of designers and printers rather than as a how-to-do-it guide. For those who want to know more about practical design I recommend David Plumb's excellent *Design and Print Production Workbook* obtainable from Workbook Publications, Avoca, Off Green Lane, Ockham, Surrey GU23 6PQ, England, price £4.75 post inclusive (1984 price).

Design, apart from the making of the product and certain aspects of financial management, is where we become involved with other professional people because, as marketers, we usually have neither the training, nor time, to carry out the creative and physical realisation of what is when we start, an idea in our minds. It is a carefully worked out idea, however, and as it was conceived it was measured up against our idea of the target market, an assessment was made as to how aware the market was of what we are trying to sell, the media we were planning to use were taken into account and some thought was given to the 'language' to be used—it is our Unique Selling Proposition. So, if we have done our job correctly, we know a lot about how we want our advertisement to look. The problem is then one of communicating how we want our advertisement to look to a professional designer who may have designed thousands of similar advertisements but has never before designed this one. (I use the word 'advertisement' to mean any piece of printed paper that carries an advertising message; it can be a newspaper advertisement, a poster or a brochure.)

On the whole, designers are very used to dealing with clients who do not know what they want and they frequently become used to making decisions which are really the responsibility of their clients. Their job, after all, is to deliver the goods quickly and if the client seems uncertain they will usually come up with suggestions, but these may not always be the best from the client's point of view. To get the best from a designer you must know what you want your advertisement to achieve and so you must have done all the thinking that leads up to deciding on the U.S.P. You then have the problem of communicating what is in your head to the designer so that he will know what you want; this is done by means of a *design brief.*

The Design Brief

There is always a certain amount of basic information that a designer should be given and this is best done in writing. He will need to know:

What the medium is: newspaper advertisement, poster or leaflet/brochure.

What printing method will be used and what technical specifications must be adhered to—you should specify how many colours are to be used and the size of the finished job, for example.

The production time scale as it affects the designer.

How you want him to proceed—that is, direct into finished artwork (which you would do only if you were in a hurry) or to provide a rough (or roughs) for your approval before he delivers the finished job.

You should also specify when and how you would like a costing on the job; do you want a quick telephone call with a rough idea of his price or do you want it in writing? Putting all this information in writing avoids the possibility of misunderstanding later on when you may both be working under pressure.

Now you have to communicate to your designer your U.S.P. and an overall impression of how you see the advertisement. I find the best way is to write most of the copy and then to sketch out how the advertisement might look. If it is a brochure I work out how it is to be folded and what is to go on each section. I choose illustrations that help me to project the unique view of the product. I locate the illustrations on the page and mark in the main copy areas, drawing in the words and suggesting size and even typeface on occasions. If I do not have suitable illustrations I draw them, albeit badly. If colour is involved I use coloured felt tip pens. The final result looks very rough but it is a very effective way of communicating my wishes to my designer.

An inexperienced designer, or an arrogant one, might think that I, a mere client, have gone too far in daring to venture into the designer's

territory but what I have sketched out is only a way of showing what I want the design to achieve. With my basic sketch to work on, the good designer will interpret my crude drawings and layouts and bring his own specialist skills and knowledge to bear on them. I may have sketched words one inch high but his knowledge of typography will enable him to choose a typeface that will achieve a similar effect using letters half an inch high. I may have chosen the colours blue and orange to suggest an effect; he may choose brown and red to achieve the effect more dramatically. I may have sketched in a picture of an artist within a rectangular border; the designer might take the same picture and make it fill the whole space with type running across it. The designer might well study my roughs, read the copy and come up with a totally different approach that will do a far better job. He might also conclude that my sketched brief offers a good solution and will use it as the basis for his work.

The essence of what I do is to combine my contribution to the design process with creating the copy and by doing the two jobs together I arrive at a very effective tool of communication. As the work proceeds my original copy is modified and improved so that through words and design conceived together I am able to create a language that will be meaningful to my market. It takes a long time to prepare the design brief if it is done in this way but it is worth every minute. To give an idea of the time involved, a major subscription brochure might take a couple of days, or even more, for a really comprehensive brief to be prepared during which time perhaps five or six versions are tried out.

When my 'rough' is completed it tells the designer about the idea in my head and usually offers a workable solution to the design problem. If the job is a brochure which involves folding, the folding is there to be examined. With the rough come any photographs and illustrations that I want used or that might be useful to the designer. The copy comes too, all typed and coded so that each copy area on the rough is clearly related to sections of the typed version.

Ideally, I like to present the rough and the copy to the designer in person so that I can explain and answer questions but often this proves to be impossible. In order to work with designers I know and trust (and can afford) I have often had to work by post and telephone alone and that is perhaps why I now present my ideas so fully; the rough has to communicate by itself in many cases. If this 'working from afar' seems strange, the first seven Philharmonia subscription campaign brochures were designed in this way. Indeed, five of them were designed in this way before I ever met the designer in person!

Keep copies of everything you send, or give, to your designer. You will need to refer to your brief when queries arise or, perish the thought, your original become lost in the post. These days I never entrust work to the post

without sending it by recorded delivery. In the past five years I have only once failed to make a copy of a brief (a complex subscription brochure that had taken me all weekend to prepare) and that, in strict observance of Murphy's Law, was lost in the post forever.

The Designer's Work

The next step is for the designer to translate the rough into a 'proper' design. Although this is not your job you should know the basic areas that a designer has to consider because it will help you provide good design briefs and to be understanding when difficulties arise. The designer works under these headings:

Lay-out: the overall arrangement of words and illustrations within the format (and folding sequence if appropriate) you have chosen. It involves deciding how big illustrations and type areas are to be, what proportions they are to have and where they are to be located.

Illustration: the designer will consider what illustrative material is needed to complement the words. If the copy is weak, as, for example, in the case of, say, a play title which must be used yet tells people very little about the play, then the illustrative aspects will be very important and will probably dominate. If the copy is strong, such as the name of a famous artist or a really startling headline, then the illustration may take second place. The designer will decide how the illustrations should be treated in the printing process, whether they will appear as line images or half-tones. If you have not provided the right kind of illustrations it is the designer's job either to find them or to make them, or to go back to you and ask you to provide them.

Typography: this covers all aspects of the treatment of words in print and it is expert's territory; the non-professional should keep well away! The designer must take the major copy, the headline, or slogan, or title and subtitle, if any, which are given to him as words sketched out on a rough and typed on paper, and present them visually so that when printed they do justice to their meaning and intent. The size of type is one consideration, but the shapes, heights, and widths of letters must all be taken into account. There are hundreds of different typefaces, each with its own characteristics and visual implications. Some have very obvious characteristics; they can be frivolous, romantic, harsh, business-like, mysterious, foreign, gentle and so on. These printed words must relate to the illustration in a variety of subtle ways so that they are perceived together and together help make the sales point of the advertisement.

The words that provide additional information, to explain and expand on the U.S.P. and to tell people how to buy what you are advertising, have

to be fitted into the layout so that first they can be read easily, and secondly, they fit into the overall plan of the advertisement. Here the designer must choose suitable typefaces (the range of typefaces for this kind of work is relatively small) and sizes of type so that the words fit into the spaces he has planned. With what is usually called 'main copy' there are perhaps only six or seven words to think about, whereas 'body copy' might easily run into a few hundred words, so the problem often resolves itself into the choice of how big the type is to be, how long the lines of type will be and what the space between the lines will be.

Any designer can handle the latter task (known as *copyfitting*)—you can easily learn the basics of it yourself—but do not assume that all designers are good typographers. The creative use of type is probably the area where most designers are weakest—so trust your own judgement and if you do not like the look of some type tell the designer and ask him to think again about it.

Colour: unless you have a highly developed sense of colour this is, like typography, an area to keep well clear of. The designer is used to considering the practical aspect of colour, that is, how clear and easy to perceive it is, together with its aesthetic effect. Tell the designer the mood of your advertisement, suggest colours to make your wishes clearer, but let him make the final choice. Because cost is an ever present consideration you will almost certainly tell the designer how many colours you can afford to use in the printing, but after that it is best left to him. Printed colours can be combined through overprinting to produce more colours and only a trained designer with a good knowledge of printing processes can use this to best effect.

Design Into Print

The Rough and the Finished Layout

The designer will take and interpret your brief and will produce his own 'rough', which is the summation of his solution to the problem you have presented. It will be far less 'rough' than yours and will have illustrations sketched in, main copy put in to show the typeface and typesize, areas of body copy outlined and colour treatment shown with coloured pens accompanied by colour samples of the exact colours recommended. If this has your approval he will then produce a 'finished layout', which is a very much more accurate version of the rough; it is so much like the finished printed job that, if your working circumstances make it necessary to seek approval from others, you can show this in the knowledge that no-one who approves this will be disappointed with the final result.

This is the time to have one final thought about the detail of your copy. No money has yet been spent on typesetting and so, if you want to change anything, now is the time to do it.

Artwork

Modern printing of the kind we are most likely to use (offset lithography and screen printing) requires the production of black and white 'artwork' as the source image from which the plate or screen used in the process is made. The transference is made photographically and chemically. The designer's job is to turn his finished layout into artwork that is 'camera ready', that is, no more work has to be done on it before the printer takes over.

Mistakes occur very often at this stage. Typesetting will probably not be handled by the designer himself, he will put this out to a specialist company, giving them the typographical instructions; the company may easily misread the instructions and may set words incorrectly. The designer will check the wording but he may overlook things, so ask to be supplied with photocopies of finished artwork and check them carefully. These photocopies are still sometimes referred to as *proofs*, a term which really means the first trial printing from the letterpress process where originally one printed a copy, checked the results, made corrections in the lettering and then carried on printing. Report the mistakes and accept only artwork that has been fully corrected. Resist the temptation to make other changes at this stage (unless you detect a serious error), as alterations to artwork, other than the designer's or the typesetter's mistakes, will cost you dearly.

The designer's work is finished when he passes over to you the final, finished artwork, complete with full instructions to the printer.

The Printer

It is better to have a direct relationship with a printer and so it is usually preferable to take artwork and instructions from the designer and then give it to your printer yourself. Some designers will offer to handle the commissioning of print for you and if you are very busy it may be worthwhile to off-load the responsibility once in a while, but your best interests lie in forming a good working understanding with the right sort of printer for you.

Printing quality, efficiency and cost vary considerably from printer to printer. This is not necessarily because the industry is divided into very good and very bad printers but because their size and their specialism may not match up with your needs. A company that works on the large scale has heavy overheads and must make good margins to cover costs and show

profit; a small job, such as the typical arts project, may be loaded with a disproportionately large margin from such a company. The same company will probably be very efficient and deliver high quality printing, but you will have to pay for it. A very small company may not be able to afford the best kind of printing machinery and so may take longer to produce what you want; as a result the cost will be higher.

The ideal printing company for the typical arts organisation is big enough to produce print of good quality, quickly, but not so big that it fails to put a value on the business it is getting. If the arts body is valued as a client the printer will think twice when he is costing out a job; he knows that you will be constantly wooed by other printers who will ask to be allowed to put in estimates for jobs and if his price does not compare he will lose the work. One of my personal yardsticks is how much running around the printer expects me to do. If there are many jobs going through my office I do not want to have to keep driving off to the printer (or the designer for that matter) to give instructions, check colour proofs and so on. I like a printer to be big enough to be able to afford someone, preferably a representative with a first rate knowledge of printing, to do the running around for me. I do not like the printer to be so big that I cannot speak directly to the boss whenever I want to.

Visit any printer you think you may place work with. Examine the work that is going through when you visit and see how similar it is to your kind of work. If you do not know much about printing then this is an ideal opportunity to find out; ask your guide to take you through the processes of making negatives and plates, printing, folding, trimming and stitching. He will not object to showing you how things work. Printers never seem to mind explaining the processes; printing is still a craft and printers take pride in their work and like to talk about it. I have never met a printer who was not prepared to find time to explain.

On such a visit you will be able to make your evaluation as to the size and suitability of the print company and also whether you think you can rely on it. One must think not of the normal, everyday project where each step moves forward comfortably but of the time when panic sets in as when some awful mistake has been made (perhaps by you) and the work must be ready by tomorrow. This is when a good relationship with your printer really counts. Such occasions happen quite frequently, not because of stupidity or inexperience, but because the whole business is heavily prone to having things go wrong. It is also worth remembering, therefore, that it is not good policy to argue your printer's prices down and down on every occasion. He wants the work and if you say his price is too high he will try to bring it down but if you always over-negotiate you diminish his margins and he will not be able to tolerate the mistakes that you will inevitably make—you might then have to pay for them yourself.

The Paper

The designer may have offered advice on the choice of paper. I am sure they always do in the wealthier reaches of the commercial advertising world but I generally find that the designers with whom I come in contact know as much about choosing paper as I do, which is very little. Paper is an area where the printer is always well ahead of the game. Buying it, how much to buy and when and what to pay for it, is, I suspect, an arcane area as rich in speculative excitement as the Stock Market. To us who buy the printed product the most important facts about paper are the type of surface and the weight. We are interested in the surface because of how our printed matter will look and we are interested in weight because the 'body' of the work is related to weight (is it flimsy or does it stand up for itself?) and because the costs of both paper and postage are related to weight. Short of going on a training course on the subject of paper and how to choose it, most of us settle for the pragmatic approach of asking the printer to provide samples and picking the one that looks and feels best for the minimum weight (weight is quoted in grammes per square metre or gsm).

If you have a designer who 'knows about paper', I suggest you hold on to him.

The Printing

You now have all the details of the print job. You know the size, the folding sequence, the number of colours to be used, whether it is to be be printed on both sides or one, the quantity, whether you need to see colour proofs or not (for one or two colours only you can often dispense with a proof and with modern printing processes proofing costs money—for full colour work I will always proof the work and will ask for this to be included in the cost quotation), and when and where the work is to be delivered. Your paper has been chosen, by whatever means. You have the artwork and the designer's instructions.

Just as with a designer, it is better to meet the printer face to face with any print job that is to be commissioned. All the technical aspects listed above should be down on paper (with a copy safely filed) and passed over as you explain the job. Show the artwork and the illustrations and the first rough that you made for the designer to illustrate, amongst other things, the folding sequence. You want to know if the printer can meet all your requirements and how much the final bill will be. It is not a good idea to pass over the artwork and illustrations until you have decided to accept the print cost quotation; if you do, the printer may feel that he already has the job (which might encourage him to be a little more generous with his margin than usual) and you may tend to feel that now he has all the material

he might just as well get on with it, even if the price is a little higher than you expected.

The factors that influence cost in printing are:

Size

Print 1 side or 2 sides

Quantity

Number of halftones

Number of colours (full colour is most expensive)

Complexity of instructions (that is, if the plate-making is difficult due, for example, to the need to use tints of colours)

Complexity of folding

Paper type and weight

If you must obtain a cost quotation over the telephone, give the printer the information according to the list above. Where you cannot be specific, such as in the matter of how difficult the plate-making is likely to be, give some idea of whether it is going to be straightforward or not. With paper you might refer to an earlier job where the paper used then would suit you well now. The printer will be able to quote on this basis. If he is shrewd he will give a figure that errs on the side of caution, his way. He will not know exactly until he sees the artwork and the instructions so accept his quotation provisionally if the price strikes you as being about right. Then, when he has received the artwork, telephone him again and ask him to price the work up exactly. It is very unlikely that he will now put the price up but he may bring it down by the safety factor he added on in case the job turned out to be harder than you made it out to be.

When the work is delivered examine it to see that all is as it should be and make sure that you settle the printer's invoice within his normal credit period. What are known as 'terms of business', which mainly means the period within which bills should be paid, are very important to small commercial concerns. A printer who wants to keep your business will be very reluctant to chase you for money but even if he does not say so, he needs the money within his credit period and it is not clever to keep him waiting beyond this. The time may come when you need his co-operation and sticking to the terms of your agreement will make this more likely.

Conclusion

There is a great deal of pleasure to be had out of designing and producing printed material—it is, after all, one of the more obvious creative areas—but there are two main dangers that can arise and can impede the effective operation of the marketing function. The first is that people become carried away with the aesthetics of it all, becoming concerned only with the artistic value of what is being produced. Posters are then produced as works of art unrelated to their primary function which is to communicate a selling message. Pieces of paper measuring 30″ × 20″ can indeed be used for wonderful works of art but if someone else is paying the bill and there are tickets to be sold, then those same pieces of paper are no more than tools of communication, well designed tools of course, but primarily functional. The second danger is that this work is often taken to be all there is to marketing. Marketing is thought to be a synonym of publicity and publicity is taken to mean producing leaflets and posters. As with each part of marketing, the work must be seen in the wider context of a campaign which involves making many decisions in several different areas. Design and print are simply the most visible parts of the marketing process.

CHAPTER FOURTEEN

CREATING SALES MATERIAL

The argument for there to be an emphasis on sales in all advertising campaigns has already been made many times in this book. Let us now look more closely at what is involved in making what we must think of as *sales* material and, in particular, the sales brochure which has become part of the arts marketer's weaponry, particularly since the advent of subscription as a widely accepted marketing method. The subscription brochure is really the quintessence of selling by means of bits of printed paper; it is the perfect example of what should be carried by the medium of direct mail. Learn how to make a good subscription brochure and you will bring a sales emphasis to bear on every other piece of print you produce.

The sales brochure is intended to advertise and to sell and because of this sales orientation (that is, it must make people do something rather than merely think about how nice it would be to do it) it must start its life with a most carefully planned design brief. In general, designers are good at producing advertising material; they can help you to make people want what you are selling by creating striking, appealing visual images and displays of print, but they are weakest at telling a sales story which has, as its punch-line, a purchase. Most of us have had the experience of the aesthetically attractive, highly motivating, leaflet which secretively tucks away the tiny application coupon that allows a two centimetre line for your name, eight centimetres for your address and expects you to write in letters no higher than two millimetres, and, back to the matter of paper, prints the whole upon a surface that repels ink like an arts bureaucrat dealing with criticism. (My apologies to those few exceptional designers who are natural born salesmen and to those arts bureaucrats who accept criticism.)

Let us start by asking a few basic questions:

What is the difference between a sales brochure and an ordinary advertising leaflet?

It is a matter of purpose and emphasis. The old-style leaflet (what used to be, and still is occasionally called, heaven help us, a 'throwaway'!) traditionally set out to tell folk what was about to happen in a way that was, it was hoped, convincing and persuasive. It devoted most of this space to this intention and gave only minimal information on the sales aspects. It was assumed that customers would willingly jump all the obstacles between

wanting to buy and buying. It behaved as though it were in a seller's market. The fact that customers did jump the obstacles was its justification but the problem was that not enough of them did. If the attraction is strong enough then people will go to almost any lengths to secure their tickets but there are not enough 'stars' to go round, certainly not enough to sustain an active cultural life for the whole country for twelve months of the year, year after year. The sales brochure, on the other hand, is totally devoted to making people want to buy and doing it with far more determination and flair than those leaflets and goes on to provide the guidance and means to make the purchase now, easily.

Why are sales brochures so big and so colourful?

They are usually big because they have far more to say, because they often need to repeat information in different ways, and because they have to carry the means of purchase. They must convey the unique selling proposition, they must provide a lot of background information to fill in the gaps inevitably left by the bold advertising message writ large, they must carry information that will add credibility, they must give details of sales promotions and prices as well as the basic sales information plus the booking form. The sales brochure is the canvas on which you tell your sales story and it must be big enough to carry it.

What is a 'sales story'?

The advertising world's traditional nmemonic (and remember that commercial advertising is heavily sales orientated) is AIDA which reminds us of the four steps through which the potential customer must be taken:

Awareness
Interest
Desire
Action

These are the main parts of the sales story. The first necessity is a good, strong, well coloured, illustration and headline to create awareness—that is, to make your target customer pick up the brochure or to delay throwing it away for a few seconds after it has arrived through the letterbox; then information to add interest, more words and pictures to explain and amplify the opening statement, plus outline details of the special steps you have taken to make it easier (and perhaps cheaper) to buy what is on offer. If the potential customer's interest has been aroused he will be prepared to go on reading, taking in more information, and more detailed information,

because now he has begun to feel the first 'tickle' of the desire to buy. He is now looking for information to back up this inclination and to lay at rest any reservations he may have. At this stage he wants facts, not generalities, not hyperbole. The facts may be stated in encouraging language but essentially the potential customer should be told what he us going to get for his money. Then, if you are lucky, he says to himself, 'Right, I'll have that, I'll buy it'. At this point your brochure must show him how to get it with the minimum of inconvenience, offer ways of paying that are simple and, if necessary, provide credit facilities and tell him why he had better not procrastinate. The thrust of this final part of the process is to encourage purchase now.

The psychology of the well-told sales story is interesting. At first the assumption is that the potential customer is unaware and disinterested. Whenever and however the brochure comes within his sphere of perception, the person is doing something else. People do not generally spend their time thinking about buying your tickets, they are thinking about far more important things like whether the bacon has spent enough time under the grill or the Meaning of Life. You have to break into these musings and you have only a visual medium with which to work. At this stage what you put before them must be arresting and simple—like the headlines of a newspaper on a news stand which, if you think about it, faces exactly the same problem. Once you have made the reader focus upon your message you can go into more detail—just as the newspaper does. You hope that you can bring them to the point of wanting what you have to sell. If you can do this you can come straight to the point, you can drop the 'sales talk' and get down to the business of purchase.

Does the AIDA formula always work?

Mostly it doesn't. Think about that full page advertisement in the *Sunday Times Magazine* with a circulation of 510,000 in London and the South East of England and a probable readership of some 1.5 million people. The readers pick up the magazine and start turning the pages. How many fail even to notice the advertisement? Thousands. Tens of thousands. Of those that stop at the page, how many sustain their interest beyond the words 'BIZET TONIGHT?' and the obvious references to classical music? Few, very few. But some have their interest aroused, perhaps by photographs, names, titles of pieces of music, perhaps early on they look at the booking form and the prices strike them as being reasonable, even surprisingly low. (We cannot assume that people always read from the top left-hand corner of a page, along and downwards, going always from left to right.)

What interests them and how interested they become will be governed by what is already in their heads, by their knowledge and their attitudes.

Perhaps they are regular attenders of classical music concerts, perhaps they like classical music but have not been to a concert in years, perhaps they only listen to classical music on the radio or on records, perhaps they have found concert-going to be too expensive latterly and have stopped going. Perhaps they feel that classical music ought to be right for them if they could only get down to listening to it. Perhaps they have been listening to light classical music, arrangements of songs from the shows, to what the recording business calls 'easy listening', and so on, and think of themselves as classical music lovers.

If what they see in the advertisement (and it applies equally to the sales brochure for they are essentially the same thing) relates favourably to their present attitudes, however formed and however rationally or irrationally based, they may be sufficiently interested to look at the concert details, the dates and the prices, and may even feel that first 'tickle' of the desire to buy. They may even pass the advertisement over to a partner and begin to discuss the possibility of going to the concerts.

But mostly, even if they are very interested, they will put down the magazine or the brochure, reach for another slice of toast and forget all about it.

Unlike the typical commercial situation, our products are only available for a certain period of time and we rarely advertise them more than once or twice. People are used to advertisements appearing regularly, being there every Sunday waiting for us to develop a need—or even a whim. In the arts we can rarely make use of that most valuable aspect of advertising, repetition.

But some will stay with the advertisement long enough to decide that they will buy. They will reach agreement with their partner, pick a seating area, even fill out the form—and then decide to make the booking tomorrow or on the evening when they usually pay the household bills. The magazine is thrown away. A heavy bill comes in that rules out further expenditure on entertainment. They realise that they may want to take a holiday around the time of the concerts. There are always many reasons for not doing something.

The process of persuading people to buy is one of steady and considerable loss as thousands fall away at each stage of the AIDA sequence. Those that are left will only number in hundreds, and the low hundreds at that.

Why bother with a structured approach at all?

Even though the odds are always stacked against you, a structured approach, such as AIDA (given good copy and design) will always improve your chances of maximising the response from those that are your

real potential customers. It could, and does, I believe, double or treble the response rate. Even if the final results from a large scale brochure distribution show only 200 buyers, without a planned approach the response might have been only around 80. If the average value of a booking is £25, the income from 80 bookings is £2000, whereas from 200 it is £5000. That £3000 difference is worth working for.

Brochures are often folded in all kinds of clever and complicated ways. Is there any rationale behind this other than the need to make the brochures small enough to fit into envelopes?

Yes, there is—or should be. If we start with, for example, an A2 sized piece of paper as our canvas, then obviously it has to be folded down to a convenient size. The final finished size is determined by the need for it to fit into one of the recognised standard envelope sizes but do not be dictated to by the size of the envelope that your organisation happens to use for its usual daily correspondence; if you want to use a larger envelope then buy a supply of larger envelopes. (This may seem very obvious advice to give but I have seen several cases where the folding of a brochure has been decided wholly on the basis of the envelopes that happened to be in stock at the time.)

The way in which the brochure is folded down to its finished size should assist in the telling of the sales story and can make a very important contribution to the AIDA sequence. Seen from the potential customer's viewpoint the brochure arrives folded and all that can be immediately seen is the front and the back; if what is seen does not then create awareness the brochure will fail amongst all save the really dedicated. The brochure is opened; what is then seen must reinforce the awareness and add interest. If there is then another fold to unfold, what is then seen must build on the interest whilst adding more and more information. When the brochure is finally opened there must then be a full display of all the goods that are in the shop, attractively presented, accompanied by the vital sales information and the booking form.

If you watch someone opening any kind of sales brochure you will see that they almost always go through the opening sequence very quickly so the information you provide in the early stages of the folding sequence must be very easily perceived. Because detail is often missed, do not fear repetition of information; if you are offering a big discount state it several times, you want the reader to know that this offer is only open for a limited period so state the closing date several times. Notice also that the person whose interest and desire has been aroused will then go back to re-read information so you may put some quite detailed, but small, words in the

early stages of the unfolding in the knowledge that they will not be read at first but will be read later on.

When planning a folding sequence there are a few basic guidelines that will assist in the communication of your sales story:

If there is one vertical fold, it should be on the left so the brochure opens like a book. If there are two then assume the left fold will operate before the right.

If there are two horizontal folds then assume that a top fold will operate before a lower fold.

Always try to create a folding sequence that keeps the sales story in front of the reader and does not require him to reverse the paper in order to go through the AIDA sequence. A good brochure has all its sales story on the front and the information on the back, although it may be the first to be seen, is repeated on the inside (that is, the 'front') so that the back of the brochure, once opened, is virtually redundant until it is re-folded. Ingenious folding can take a piece of paper which, of course, has two sides of equal size and shape, and create a 'front' that occupies as much as 90 per cent of the space available on both sides; this can be achieved with only four folds, creates 'working' spaces of practical size and proportions and is capable of being handled by ordinary printer's folding machinery.

As the unfolding proceeds ensure that as the sections of information appear they are the right way up (I have a rogue's gallery of brochures produced by some of our most eminent arts organisation where this fundamental rule is broken). If you are telling a story you do not suddenly reverse the order of the words which is, in terms of the process of communication, what you do when you suddenly turn something upside down.

Use the unfolding to create interest and surprise and so, if you are producing brochures regularly for basically the same group of people, keep ringing the changes, do not adhere to the same folding pattern any more than you would use the same cover design.

Try to use folding sequences that can easily be refolded once the brochure has been read. Experiment with blank paper to see how easy it is to unfold and fold (to your potential customer the unfolding comes first).

When handing over finished artwork to the printer also give him a dummy of the brochure showing the folding sequence exactly, marking on it which way

up the sides are to be printed in relation to each other. Many cases where information appears upside down in the sequence of unfolding are due to printer's error. Your designer can assist by marking the artwork for each side 'top' and 'bottom' so that it does not get turned upside-down by accident. There is also the risk of mis-folding following printing which can totally change the order in which the sales story is read. It is always a good idea to show your proposed folding plan to the printer well in advance so that it can be taken into account in his costing and to ensure that your enthusiasm for this interesting branch of origami does not exceed the capabilities of his folding machinery.

Do not become so fascinated with folding that you forget its purpose which is simply to help you tell the sales story interestingly and to bring the paper down to a convenient size. Make it no more complicated than it needs to be.

Do not blindly copy other organisation's brochures or folding sequences. Start with your sales story and create a fold to help you tell it.

Some examples

I have included here some illustrations of folding sequences I have used over the past year or so.

BROCHURE FOLDING SEQUENCES

The sequence printed at the head of each set of diagrams gives the order and direction of unfolding, e.g. for A the horizontal fold opens first, then the vertical. The coding indicates paper edges and folds (folded and unfolded).

CODE	
PAPER EDGE	————
FOLD - folded	– – – –
FOLD - unfolded	··········

A 1 horizontal fold, 1 vertical fold.

1.

2.

3.

4.

5. BOOKING FORM

B *1 horizontal fold, 1 vertical fold, 1 horizontal fold.*

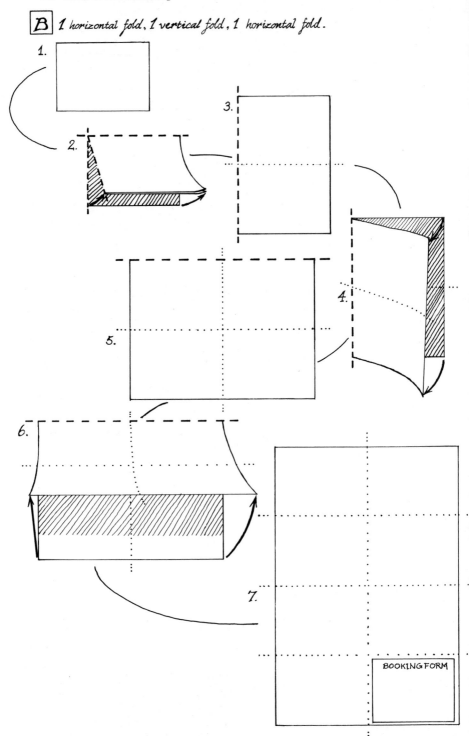

C *1 vertical fold, 2 horizontal folds.*

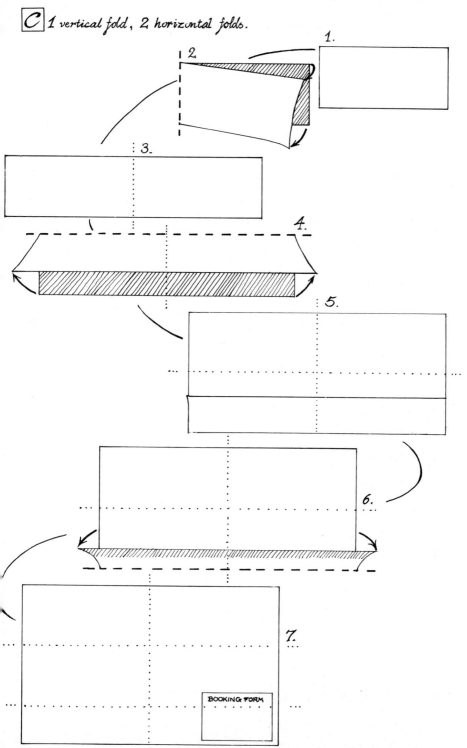

D 2 vertical folds, 1 horizontal fold.

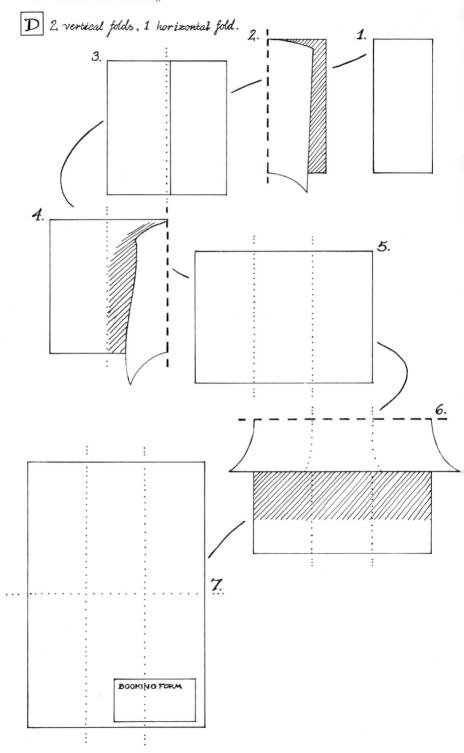

E 2 horizontal folds, 2 vertical folds.

1.

2.

3.

4.

5.

6.

7.

BOOKING FORM

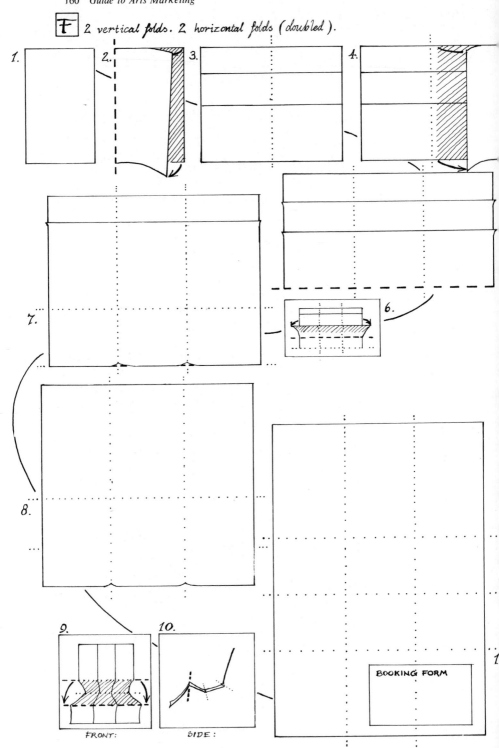

2 vertical folds. 2 horizontal folds (doubled).

FRONT: SIDE:

BOOKING FORM

CHAPTER FIFTEEN

COPYWRITING

Words are partners to design in the make-up of our advertising language. Words used in advertising are called 'copy' and putting them together is called 'copywriting'. In our world, design is the province of professional people called designers but copywriting is something that is almost always done by amateurs—us.

Usually the story goes like this. The designer meets his arts client and spends an hour or so discussing the next campaign. 'Right,' he says, 'I'll have a rough back to you in a week's time. Now, what about the words?' 'Have another cup of tea,' says the client, 'and I'll jot something down for you.'

Ben Duncan, who has contributed a very good piece on copywriting to Volume 1 of the *TMA Marketing Manual*, says that if you can afford a professional copywriter you should get one and goes on to make the point that copywriting is very difficult. He is right on one score, it is very difficult but I am not sure that the money in the professional copywriter's pocket would not be better spent in training the arts publicist to be a good copywriter. It is the copy that helps to communicate the intention of advertising to the designer and is therefore part of the design brief. Communicating with one person, the designer, is hard enough; communicating with designer and copywriter is almost impossible. It is different in commercial advertising where designer and copywriter can work together to produce a combined effort for the approval of a client. Our advertising takes place on the à la carte principle where the person handling advertising must agree the U.S.P. with the organisation, will usually use an independent designer, will very often book media space and will then commission print. From a practical viewpoint it does make far better sense for this person to learn how to use words for advertising purposes.

The first intention in advertising is to persuade, and so copywriting requires an acute sensitivity to the effect that words have on people. Words are invested with shades of meaning that transcend the definitions given in the dictionary; often those meanings, because of fashion or usage, can create a response in the mind of a reader or listener very different from that intended by the author. Copywriting, then, is concerned with selecting words with their effect in mind as well their literal meaning.

In a way all of us are copywriters; we sense the effect of our words as we write and speak. We modify our language to suit our company. When we write to the bank manager we use a different language from that we would use in writing to a close relative; we use a different vocabulary and a different style. With the bank manager we pay more attention to our grammar and we observe the conventions of formality. We use words to convey more than literal meaning, we use them to let people know how we feel and we use them to define what sort of people we are.

Let us look at the example of a letter written in response to a refusal or rejection of some kind. The variety of ways in which the letter may open shows the same variety of real meanings, that is to say, they will result in many different effects upon the reader. This will influence the reader's view of the writer and may so have a bearing on the reader's subsequent actions.

I was sorry to learn of your rejection of my proposal.
I was so sorry to learn of your rejection of my proposal.
I was most upset to learn of your rejection of my proposal.
I was amazed to learn of your rejection of my proposal.
I was quite frankly astounded to learn of your rejection of my proposal.

(It might have been better to say, 'I'm very sorry you couldn't accept my idea on this occasion, maybe we'll have better luck next time.')

All of the media we use in the arts will involve the use of words. Mainly they will be words written to be read but, where radio and television are concerned, they may be words written to be heard. It is important to appreciate the difference. With the printed word we are influenced by the visual aspects as well as the effects on us of the words themselves: the size, shape, arrangement and colour of the words all play their part in our perception. Design, and in particular typography, are to the printed word what voice production is to the spoken word. Also, printed words when they appear on brochures and newspaper advertisements are before our eyes for longer, for as long as we want them to be. The spoken word is an instantaneous medium; we have no control over duration and in place of typography we have the qualities of volume, pace, pitch, inflection, accent and voice quality. Copywriting for the spoken word is bound to be very different from that for the written word.

Most of us, when we write, simply attempt to express ourselves, to say what we want to say. We take into account the reader if there is a known reader but the emphasis is really upon ourselves. We also pay very little attention to the way in which our words appear; apart from developing a style of handwriting we do not develop much in the way of a personal typography. Yet, even at this simple level of letterwriting, which is usually the only form of regular written communication we have, we can change the effect of our words upon a reader. Most of us will remember the surprise

we felt when we first saw something we had written by hand transformed into writing far more dignified and significant by a typewriter. When we then see something produced on a typewriter 'properly' printed in a newspaper or a book, what a metamorphosis! The words stay the same, the effect and hence the real meaning is different. 'If it's in black and white, it must be true', goes the old saying.

These are the first lessons to be learned in copywriting: to focus upon the reader and to be ever-conscious of the effect of words rather than only their literal meaning; always to take into account the medium that is to carry the words and the intrinsic qualities that the medium posseses; to see words as tools that require considerable skill in their use.

The encouraging thing to remember is that most of the time you will be 'speaking' to people whose reactions to your words can quickly be anticipated. Although you do not know them all, you know your Attenders and you know the kind of language they respond to and the language they reject. It is basic to this approach to advertising that in the search for more people you do not depart very far from this language (which has already been defined as the combination of words and design: see Chapter Eleven: Advertising). Whenever we speak to a broad mass of relatively 'unselected' people, that is, people whose attitudes and habits we know little about, the language we use can help us to seek out our Intenders without alienating our Attenders. This means that although copywriting is indeed a difficult skill to acquire we do not have to change our language very much. Only if you make a radical change in your job, and find yourself with a different product and a different community, do you have to learn a new language.

Headlines

When we approach an advertising campaign we make the basic decisions as to what we want to say, to whom we want to say it and the media we are to use to carry our message. Immediately we find ourselves with a blank sheet of paper before us and the need to express what we want to say. Remember, Awareness, Interest, Desire and Action. The first words you write must make people Aware and Interested. These are the big words, the few words—what is called the headline (just like the newspapers), sometimes known as the main copy.

These few words (Ben Duncan correctly says that if you use more than twelve the effect is diminished) can take some writing. When they are there on the page and you know in your heart that these words are just right for your purpose, you and everyone else will wonder what all the fuss was about.

The headline must engage the reader. These words are, together with any major illustrative element, the first things to be seen. You must assume

that the most likely action of your reader (who is not yet even a reader, he is merely looking at the newspaper page or is reluctantly holding a brochure) is to turn the page or to drop the brochure. If you want the looker to become a reader you must engage him quickly. The best way of engaging someone is to give them something to do, some act of participation. The trick lies in the fact that almost everyone but the mentally dormant wants, needs, to understand. It is a compulsion. Present people with words that are not in themselves wholly explicit and they will automatically try to make sense of them. So, your headline may pose a sort of puzzle which engages the attention. Once the attention has been gained there are more words and pictures that, as it were, provide the answer to the puzzle.

In several of my subscription campaigns from 1980 to 1982 I arranged sales promotions which were simple competitions and draws where the prizes were free flights and holidays in the Philippines. The sponsor, Philippine Airlines, asked me to liaise with their advertising agency to produce advertisements that would go on the back of the subscription brochures. The intention of the sales promotions was to accelerate purchase, people who subscribed by a certain date would be eligible for entry. The advertising agency produced a headline that read:

TO WIN THESE PRIZES YOU MUST FLY

Apart from these words, all that was immediately visible was a picture of the liveried nose of a Philippine Airlines Boeing 747. This headline, when perceived in the first second or so, does nothing but engage one's attention but that is enough; you have to read on because something compels you to go on to make sense of it. Once you go on to read the rest of the words, the small words known as the 'body copy', the message has been delivered to you and you are either brought to a state of desire and take the required action (to open up the brochure to find out more about it) or you do not.

You can engage people in many ways. Puns, double meanings, rhymes, alliterative statements, missing words, well known phrases re-arranged, can all have the effect of drawing attention and engaging interest. Here are some more examples drawn from my own campaigns but you will see plenty more if you look at the work of commercial advertisers; when it comes to drawing attention and arousing interest there is no difference between our two worlds beyond the markets and the languages.

The Philharmonia's direct response advertising campaign, already referred to in an earlier chapter, opted for the pun, based on the presence of Bizet's Carmen Suite in the first concert of the series of three that it was selling:

TO WIN THESE PRIZES YOU MUST FLY...

You might be excused from associating the Philippines simply with tropical sun, exotic islands and smiling friendly people. But when you get there you'll discover that its reputation for music and dance is not confined to its rich ethnic eastern tradition. The Manila Metropolis Ballet will dance for you under the stars. A string quartet will entertain you. The Cultural Center of the Philippines has its own symphony orchestra, theatre company and dance group and regularly plays host to great international companies and artists. So Philippine Airlines finds it quite natural to play host to those who admire the Arts.

All those who subscribe on or <u>before 7 July 1980</u> have a chance to win 2 free tickets to Manila on Philippine Airlines brand new 747 Jumbo flying first class with skybeds unique to PAL, enjoying en route the airline's renowned "nouvelle cuisine." A sybaritic experience. There are 2 of these first prizes to be won plus runner-up awards of 5 box sets of Philharmonia recordings.

BIZET TONIGHT?

it asked. It was a pun and a question, both good ways of attracting attention. The sub-text below went on to say and implicitly to explain, TAKE TIME OFF TO CONSIDER THE ATTRACTIONS OF THESE THREE FINE SPRING CONCERTS . . .

The campaign which followed tried a different tack, relying on an apt, slightly altered, quotation from a song that, again, required the reader to read on to make meaning out of it:

SOME ENCHANTED EVENINGS

The body-copy went on for a while with the theme, saying YOU MAY SEE THE MAGNIFICENT PHILHARMONIA ORCHESTRA . . .

My first subscription campaign for the Everyman Theatre, Liverpool, had to sell season tickets for Ken Campbell's production of *The Warp*, an extremely unusual show in ten episodes, with one episode a week over ten weeks. Leaving aside the challenge of trying to persuade people to make a commitment for one evening a week over such a long period, the thrust of the advertising was bizarre and mysterious with a style, in 1981, that owed much to long-gone magazines such as *Oz* and *International Times*. The headline, which appeared on the front of the brochure took a marvellously appropriate quotation from a review of an earlier production written by Michael Coveney of the *Financial Times*:

HURRY—THE WORLD MAY SOON DIVIDE

When the brochure was opened the copy continued . . . INTO THOSE WHO HAVE BEEN THROUGH THE WARP AND THOSE WHO HAVE NOT. The opening words were printed in black, the remaining words AND THOSE WHO HAVE NOT were printed in red which gave them the quality of Valentine Dyall closing one of his early broadcast horror stories.

A subscription campaign I planned for the Palace Theatre in Westcliff, Essex, had as its theme, 'The Best of British Theatre', and used red, white and blue and Union Jacks (it was just after the Falklands War and it seemed like a good idea at the time). The brochure cover was a Union Jack, with the headline in the centre:

AN INVITATION FROM THE PALACE

When my colleagues and I launched the Danny Newman seminars, in January 1980, we produced a sales brochure to sell seminar places. On the cover there was a picture of Danny and the headline read:

THIS MAN WANTS YOUR JOB

Inside the text continued, TO BE A SCINTILLATING, SATISFYING SUCCESS. This was not, strictly speaking, using the language of the market (senior arts administrators in the UK) but it was true to the product and was a gentle pastiche of Danny's own style. We expected it to polarise people; those who were offended by the Yankee language and did not appreciate the humour would never had bought tickets anyway; those who liked it had their interest in the American subscription method reinforced.

All of these examples use words to explain the puzzle but the answer can be given wholly or in part by a picture, or the puzzle may lie in a picture which then has words to provide the answer. In late summer 1983 I created an advertisement for a campaign on behalf of Boots, the pharmaceutical company. Dominating the space was a picture of Julian Lloyd Webber, the eminent cellist. He has clearly just stopped playing cello and is holding his finger to his lips. SSH! he is saying. The explanation comes, not too explicitly, in the statement **JULIAN LLOYD WEBBER SUPPORTS THE MELOIDS CAMPAIGN FOR QUIETER AUDIENCES.** Just under this is the 'pack shot', the tin of Meloids, the little lozenges that stop people coughing. All is revealed.

Years ago the Walker Art Gallery in Liverpool produced a poster the headline of which was **WHEN DID YOU LAST SEE YOUR WALKER?** Immediately above it (headlines do not have to be at the head) was a reproduction of the famous picture, which is in the gallery, *When did you last see your father?*

An important fact which is common to all these examples is that they all set out to create awareness and interest and do so by giving the reader something to do to make sense of them. They are also well matched, I believe, to the taste of the market they are aiming for, they speak in appropriate languages. Thus they do their job and they do not alienate. One of the temptations in copywriting is to use the first joke or puzzle or pun that comes to mind and to force it unnaturally into the advertisement. (The **BIZET TONIGHT?** headline started its life as **AIMEZ-VOUS BIZET?**) Ideas are always precious to us and it takes time to realise that ideas are ten a penny and most are worth less. So take time, lots of time, when producing copy of this kind and be ruthless with your ideas. Make sure that you are really speaking in the language of your market, like that excellent Walker Art Gallery poster, which achieves a perfect match.

The headline can be a more direct expression of a sales promotion (that is, the U.S.P. can quite easily be a sales promotion) so it might say:

THE MELOIDS CAMPAIGN FOR QUIETER AUDIENCES

JULIAN LLOYD WEBBER SUPPORTS THE
MELOIDS CAMPAIGN FOR QUIETER AUDIENCES

FOR RELIEF OF HUSKY AND TICKLISH THROATS

AVAILABLE FROM ALL LEADING CHEMISTS

SEE SIX PLAYS FOR ONLY £14!

This kind of headline makes a very direct statement which should be of interest to the market and the reader would have to read on to find out more about the offer but, in my view, it does not have the impact or the compulsive quality of the earlier examples. It is, in a sense, too explicit. The reader can all too easily give a 'so what' reaction.

Another problem with the headlines of the **SAVE 30%!/ SAVE £10!/ SUBSCRIBE NOW!** type is that they are already clichés. Since the 'subscription boom' of 1980/81/82 these statements have appeared in so many places, so frequently, that their impact has been lost. Just as folding sequences in sales brochures should be varied, so must this kind of copy—in fact, it is much more important. The great advantage of the first approach to headline writing is that the pressure is always on the copywriter to come up with something fresh. Writing copy is like telling jokes, they must be good and they must be new.

In Chapter Eleven: Advertising, I touched on the language problems imposed by the different art forms. It is extremely hard to write good headline copy for classical music because the whole atmosphere surrounding those who play, promote and regularly attend music is conservative, restrained. Even the Philharmonia Orchestra, which has pioneered all kinds of adventurous marketing methods, could only move into the BIZET TONIGHT? mode on its sixth subscription campaign. Even as I write, the brochure style, for all its colour, is essentially dignified and makes the tacit assumption that those who receive it will want to open and read it. As the brochure becomes more and more a tool for communicating with the very regular Attenders and less of a way of gathering in new customers, this assumption is reasonably well founded. The direct response magazine advertising using the BIZET TONIGHT? style has to work much harder to create awareness and interest because it is dealing with people whose interest must be aroused. The ultimate justification of this approach is that it has worked very well.

Other classical music organisations that do not enjoy large audiences should look hard at their advertising to see to what extent they are inhibited in their language by their view of their known Attenders. Although I said earlier that you should speak in the language of the market I also said that it was possible to move a little way from it without causing alienation. The regular Attenders of the Philharmonia do not, I am sure, turn up their noses when they see advertisements saying SOME ENCHANTED EVENINGS. I might add that this is yet another vindication of the subscription method; the relationship between customer and orchestra is so much closer and warmer that the committed customer is likely to be quite tolerant of attempts by 'his' orchestra to build audiences. The

Philharmonia does, however, take the precaution of timing these advertisements so that they are seen well after the distribution of the brochures and the bulk of the sales have been made.

A regular series of contemporary music provided me with the most inhibiting influence upon copy and design that I have ever experienced. It was attracting a regular audience of around 30 people, supplemented by a few more that came occasionally. Every attempt to use good headline copy was vetoed by my client who related every word I suggested to the likely adverse reaction of his 30 regulars. Without knowing it, those 30 music lovers were effectively stopping any attempt to fill the remaining 170 seats. These concerts were never advertised, therefore, they were merely announced.

Theatre has a greater chance of overcoming these inhibiting barriers, partly because the nature of theatre in general is more suited to lively copy and design and partly because theatre marketing people are becoming very determined to do something about small audiences. In earlier days the title of the play was the only headline and was perhaps backed up by a short sub-text that told people it was a 'rollicking farce' or a 'stark modern drama of our times'. But it is extremely difficult to use the classic commercial advertising headline approach for plays that are advertised one at a time and where the usual media of posters, single sheet leaflets and press display advertisements are used. One can instead use approaches like:

<div align="center">

LESLIE PHILLIPS
IS
'THE MAN MOST LIKELY TO SUCCEED'

</div>

But here the interest is aroused by the name of a star performer and it would not work if Keith Diggle were playing the lead.

Single play advertising will probably always have to rely more upon the visual than on copy. There is no law that demands the use of a copy-based approach on every occasion. But the play's title, and particularly that of new plays, is so critically important—because the title is willy-nilly advertising copy—that it is, I sometimes think, too important to be left to authors. Extracts from play reviews have always been the standby of theatres and they are still a most fertile source of copy for advertising. If the theatre says YIPPEE! WOW! HALLELUJAH! the reaction may be 'Well, they would say that wouldn't they?'. If an eminent theatre critic says it, it takes on the character of an endorsement, it has credibility.

Theatre subscription schemes have created much more advertising freedom. They have higher financial targets and thus higher budgets. The media used are direct mail and direct response advertising and so the canvasses are larger. The U.S.P. is no longer an aspect of the play but of *subscription* and all the customer benefits that go with it. The theatre may

then use everything in its advertising arsenal and its copy can range far and wide without fear of alienating existing customers.

The art galleries and museums have more freedom with copy because the choice of title for exhibitions is often left to them. If the publicity officer is aware that in thinking up a title he is thinking up copy, then effective advertising can be the result. Thus an exhibition of portraits of kings and queens of England is called MEET THE FAMILY (the copy being complemented by a montage of portraits making up an amusing family gathering with Queen Victoria at the centre). Several years ago a London art gallery advertised itself with a poster bearing a photograph of its staff looking particularly friendly and welcoming; the headline read WE'LL SHOW YOU THE WORKS. Sad to say, this freedom to use words in this way is not exercised very much and the exhibitions are still mainly given titles that are simply the names of the artists (fine, if you have heard of them), stark descriptions such as RUSSIAN REVOLUTIONARY ARTISTS and EUROPEAN PHOTOGRAPHY or mysterious titles such as PAPER AS IMAGE.

Body Copy

Once the headline and the main elements of design have done their work in attracting and engaging the attention of the reader the advertisement must go on to provide all the information on the product, sales promotions, prices and any other categories such as press quotations and endorsements (to add credibility), sales points such as lists of customer benefits, the instructions necessary to facilitate purchase and the booking form. This information falls into the two categories of that which is intended to make the customer want to buy and that which is concerned with the action of buying. All of this is known as 'body copy'.

Writing good body copy depends on following some simple guidelines:

Keep your sales story firmly in mind as you write. Remind yourself regularly of exactly what you are trying to communicate.

Do not write more than is necessary. Keep every section of information simple and economic.

Maintain consistency in language and style throughout the item.

Although you are probably not a typographer think about typography as you write, particularly in terms of emphasis. Write the important things in big letters and give some idea of spacing to guide the designer.

If the copy is intended to help build the buying desire, be positive and enthusiastic. You can create lots of minor headlines within the advertisement. Build your sales story with these headlines as you outline all the reasons why this is too good an opportunity to miss.

If you want to describe your product but do not know enough about it, obtain the information from an expert but do the writing yourself.

Remember that a sale delayed is almost always a sale lost. There will be a date after which tickets cannot be bought; make sure this date is kept well to the fore.

Do not be frightened of repeating essential information, particularly in sales brochures with complicated folds. If you have a good sales promotion to offer, then refer to it several times—people do not read brochures as carefully as you would like them to.

If the information deals with a complicated buying procedure which, for example, requires careful study of seating areas, prices, discounts and dates, get other people to read it through to make sure it has no ambiguities.

Use tables and diagrams to explain if you find your words are becoming complicated.

If you are including a booking form, make sure it is totally clear and contains space for all the information needed by you and the box-office staff. Ask for home and business telephone numbers—you may need them for your next campaign.

As you write each section, think about the kind of illustration that might be used and include your thoughts in the design brief.

Give good emphasis to your telephone booking service and its number(s). Encourage people to use the telephone—it is faster.

Put your organisation's name and address on the booking form and on the main part of the form so that the customer has a contact point once the booking form has been sent to you. A Freepost address does not enable a customer to locate you personally because it is not a full address; if you also want to encourage personal booking make sure you give the full address as well.

Programmes and artists can change. Put a caveat telling people of this and explaining the conditions under which your tickets are offered.

Do not forget the credits necessary for those whose financial support sustains you. Check with them to make sure the wording is mutually acceptable.

When you have finished put your copy away for at least 24 hours and then read it very carefully. You will probably want to make a lot of changes and will spot many omissions.

If you are satisfied with your copy, sketch it in on the rough you have prepared for your design brief.

Changing Styles

As an independent consultant I can find myself working simultaneously on several, very different, campaigns aimed at different markets, and have to speak a different language or adopt a different style for each. You need the skill most when you decide that you will add a dash of credibility to your advertising through the use of a written endorsement from a famous person or when you ask the artistic director to pen a message of welcome to go in your season's brochure. Most of the time these folk are happy to lend their name but are too busy to get down to the writing and they say, 'You write something suitable and if I agree with it, I'll sign it'. So, for a little while you have to become a different person and adopt a style which is not your own. For practical purposes it is better this way; you can write to a specified length (because you know how much space you can spare) and you can make sure that the essentials are covered. Here are some examples of personal statements that I have written on behalf of other people (I am sure they won't mind these revelations!). You will be able to draw your own conclusions about the target markets in each case and the overall approach used in the rest of the copy.

This is an opening message from the artistic director of the Nash Ensemble, Amelia Freedman, for a subscription brochure:

The Nash Ensemble is very pleased to be giving its Spring Subscription Series in St John's, Smith Square this year. It is a beautiful church with extremely good acoustics and is ideally to our musical needs and your pleasure.

These five concerts have been planned to make up one entire musical experience—we tend to think of the series as being one extended concert with four long intervals! The theme is French music from the 1850s to the 1950s and

this allows us to play music as diverse as that of Saint Saens, Ravel, Debussy, Satie and Milhaud through to works by Messiaen and Boulez. We have added to this a first performance at each concert of works by some of Britain's leading composers of today. It is a sort of musical entente cordiale *which spans time as well as the English Channel.*

With this common theme and development we should prefer a regular audience and that is why we are now placing so much importance on attracting subscribers to the series as a whole. Of course, those who want to come to only two or three of the concerts are very welcome but we should prefer you to come to all of them and hope that the modest inducement of one concert free will assist in your persuasion.

This is a message from Ken Campbell, then artistic director of the Everyman Theatre, Liverpool, which appeared in the theatre's subscription season that followed *The Warp*:

We've got this REALLY AMAZING set of truly, BIZARRE & EXCITING shows that you've really got to see!

The thing is, if you come and see the shows one at a time, it could cost you £12.50 plus all the worry and uncertainty of perhaps not getting what you want when you want it :...

BUT, IF YOU BOOK NOW you get five months of REALLY ELECTRIC THEATRE–any seat in the house any night of the week—for only £8.50! Plus if you buy this lot you get first crack at the Late Night Special 'METAPHYSICS & STRIP'!!

So you get MORE FUN and NO HASSLES for LESS MONEY... And we get you—more often!

(I must be fair and give credit to the Everyman's publicity officer at the time, Cathy Clift, who added a few well chosen words of her own to this fine example of the copywriter's craft!)

This is a message from Ian Watt-Smith, artistic director of the Churchill Theatre, Bromley, for the theatre's second subscription season brochure,

I know you are going to enjoy this Spring and Summer Season of plays and it is a great pleasure for me to announce that as a result of our very successful inaugural subscription season we are able to keep our prices at the same level as before. You can buy this wonderful package of contrasting entertainment for only £7.60.

Our first campaign has increased audiences by 30% so that attendances have now reached the staggering figure of 80% plus. This is a record for the Churchill—thanks to our Subscribers.

Of course, this means that it is becoming more difficult for latecomers to book the seats they want on their chosen night.

YOU should become a Churchill Subscriber and enjoy the advantages which are too good to miss.

And finally, a message from Segovia, the guitarist, whose recital opened the first subscription season for the Borough of Lewisham in 1981,

I congratulate the Borough of Lewisham on its first impressive Subscription Season. You have here a marvellous variety of the best in music today and I am proud to be associated with it. I look forward to my inaugural recital here on Saturday, 3rd October.

Practice Makes Perfect—Or Better, Anyway!

For the average person copywriting is an unnatural activity requiring as it does such complete concentration upon the readers and such subjugation of the ego. This kind of writing is never taught in school. It is craft writing, the use of words for a specific and businesslike purpose. It is, in a sense, the antithesis of creative writing and yet, the economy and concentration of purpose makes the process—to the writer anyway—very rewarding and, I suspect, very good training for a better class of writing altogether. Whenever I come to a copywriting job I remind myself that one of our very successful writers and television playwrights, John Bowen, was the man who gave the world 'DON'T FORGET THE FRUIT GUMS, MUM'.

CHAPTER SIXTEEN

PUBLIC RELATIONS

The practice of PR is about creating awareness and approval of your organisation and what it does. It is very pleasing to have people aware of you and for them to approve of you but if you leave it at that it will not make much of a contribution towards reducing your annual deficit. PR must work in the context of marketing so that the knowledge disseminated and goodwill created make a positive contribution to your sales now and in the future.

The companion to PR is advertising; they should work together to create effective publicity. Advertising is usually concerned with a specific event or series of events and it sets out to motivate those who are already favourably inclined towards the art form either as Attenders or Intenders. Advertising is capable only of delivering fairly briefly stated messages and it must make some assumptions as to the level of awareness in the minds of its target market. Those who are favourably inclined will obviously have a far higher level of awareness than the rest but there will always be a tremendous amount of information that they do not have that the advertiser would prefer them to have but cannot, through the media of communication open to him, give them. One of the jobs of PR is to provide that information, to fill in the background, to create an atmosphere in which advertising can do its work.

Thus, the theatre advertises a play. It states its title, its author, its starring actors and actresses. It will use a few words to sum up the essential quality of the play and will complement these with illustrations. It will give its sales, sales promotion and pricing information. It will choose appropriate media to carry this information. For some of its potential customers this will be enough but for many, particularly those who are further away from the centre of the 'attitude target' more is needed. It is the function of PR to find ways of telling people more about the play, its author and its actors and actresses and to make the whole project appear significant and exciting in the competitive setting of all the other advertisements vying for attention.

People make their assessment of an advertising message partly on what the advertisement says and partly on who is saying it. If a stranger offers you a brand new Rolex watch for £50 you will be dubious about buying it. It appears to be a very good watch and at that price it is a gift but If a close friend or relative makes the same offer you will take it because

they have credibility in your eyes, you trust them. So, while you are advertising your artistic product and fleshing out your message with extra information with what we may call 'product PR', you must also be be building up credibility for your organisation through 'corporate PR'.

Then we come to the hardest kind of PR, the kind I referred to in Chapter Three when I challenged part of a speech made by David Pratley. David Pratley's view was that at present our audiences are drawn from the same social and educational group. My Attenders and Intenders are almost certainly drawn largely from that middle class group. The question facing us now is really whether or not we can ever hope to change the attitudes of the broad mass of the Indifferent. Now there are people who are indifferent to the arts in all classes so, rather than set out to convert, say, all the working class to the arts (which is just as impossible as trying to convert all the middle class) let us simply focus our attention on those whose attitudes do not at present make them part of our potential audience—whatever their social class and educational background.

Can it be done? I don't know because, as far as I am aware, no-one has ever tried. What I do know is that attitudes can change and can be changed. If they did not change then there would be no point in holding general elections, we should only ever need to hold one and that would do for all time. Our attitudes change towards all kinds of things, morality, other countries, methods of transportation, fashion, nuclear weapons, racial and sexual equality, diet and so on, so why not towards the arts?

Our attitudes change because circumstances alter and the knowledge of the altered circumstances, knowledge obtained through the media of broadcasting and newspapers, works upon the attitudes we hold now and we adjust them to take into account the new information. It's healthy to consume dairy products; we are brought up to see milk, butter and cheese as being wholesome, full of 'natural goodness'. Then we see a television programme which makes the telling point that the consumption of animal fats is a major cause of heart disease. Instant change of attitude.

Our attitudes also change because groups of people set out to change them. Pressure groups, ginger groups, lobbies, decide that they will put before us information that may run counter to that which is already in our heads and often it results in a reversal of attitude or, perhaps, a reinforcement of attitudes already held; in either case the way we feel about the subject is changed.

We also change the way we feel about things as we get older. As we tuck the years away we gather in more information and we learn how to assess it; we like to think that we get wiser. People are not born with an affinity for any art form yet some of them, by their late teens, have developed serious interests which last throughout their lives. To others it comes later. To most, not at all.

The reasons for the indifference or hostility that most people feel towards the arts and the different art forms are beyond my powers of divination but one can make a number of fairly good guesses. Appreciation of most of the traditional art forms requires intelligence and a certain amount of persistence; the majority of people are not very bright and not very persistent. (Low intelligence is fairly uniformly spread across the class boundaries although it is better disguised amongst the middle class.) A greater affinity for other activities—'I like rugby so much that I just haven't time for anything else'—is bound to be another factor. So is experience; if you have not experienced an art form or if you have had a bad experience early on, you will probably fall into the Indifferent or Hostile category. Education and social background are clearly factors that influence one's early experience of the arts but they are not, I suspect, such ultimate determinants as people might believe. We have all met lots of well educated people from comfortable backgrounds who do not give a toss for any of the arts and we have also met people from uncomfortable backgrounds who have developed an affection for one or more of the arts. We would all probably agree that a high proportion of Attenders and Intenders come from the middle classes but that does not mean there are no others; I have met so many people whose interests today belie their backgrounds that I am sometimes even tempted to doubt this first assumption.

Notwithstanding the generous arts coverage in the quality press, the overall climate of opinion towards the arts in this country is not favourable. The information that comes through the newspapers that are most widely read portrays the arts as being remote, stupid, highbrow, queer, and incomprehensible and deals with artists only when their behaviour is in some way or other 'newsworthy', which means that we hear about those who get arrested for possession of drugs or get married a lot but not so much about those who are simply rather good at their art. We must not blame the newspapers for being the way they are but there is nothing to stop us doing what the Friends of the Earth do about ecology and MIND does about the welfare of the mentally ill. We could provide more information and we could bring it before those whose attitudes we want to change. We could start a real Arts Lobby; not just a pressure group to influence politicians to increase arts subsidy but a campaign to increase public awareness of what the arts are about and how much pleasure can be had from them; a campaign to create more Intenders.

To sum up, we have to think of public relations under three headings: *Product PR*, which backs up specific advertising campaigns, *Corporate PR* which builds credibility for our organisation and goes on for as long as the organisation exists day in and day out, and what we might call *Educational PR*, where we all, individually and collectively, set out to raise the level of favourable public awareness of our art form and the arts in general with the

intention of creating a larger potential market for our advertising to work upon and so, ultimately, of increasing sales. The three activities cannot and do not operate separately. Product PR almost always has a corporate PR effect and vice-versa; both may make a contribution to educational PR which, in its turn, can influence for good or ill product and corporate PR. This is what happens when you start to shout loudly; lots of people can hear and it is impossible to ensure that your message reaches only the ears for which you intend it.

Product PR

The orientation of my work has always been to favour advertising as the main arm of communication, using PR to back it up and to fill in the gaps. This is because when there is such a short-lived product as an art event, where the lead-in time is short also, it is vital to have control over what is being said to the market. The expression of the motivating message, the details of sales promotions and sales information, pricing and so on, must be brought before the public in the best possible manner and the only way to achieve this is to have full control. Advertising, involving as it does the purchase of media space and time, gives us the power to say exactly what we want in the language we choose. In the context of a time-limited campaign I have tended to see product PR as being an optional extra that can be done without if time is short. Where one has a very well defined target of known, identified Attenders this is not too serious a shortcoming but I have to admit that I can think of few advertising campaigns that would not have benefited from the enhancing climate of interest and excitement product PR can create.

Product PR starts by looking at the product to see what there is about it that is likely to interest the target market. Most product PR relies upon the mass communication media of newspapers, magazines, radio and television to convey its information so almost always the other, and dominating, consideration is what there is about the product that will interest those who work in such media. Therein lies the first problem of public relations; there are always aspects of the product that you think will be of interest to your market and you know will complement the advertising message, but these do not necessarily appeal to the media people who have their own ideas. Thus public relations, which is obviously concerned with your organisation's relationship with the market, becomes, in most cases, a matter first of media relations.

For this reason there has grown up in the arts business a small industry that works in the field of media relations. It is interesting to note that there are very few people or organisations that work independently and exclusively for the arts in the advertising sector. There are small advertising

media buying companies but those that provide the full range of advertising services are very few indeed. PR outfits on the other hand, abound. The reason is easy to see. Public relations, which usually depends on media relations, is about personal contact with the journalists who decide what it is the public are interested in and know well what their particular medium believes the public is interested in. The PR practitioner is an expert in knowing which story to place with which journalist. Advertising, on the other hand, is very much harder to devolve and most people prefer to do the creative and media buying work themselves, paying for the talent of a designer when required and building personal relationships with printers.

But PR is, at best, an uncertain business and that is why I have never felt able to rely on it alone. The journalists that cover the arts are in a position of considerable power that few are able to exercise impartially. Of course they will spend more time listening to someone whom they know and trust and they will treat any newcomer with a caution bordering on disdain if there are other more urgent and more interesting matters around. The journalists that do not specialise in the arts will be even more difficult to deal with and unless the story has powerful reader appeal—which usually means it must concern a celebrity or be scandalous or concern something that is little to do with the arts—their response will be very negative.

The person who is trying to build a climate of interest and excitement as a background to an advertising campaign is therefore faced with a long haul that is primarily concerned with building relationships within the media—and that takes time. Consider at first, therefore, the use of an independent specialist because their business is based upon those vital relationships and they will almost certainly do better than you. As time passes the new 'in-house' publicity officer builds up a network of contacts and the flow of information can begin, never with certainty, never consistently, but enough to justify the expenditure of time. The great advantage of PR is that it is relatively cheap; the price of one page in a quality Sunday colour magazine could buy you the part-time services of a media relations consultant in the arts for a year.

It is quite easy to learn the tricks of this kind of PR trade. It is something that is learned through experience, preferably under the guidance of an old hand. You can learn the basics through reading; there are plenty of public relations reference books on sale and the TMA marketing manuals have sections dealing with subjects such as Press Calls, Press Conferences, Photo Calls and Press Releases.

Can the orientation ever swing the other way, with the burden of communication falling upon PR rather than advertising? It can and frequently does, particularly in commercial theatre and classical music.

There is, in these areas, still a traditional of 'advertising by announcement' (that is, the simple statements of what it is, where it is, when it is and how much it is) combined with heavy PR activity that brings interviews with the star performers on radio and television and in newspapers and magazines, preview feature articles, photo features and so on. Such a high level of awareness is created that it manifests itself as real customer demand; all that is necessary is to provide the basic information and the customers do the rest. It is possible to make this approach work and when it does then it will have been a relatively low cost operation. But there has to be an element in the event that can be so exploited and if it is not there then all the press releases, parties, conferences, frantic telephone calls and generous lunches will have been wasted. The great virtue of advertising is that it can be made to succeed without the star names and the elements that PR must have; in the world of the subsidised arts which covers the whole country and not just the capital city, we usually do not have the raw material for highly successful PR campaigns of this nature and so must use our skills as advertisers to make attractive that which is not immediately so.

The point to keep in mind at all times is that product PR is used to contribute to the motivation of potential audiences which must lead to sales; if it does not produce sales then it is more or less wasted. There may be some peripheral benefit in terms of how the public regard the organisation but the objective has been sales and if this is not the outcome then it has failed. It is possible to build up a high level of awareness which does not translate into sales. I remember a campaign in Merseyside which we of Merseyside Arts Association carried out to promote a visit from an Indian Kathakali dance drama company. We mounted a substantial advertising campaign and simultaneously launched an onslaught upon the media. There was much to interest them. Marvellous costumes, unusual themes, performers from far away, incredibly elaborate make-up that took hours to complete. The media loved it and as soon as the company arrived the stories and pictures started to appear. There was exposure everywhere culminating in lengthy regional television coverage on both BBC and Granada television; there was even an article on the women's page of a local paper on how to wear a sari notwithstanding the fact that the company was all male. It seemed to us that there could hardly be one individual in Merseyside who had not heard of Kathakali. The awareness created did not produce ticket sales. At the box-office the show was almost a flop.

Conversely, the Danny Newman seminars in January 1980 were promoted through a very simple direct mail campaign to a well defined target market and a product PR campaign through the media. At first the newspapers were cautious, the journalists we spoke to being unsure of the significance of what was about to take place. We spoke of the dwindling

audience dilemma of this country and we cited the huge successes of the Danny Newman approach in North America but there was no response beyond guarded expressions of interest and the possibility that more would happen later on. Ticket sales for the seminars were quite good but not as good as we wanted them to be. Then one newspaper took an interest. Then another. Then another. Suddenly the telephones seemed to be ringing non-stop with calls from journalists who wanted to talk to and talk about Danny Newman and us. There were articles about arts marketing, subscription and Danny Newman, it seemed, everywhere. We then started a telephone sales follow-up to our direct mail campaign and the seminar bookings flooded in. Product PR had worked on this occasion.

Television is a marvellous medium for product PR if it is on your side. Certain kinds of television programmes, particularly the news magazine type programmes, are usually—no matter how well-intentioned the personnel—so bad in their effect that they are probably best avoided. Their problem is lack of time and, sometimes, lack of sympathy and understanding. If a television programme is able to give time to an arts subject and not simply try to extract the bare bones of newsworthiness within a couple of minutes, it can do much good. Many years ago, when I was helping to build the English Sinfonia orchestra in the East Midlands, we arranged a concert in Melton Mowbray and engaged the eminent oboist Leon Goossens to play a concerto. Goossens had, some few years before, been in a car accident and had not played much in public since as his lip had been injured. He was thus somewhat out of the public eye. The orchestra had at that stage never been in the public eye so the concert stood very little chance of attracting an audience. One might say that the product was good, the advertising was adequate but success rested upon the matter of credibility. Without our knowing it, BBC Television had arranged for the screening of a documentary celebrating the 70th birthday of Goossens which fell within a few days of our concert, and showed it a couple of days before our date in Melton Mowbray. It provided all the credibility one could have wished for. Not for the orchestra, of course. The star of the show was Goossens whose previous fame had been restored and reburnished by a television programme that gave time and consideration to the life and work of a great musician. Of course, that capacity audience was not made up of people who had been converted to a love of music through the television programme. The audience was of music lovers, Attenders and Intenders, for whom the word GOOSSENS on a piece of paper had become flesh and blood; our advertising merely provided the basic information.

Communication with the public does not always have to be through media. A visit to Liverpool by the Japanese Red Buddha Theatre, arranged by the Merseyside Arts Association, was launched by a street parade of the

entire company in costume, with gongs, whistles and rattles; they marched from Williamson Square to Hope Street and as they made their noisy and colourful way they created an image that brought life to the posters advertising the event. This kind of 'stunt' activity is fun to do but can be costly in time and it has the disadvantage of not being specifically directed at the market. Whether one is reaching the market through media or directly, most of this kind of PR is very unselective and although it certainly creates awareness it is doubtful if it can do any more than increase the likelihood of purchase by those who are already favourably inclined. Of course, this may well be enough to justify it and this appeared to be the case with our Red Buddha Theatre parade.

Direct public contact is obviously best if it is concentrated upon those whose attitudes are already well disposed or who are, at least, open-minded and have less fixed attitudes. Special introductory activities, workshops, seminars, question and answer sessions, where the artist can meet people without the plate glass separation of the traditional European style performance will make a substantial contribution to the publicity process. This is particularly valuable for young people who may well be sufficiently free of prejudice to watch and listen and then decide that it is worth a try.

Corporate PR

Whoever you are and whatever you do, you want your market to know about you, to think well of you, and to trust you. Remember the £50 Rolex watch. Without that credibility your advertising, no matter how brilliantly conceived and executed, will fall flat on its face. If you have been around actively for some time then your market will have an opinion of you, whether you have tried to influence that opinion or not. The very fact of your advertising will have made an impression on people, whether they have bought tickets as a result of it or not. The quality of the product that your market has experienced will have had an effect upon how people regard you. The product PR that you have carried out will have had its influence upon the attitudes of people towards you, for good or ill. In short, unless you are determined to pull down the blinds and sit very quietly hoping that no-one will notice you, you will develop in people's minds an image of yourself. Corporate PR is concerned with trying to influence that image so that people are aware of you and approve of you.

The Institute of Public Relations in its oft-quoted definition of public relations describes the activity as 'the deliberate, planned and sustained effort to establish and maintain mutual understanding between an organisation and its public'. The first point this makes is that you do not just let it happen, you work to establish and maintain the relationship. The second point is that the relationship is mutual; if you want them to

understand you, you must first understand them. Like all definitions of this kind it is a little high-falutin' but the basic message holds true. If you want people to think well of you, you must understand the people, know their values, their priorities and their language.

The first consideration is how people perceive you initially. Your building, your advertising, your staff, your letters, your telephone calls. These impressions combine to make up what is called your 'corporate identity' and you must make sure that what is perceived is what you really are—and what you really are is what you really want to be. You are an arts organisation and you know what kind of arts organisation you are. You do not exist solely to make a profit. You receive a subsidy to help you go on being the kind of arts organisation you want to be. So you must be true to yourself and true to those who see you. But look at yourself as a member of the public would look at you; be truly objective. If you want to know what it is like being a ticket buyer by telephone, go outside and call your own box-office, be a customer, see what it is like. Does your experience as a customer match up with how you would like the organisation to be regarded? Look at the posters outside the building. Do they match up with how you see your image? Your brochures? Your letters?

The concept of the corporate identity is a subtle one. Sometimes organisations are seduced into thinking that all that is required is a stylish piece of letter paper and a logo, a symbol for the organisation. This provides very good business for designers but there is much more to it than this. The product you offer contributes to your corporate identity, so does your pricing policy, the kind of sales promotions you mount, the atmosphere in the building in which you promote your shows. Practise being a customer. Practise looking at yourself through a customer's eyes. Are you looking the way you want to look? If not, start making changes.

People do not automatically know what arts organisations are about and so they must be told. Corporate PR requires us to offer information, explanation and, where there is misunderstanding and threat, to defend the organisation. The price that arts bodies pay for their subsidy is that they often have to justify it in the face of antagonism; this justification is part of the corporate PR work.

Corporate PR begins to work when the public meets the organisation on its own ground, when people come to buy tickets, telephone in with enquiries, take five minutes off to have a cup of coffee in the gallery snack bar and so on. What they see and hear within the organisation's premises, the other people they find themselves mixing with, how they are treated by staff, will all contribute to their impression. If they feel comfortable in the surroundings and find themselves interested in the display material around them, they will form a favourable view of the organisation and it will begin to have its own identity in their minds. Not just theatre, concert hall, opera

house, arts centre, gallery or museum in the abstract, but your organisation, something real.

The organisation can contribute to this process by going out to meet people on their territory, or at least on the territory of the clubs and societies to which these people belong. The talks that PR officers are asked to give to schools, colleges, Round Tables, Rotary Clubs, Townswomen's Guilds, Housewives' Register groups and so on, should never be thought of as inconvenient interruptions of the day's work but as marvellous opportunities to make your organisation come to life in the minds of the members. Talk may not be enough and these occasions are considerably enhanced by the use of visual aids. Latterly quite a few arts organisations have put together audio/visual or video presentation packages that explain their work effectively using really good photographs, video and scripts read by experts.

Product PR, which tells people about the events you are promoting, has a powerful, cumulative corporate PR effect. The more and the better you do in your artistic programme, the better will be your corporate identity. This must be taken into account with new organisations that do not, at first, have any kind of relationship with their community; it is hard to make the advertising work because it has low credibility. In my professional career I have had to launch four new projects, the English Sinfonia, a chamber orchestra based in Nottingham, Merseyside Arts Association, the regional arts association for Merseyside, *Classical Music* magazine and, over the past 10 years, myself as an independent arts marketing consultant. In all cases the first few years were extremely difficult. The orchestra had no image, no reputation, and audiences were hard to come by; the regular programme of concerts which we promoted through thick and thin, eventually created an awareness and audiences grew. Today, some 20 years on, the English Sinfonia has a regular following and often attracts capacity audiences.

With this experience of the English Sinfonia's early years I based the first five years of Merseyside Arts Association's growth on a policy of direct promotion of a wide variety of arts events. It started with nil awareness in the region and amongst the 'arts' watchers' even prejudice, based on the fear that this organisation would simply channel money from the region and from the Arts Council of Great Britain into Liverpool. A constant stream of arts events, across the arts spectrum and across the region, slowly built up the kind of identity we wanted and overcame the prejudice.

Classical Music magazine's first task was to create credibility amongst its advertising market, which in practice meant ensuring that there was a substantial readership quickly. My solution was to identify the 'key' readers, the groups of people who were significant to the advertisers, and to build an economic structure that made it possible to send magazines to

them free of charge. The clear evidence of the magazine's presence in the hands of those people did the trick and the advertising revenue grew quickly and sufficiently to make sense of the cost of the exercise.

It has even proved true in the case of the product that is me. Simply by doing what I do and from time to time letting people know that I am doing it through the help of the media, I have developed my own corporate identity. This book, for example, through what it says and how it looks, makes its own contribution, for good or ill, to this identity.

Because its aims are wide and are intended to influence people who are not necessarily going to be customers, corporate PR need not be so specifically focused as product PR. Because of its financial dependence on the community, the organisation must try to inform and influence local opinion and, from time to time, try to reach significant individuals and groups outside its own local catchment area. Thus, any form of PR outreach (whether it be product PR or corporate PR) that makes contact with the nation, is good to have because it will reach the leaders of national opinion (including media personnel) and it will have greater impact on local people simply because it has achieved national importance, if only for a short while. These 'non-customer' contacts include politicians, civil servants and local government officers, arts council and regional arts association committee members and officers, the personnel of other arts organisation and the business world, particularly those interested, or likely to be interested, in sponsorship.

The aims of corporate PR may be summed up:

To convey an accurate and favourable (they should not be incompatible) picture of the organisation to local and national publics.

To explain artistic policy in a way that is informative and interesting.

To attract attention to the organisation in a manner appropriate to its character.

To show how the organisation is trying to serve the public and how it is prepared to respond to public needs

To project warmth, ease and friendliness in all forms of contact with the public.

To represent the organisation in its contacts with the media and the public.

To point out the corporate (and product) PR implications of any intended activity of the organisation and to ensure that these are considered when decisions are being made.

To defend the organisation when criticism is levelled at it and to ensure that its interests are represented at the appropriate level.

Educational PR

If the arts organisations were producing something like eggs they would combine together to create the equivalent of an Egg Marketing Board. If you have a few million chickens dropping a few million eggs every day you cannot afford to wait for people to get interested in eating more eggs. Come to think of it, our arts organisations *are* producing the equivalent of a few million eggs every day.

In the absence of Theatre, Visual Arts, Music, Opera, Dance, Literature, Film and any other art form you can think of, Marketing Boards, we must look to the actions of organisations acting individually in the hope of generating a wider public interest. Every theatre wants a bigger audience for itself and for Theatre. Every orchestra and concert club wants a bigger audience for itself and for Music. Every arts organisation, whatever its interest, wants more people on its side, for itself and for its art form. What is good for the company is good for all companies. Every artistic success, every full house, contributes to the success of the art form. If everyone achieved success simultaneously it would reach a kind of critical mass and there would be an explosion of interest. We have seen it happen on a limited scale with the theatres outside London between the sixties and the middle seventies, when everyone seemed to be doing wonderful things and the public interest was huge. It has happened to modern dance since the early seventies when, due to the pioneering work of London Contemporary Dance Theatre and Ballet Rambert, there began a growing interest in the form that grew and grew so that now there is a substantial audience that was not there before.

People's attitudes had been changed. How they had been changed is hard to say but it must have hinged on the quality of experience that people began to receive and some kind of social osmosis that passed the word around. Success, as it often does, bred success. It must have happened like this in the early days of cinema and probably did with television when, at first, only a very strong interest would have overcome the financial barrier involved in buying a set. First there was no knowledge, no awareness, and then there was—and then they did something about it.

But how do we start the chain reaction? How do we begin to change the attitudes of people who can live their lives perfectly well without us and all our works?

Let us be realistic and admit that most people's lack of interest in the arts is probably well founded. They don't like the stuff. If you don't like eggs there is nothing that the Egg Marketing Board can do apart from suggesting that you buy eggs for someone else. But there are people whose indifference is founded on ignorance and, perhaps, prejudice, but who have, underneath it all, whatever it takes to be an appreciator of this or that art form. What it is, that potential for appreciation, is hard to define. Sensitivity? Intelligence? Or simply something they need that they cannot get from other things? I am not sure that it is worth spending too much time on trying to answer that question because all that really matters is that we believe the potential is there, amongst some people, and that if we provide knowledge and experience of the right kind at the right time we will fill up the hole of ignorance and knock down the wall of prejudice.

Also let us admit that we are never going to try to create an interest in 'the arts', that is, all the arts. Each art form has to build its own potential audience, whether it does it through the disparate efforts of the many or, one day, through its own marketing board.

Inevitably we find ourselves thinking that the real potential lies with young people. Older people tend to cherish their loves, their hates, their ignorance and their prejudices; their attitudes are harder to shift and we are only likely to influence those who are already fairly close to the centre section of the attitude target. We start looking closer at the schools, therefore.

It is a sorry picture. Schools that are so dreadfully underfunded that they can barely afford to carry out their statutory obligations are unlikely to leap into a campaign to make children interested in the arts. Around the country there are hundreds of staff rooms of teachers who, even if there were not acute financial problems, would probably show no more interest in the arts than the majority of their pupils (to those few exceptions I offer my sincere apologies for the generalisation and would draw their attention to my words elsewhere in this book where I plead the case for more enlightened treatment of school party organisers). The orientation of the schools has always been towards the practice of the arts rather than the appreciation of the efforts of others so that school music, drama and visual arts does very little to build audiences for our professional arts.

Many years ago I found myself at the entrance to a secondary school hall waiting to sell tickets for a performance of chamber music by a group of visiting Polish musicians. People kept coming into the building, they looked briefly into the school hall and walked on down a corridor. Occasionally someone would come in, buy a ticket and sit down to await

the performance but by far the largest number walked on by. Later I discovered that they were coming to attend an evening class on musical appreciation. The problem does not just lie with the schools!

The organisation of a school party to visit a theatre or concert hall involves a considerable amount of time and money which is why they happen so rarely and why, as a result, their effect upon children's attitudes is so slight. So the arts organisations must go to the schools and it must be done in such a way that the schools are not expected to pay (because they do not have the money) and are not expected to make major changes in their daytime programmes (because they have other priorities).

What the children experience is crucial and that is why the traditional school visit to experience what is primarily intended for adult audiences probably does more harm than good. On the other hand, a visit to the school by a professional company doing work that is produced for children, which has the mysteries explained, which allows them to discuss and to participate—which is followed by more visits and which may lead to the children meeting the company on its own ground—will result in young adults who see that art form as being part of their personal spectrum of entertainment.

But the arts organisations are under severe financial strain as well. The Theatre in Education groups are fewer. Music, opera and dance organisations are not funded to make those regular school visits so they do not happen. The potential that lies within the vast school population is untapped. The children become young adults, mature adults, and old adults and mostly the arts do not touch their lives. For all practical purposes the young person at school, most open-minded, waiting to be guided, the customer of tomorrow, will not be reached by us until somebody decides that it is important enough to be financed.

In the meantime we are left with the adult population. Active product and corporate PR will at least maximise the response from the favourably inclined and may, from time to time, even sway the floating voters. The influence, however, is unco-ordinated which means that in some places, at some times, there may be some good PR work, accompanied by good advertising and good sales, but the ripples are quick to die away and the effect is dissipated. The idea of the 'marketing boards' for each of the art forms begins to appeal more and more. They could start as working parties set up to consider a variety of PR approaches; at first they would need only low-level financing and then could move into a phase of experimentation working with whatever funds were available. As they progressed they would learn which avenues were most productive and could report their findings to their members, the constituent arts bodies. The idea has something in common with the officially endorsed 'marketing experiments' that took place in Sheffield, Bristol and Birmingham in the early seventies,

but the critical difference is that the marketing boards would be concerned only with this aspect of PR, would be specific to each art form and would have a national scope. I hope someone takes up the idea.

This kind of approach is what I mean by an Arts Lobby and what I mean by 'marketing at its best'. Given the will of a government that sees the real (and rather frightening) implications of a population that has not been prepared for more time with nothing particular to do, it is possible for the arts community to do more for more people, but it needs that will to be expressed in the form of money.

CHAPTER SEVENTEEN

PUTTING IT TOGETHER AND MAKING IT WORK

The Management Structure

Marketing is the organisation of resources towards an objective. Any practitioner knows that getting the resources of money, time, and people with knowledge, experience and talent, is difficult enough. Organising those resources, co-ordinating them so they work in harmony, is even harder.

We have seen, through the chapters of this book, that marketing involves a lot of different activities; to be effective they have to be co-ordinated so that they work together like the cog wheels in a clock. Many people can be concerned with these various activities and so the problem of co-ordination is also one of personnel management.

The one-man business, or the very small business run by an autocrat, is quite common in the entertainment world and it can be extremely successful—one thinks of agencies and commercial entrepreneurs as examples. Most arts organisations in the subsidised sector cannot behave like one-man businesses, even if they have the minimum of staff, because they have to be accountable and must have their controlling boards and committees; the small organisation can thus have quite a large number of people involved in its management. When I took up the post of director of Merseyside Arts Association I was at first the only staff member and after two years there were only three, including myself, on the staff; yet we had an executive committee of 23. Committees like this are part of the management structure and inevitably make it more complex and, therefore, harder to co-ordinate, and certainly make it harder to arrive at good decisions. The involvement of funding bodies such as the Arts Council, local authorities and the regional arts associations (all of which, whether or not they have direct representation or not on the committees, exercise considerable influence on the 'he who pays the piper ...' principle), and so even further complicate the decision making process.

The typical arts management structure consists of a top layer made up of the committee of lay people, with its chairman, and then a second layer of senior employees who have responsibility for artistic matters, administration and finance; below this the structure fans out into whatever strands of responsibility are necessary for running the organisation. The

committees vary in their character and their degree of dominance; some try to run the show and keep a tight rein on senior management, others act more as rubber stamps and see their roles as supportive, only playing the heavy when things go seriously wrong. They all require consultation, however, and this can cause delays even if there is no conflict.

It is still rare for marketing to be overtly recognised as a senior management responsibility, the artistic director, general administrator and financial director, or artistic director and general administrator incorporating financial management, being the most usual combination of senior management. Marketing is most commonly assigned to a middle management position where it is called 'publicity' or 'press and PR'. The sad truth about these titles is that they frequently describe quite accurately the duties of the post holders; the organisation consciously recognises only that it practises publicity; the wider scope of marketing is ignored. Such an organisation also makes decisions affecting sales and sales promotion, pricing and financial planning, but does not do it as part of an integrated marketing decision making process. The co-ordination which is vital to good marketing is thus almost impossible to achieve.

Fortunately it does sometimes happen that the senior administrative manager (and occasionally the artistic director) has a good grasp of marketing and takes on a co-ordinating role, influencing decisions and directly managing personnel with marketing responsibilities. Under these conditions the organisation can function and succeed but will only do so as long as that individual is holding the job. If the management structure does not overtly recognise the marketing responsibility and enshrine it in a named senior management position, the necessary co-ordination will last only as long as the administrator lasts.

Such a partnership of two will be marred if the artistic director has greater influence than the administrator and does not accept that he, too, must contribute to the marketing function. The artistic product may then be created or selected with little or no reference to what the organisation needs and its market shows that it wants, with the result that audiences and audience-income fall. If, on the other hand, the artistic director makes the running—it is by no means uncommon—and also has an active interest in the marketing aspects, good progress can be made

It can happen that senior management does recognise the importance of marketing and practises it well (with or without the presence of a senior marketing person in the team) of the team, but the committee of lay people does not understand how the marketing process works and will insist on tinkering about with crucial decisions. A marketing plan is a network of interlocking decisions and if one piece is dislodged the whole assembly can fall apart.

I once had a client, a music organisation, which had a dominant committee. I, as consultant, only ever dealt with the person who was paid to run the organisation and never met the committee. The two of us would meet, I would outline my recommendations, and the officer would then seek the approval of the committee for action. On one occasion the plan (it was not a particularly adventurous one) sought to introduce credit card booking and suggested, amongst other things, a very substantial ticket discounting scheme. The committee's reaction, conveyed back to me by the officer, was that they would under no circumstances accept credit card booking because of the commission charges. The discount scheme, which carried with it some considerable risk and involved a lot of money, they would leave to us to sort out.

Anyone who has ever attended a committee meeting will agree that this story rings very true.

Not much can be done about committees beyond hoping for a strong chairman and winning his confidence. The best way of doing this is to learn how to develop a strong, convincing marketing argument.

The first step must be to introduce into senior management a marketing position so that this vital function has a voice at the top. The marketing manager will never, and should never, have total control over artistic matters, administrative matters or financial matters; there must be different voices to speak up for all these interests. The marketing manager's job will be to manage the personnel who have direct marketing responsibilities such as advertising, PR, sales and sales promotion, and, in the course of creating marketing plans, to make recommendations concerning pricing and financial planning. As part of the senior management team he will also be free to express opinions on artistic programming and as another member of the same team, the artistic director will listen.

These are but the components of the job. It is the marketing manager's job to develop an overall marketing strategy and to put forward 'total' marketing plans, schemes which state their objectives in terms of audiences and revenue and take into account all the factors necessary for their achievement. The marketing manager will have to argue his case with his colleagues, obtain their agreement on all aspects and may frequently have to rethink his plans to allow for the other views but, at the end of the day, will have plans that organise all resources in the direction of achievement. With the support of the senior management team such plans will stand far greater chance of success when they come to be judged by a committee because their logic will be transparently clear—there is something very convincing about a good marketing plan.

Most arts organisations do not have marketing managers of senior management status; they sometimes have people *called* marketing

managers but they are mainly misnomers for publicity officers. The title is not enough; to be effective the job must carry senior status and the organisation must practise total marketing.

Personnel

Obviously the staffing of an organisation will depend on its size and what sort of work it is doing but it is useful to consider how an ideal marketing department might be made up. The departmental head will obviously be the marketing manager, the specific title depending upon the organisation and the status it confers upon its senior management; if the others are directors then the person in charge of marketing is a director. Reporting to this position will be the people in charge of advertising, public relations (which would in practice mainly be concerned with product and corporate PR), and sales (which would incorporate sales promotion). Beneath this second management tier there could be more sub-divisions according to the ambitions and financial resources of the organisation. Advertising could be a department employing a designer, either full or part-time, and could involve the part-time services of a copywriter. Public relations could have a specialist media relations officer, a corporate relations officer whose job it is to handle all the direct and indirect public contacts and an educational PR officer who specialises in the outreach work intended to create favourable awareness amongst the indifferent young and old. Sales would have its own manager responsible for all the activities covered in Chapter Seven, who would liaise closely with the marketing manager over the creation and implementation of sales promotions; within this group there would be the sales force amongst whom there would be those formerly known as the box-office staff.

Training

Merely creating jobs and giving people titles does not make effective marketing; the personnel must have experience or training to fit them for their roles. In some areas there is already no shortage of experience. There are plenty of experienced media relations and advertising people because these two activities are widely practised. There are not, however, many experienced sales people nor are there many who fully understand the principles of sales promotion. The special kind of PR which I have termed educational PR, is also not widely carried out although it would be comparatively easy for an intelligent PR person to develop appropriate programmes. Oddly enough, the biggest shortage may be of people suitable for the more senior position of marketing manager because very few people will have had the experience of working in marketing at a very senior level.

If one were to imagine the creation of such an ideal department the first problem the personnel would face, with the inevitably wide variations in knowledge and experience, would be the difficulty of working together as a team. Training for individual members would be necessary but so would group training; the *in situ* seminar is probably the best way of improving the performance of the marketing team.

In the profession as a whole there is a marked need for training programmes in the detailed aspects of marketing. There have been plenty of 'marketing is a wonderful thing' seminars and training courses on telephone selling and direct mail techniques but few, if any, on sales (as a function in its own right), sales promotion, financial planning and marketing management. Although standards have undoubtedly improved over the past ten years or so, the overall level of marketing knowledge amongst staff is not yet high enough. For box office staff to begin to operate as a sales force there would need to be a substantial change of attitude amongst them and specific training would be vital. I have conducted a few such seminars with box-office staff and usherettes and ushers; I have found the resistance that one might expect initially but, at the same time, I felt that staff were almost flattered by the attention that was being paid to them and would be prepared to learn provided that what they were asked to do took place in the context of an overall change of orientation on the part of management. It is no good just giving them a 30 minute pep-talk.

At the end of Chapter Two I suggested that what we needed in this country was a membership organisation dedicated to improving the standards of marketing the arts. It would not be restricted in its scope to one art form (as is the Theatrical Management Association) or to one geographical area (as is the Society of London Arts Publicists) but would see its interests as including the promotion of all the arts in all places. Not only could it make a powerful contribution to the marketing of the performing arts but, by combining the knowledge and experience of its members, it could begin to develop an effective approach towards the marketing of the visual arts, publications, cinema, museums and other areas of known difficulty. I hope that this suggestion and this book will prove to be the starting point for the creation of this much needed body.

The role of the consultant

In the commercial world the consultant, whether it be in marketing or an aspect of marketing, or any other discipline, has a particular contribution to make. He spends all his time working in his field and if he sustains himself from this work he is probably competent. Because he works for many kinds of organisation his experience is broad. He is available on

demand and, being an independent and probably self employed, he will appear when required—his livelihood depends on reliability. He is, in relation to his expertise, not expensive to hire and using him does not involve his client in overheads: no desk space, no heating and lighting, no company car, not even an employer's national health insurance contribution. He has a very strong motivation towards success because his future client list depends on how well he does with his present clients—not because he will boast of his achievements but because if he is successful, they will. Oddly enough, he is more permanent than a member of staff because he is part of the industry, not part of the organisation; once an agreement has been reached he is there to be relied upon and will not be scanning the Creative and Media job advertisements in the *Guardian* every Monday.

Apart from these advantages, which I believe apply as much to an arts marketing consultant such as myself as they do to other consultants, I have found that my independent status enables me to talk authoritatively to senior management and to committees without inhibition. It is accepted that the advice I offer is objective and intended only to improve the marketing practice of my client organisation—no-one suspects me of trying to build an empire. I am thus able to look a chairman in the eye and tell him what needs to be done without fear. For certain kinds of organisation I become the marketing director for practical purposes and have the status that permits me to act with authority.

One has to introduce a consultant very carefully. Staff do not like the stranger whom they fear may be some kind of spy who will report their shortcomings to the boss. In what is a competitive business—jobs are few and far between—they also fear that the consultant may steal their thunder, may take away the credit that is rightfully theirs. They may also feel that the introduction of a consultant is something of an insult which reflects unfavourably on their professional ability. Sometimes these fears and suspicions cannot be allayed and all the consultant can do is creep quietly away; there is no point in continuing because without co-operation the consultant's job cannot be done.

My work as a consultant starts to bear fruit as soon as the staff acknowledge to themselves that I have a contribution to make that they cannot make themselves. They will only acknowledge this if they have had the opportunity of meeting me and talking about what they do and what they believe their problems to be. If they feel that I can help them, that they can learn something, and if they form the opinion that I will not rush off and claim any success for myself, then we may begin to work productively together. Of course, those first few meetings will also reveal to me whether they need assistance or not and if I feel redundant I will be the first to

withdraw. What must be avoided at all costs is the imposition of a consultant upon a staff that does not accept the need for one.

After what is almost always a difficult beginning the relationship can grow; the staff learn from participating in structured discussions and the results start to speak for themselves. Often I find that I do not need to present startlingly new ideas but simply to guide the organisation into a different way of looking at tasks, to clear away the old wives' tales and to introduce order into the various decisions that must be made. Bright new ideas are usually in plentiful supply, both from the client's staff and from me, but I try to persuade them that ideas are worth nothing unless they contribute to the marketing plan that we are developing together; objectivity is a quality to be sought. Of course, creating the marketing plan is the biggest hurdle.

Putting it together and making it work

It is hard to describe the process of making a marketing plan; it seems to involve, as with so many other jobs in life, 10 per cent inspiration and 90 per cent perspiration. The inspiration provides you with the kernel of the project, the fundamental approach that takes into account the known resources, the market, the product, the relationship of the organisation with the market, the financial aspects, the historical factors, and then offers the market something that it is likely to want which the organisation is able to provide. I would not want to elevate the process to the level of an art but I do sometimes find that 'getting it right', finding that one approach that is fresh, achievable and convincing is very similar to, say, writing a story.

At a certain level commercial marketing is a science, that is where market research is involved, where the relationship between price and demand can be charted and expressed in mathematical terms and so on. But, as we observe, most commercial marketing happens on a wing and a prayer and that is how we in the arts operate. There is little or no science in the sense of measuring values and relationships and extrapolating from them; the only kinship that our kind of marketing has with science is in the way we observe and analyse and in our methodology. When we have a task before us our job is to provide a solution and to that end we must put aside our personal preferences, stop thinking of how people and situations *ought* to be and get to work on them as they *are*.

There are very few situations where one has to start from scratch so most marketing tasks take place against the background of previous, similar activities. The first step is to observe and analyse. When I meet an organisation is a consultative capacity I watch, ask questions, and talk about how things are. I follow the simple check list that I gave in Chapter Three. I want to find out about artistic policy and how that is expressed in

terms of recent activities (policy does not always square with programmes). I am interested in who the staff believe the product is aimed at and who is actually buying it; I want to know how many people buy it and whether or not these customers are on record. Has there been a recent audience survey and what were its findings? Has there been any change of marketing approach following the survey and has it made any difference? I look for evidence of entrepreneurial flair in the matching of product to market. I also look for signs of wishful thinking (call it deathwishful thinking) where product is chosen because people ought to like it even if they manifestly do not.

I am particularly interested in the sales aspects. Staffing is an obvious place to start; is it adequate? How do people with sales responsibility speak to their customers? How many obstacles are there in the way of the would-be customer? Have the staff ever had training? Do they need it? Is there an emphasis on encouraging purchase in the home by telephone or in response to direct mailing of sales material or to advertising? Is there evidence of an active sales stance—do staff openly encourage customers to buy more, do they have enough knowledge of the programmes to be able to do this? Are the staff motivated to sell? Are they thought of, and do they think of themselves as being, a sales team? Is the organisation sales orientated?

When it comes to publicity I know that I shall probably see evidence of good advertising work so I look to see how well it is integrated into marketing planning. Are the budgets adequate? What would the staff do if they had more money? Do they, in fact, need more money? What do they have to advertise—are they advertising show by show or are they able to build packages? How sales orientated is the advertising—does it aim to persuade people to buy now? I look for talent in copywriting and design. I am interested in the staff's understanding of PR and what it is meant to do and I look for evidence that product PR is being used to complement the advertising—I usually find this. I want to see if there is an understanding of corporate PR and to what extent it is being practised—I often find that it is not being practised. Because of the inevitable shortage of staff, corporate PR and educational PR usually go to the wall in the face of the immediate pressures to promote the shows that are just about to happen.

Sales promotion—does it happen? If it does, is it as part of the marketing strategy, used deliberately, with knowledge and originality, to increase and accelerate sales? The approach to party booking usually tells me a lot (do they still think of a party as being 20 or more?) and, if they sell by subscription, do they ring the changes season by season or do they keep on offering the same old incentives?

I try to find out as much as I can about the way the organisation makes its estimates and the view of senior management towards subsidy—does its presence, if it is present, influence in any way, no matter how subtly, its

determination to do better in terms of audience levels and revenue and in the quality of what it is presenting? Is the controlling committee benevolent and supportive or does it impede progress? Does the power structure permit an expansionist financial policy? Are there the proper marketing budgets for publicity, sales and sales promotion and are they adequate? Most important of all, I try to discover how much senior management personnel, and the committee if it is influential, believe that progress is possible and how hard they are prepared to go for it.

The management structure and the personnel are key factors too. Does the structure permit effective decision making and are the people involved up to the job? How well do they work together? Are there personal animosities that inhibit co-operation? Do they set themselves goals, do they measure their progress, do they try to learn from their mistakes and their successes?

It is comparatively easy for me, as an outsider who has been invited and who is being paid, to make my assessment of an organisation; it is far harder for someone who is part of it to be so objective but objective you must be because it is against this background that any marketing plan must be made. Many of the shortcomings detected cannot be put right overnight but the events loom and something must be done to bring in those audiences. The marketing plan for those events must allow for the deficiencies, must work within them. The marketing plan, which I obviously see as being concerned with activities over the short term, must be part of a longer term marketing strategy that is intended to correct the organisation's shortcomings.

At this stage it is a good idea to draw up an outline strategy for marketing, to list the changes that should be made and to encourage internal discussion on it. People will readily discuss—and will agree to—plans for improvement provided they do not have to foot the bill for them now. Get the strategy on the statute book as soon as you can so that it can lie there quietly waiting for your next move. What should the strategy be? Its outline is here within the chapters of this book. Apart from variations due to the different kinds of organisations there are and their varying levels of success, all marketing strategies for arts organisations are essentially the same.

The marketing plan itself is then a matter of answering many questions and combining the answers into a whole. There is no one set way of doing it. Here is one way that illustrates how a simple plan can be developed. It is, roughly and briefly, the way I set about it.

On the basis of previous experience and practice (that is, if we do more or less what we did last time) how many people can we expect? How much money can we expect?

How much money did we spend achieving our results last time?

If we set out to increase results by 25 per cent what would we have to do?

Spend more on advertising?

If so, where and how? But first, are we wasting advertising money by trying to persuade *everyone* to buy? Can we spend what we have more effectively? If we are already in contact with customers because we have their names and addresses or because we meet them when they come to buy other tickets or attend other events, can we achieve more by improving our direct selling and so spend less?

As we do not have sufficient contacts with known purchasers, we must try to reach the unknown purchasers and would-be purchasers. Shall we try a direct mail or direct response advertising campaign? Over what area? How much would it cost? (If it works, the next campaign will be much cheaper.)

Reduce prices?

Dropping prices by 10 per cent probably would not make much impact. Dropping them by 50 per cent probably would but we are trying to increase results (that is people and revenue) by 25 per cent. If we dropped prices to half we should have to sell two and a half times as many tickets to increase the revenue by 25 per cent. If we could achieve such an increase in sales it would certainly be marvellous but the risk of relying on a price cut to do the job is too great; people are not staying away because our prices are too high.

Revise price range?

That is a possibility. We could introduce more lower price seats—or more higher price seats. Which seating areas are most popular? Could we make all the seats the same price but at a level which gives us a higher yield on sell-out (so it is a price increase but one which is concealed by the overall change in the pricing policy) and then introduce a special early purchase incentive?

Use sales promotion?

That is what the early purchase incentive is. When we launch the direct mail/direct response advertising campaign, which will go to many more people than ever before, we will offer them £1 off all their tickets provided they respond within ten days. And on top of this there is the incentive of

securing the best seats—that is another sales promotion in itself. What about the cost of this? We'll have to make a guess as to the number of respondents taking into account the fact that not all will buy before the closing date for the reduction. Let us assume that we achieve our target increase of 25 per cent in audience attendance and assume that 75 per cent of them will respond before the closing date.

Can we use sales promotion in any other way?

If this works, our next campaign will not need a big increase in advertising budget because we shall have substantially increased our stock of Attenders; our main problem will lie in keeping them loyal. Why don't we add another incentive to all purchasers for the forthcoming show in the form of a £1 discount voucher that is valid for the next show? Shall we restrict it only to those who buy within the ten day period? No, we'll give it to everyone. In this way those who miss the £1 early purchase incentive will still feel that they are getting something and we'll have a much better chance of holding on to them.

What about the sales aspects?

Naturally we shall encourage telephone and postal response to our advertising so we must make sure that we have enough staff to deal with telephone answering and handling the post. We already accept the major credit cards. This time we'll use a Freepost address, it will only cost us £135 for every 1000 orders we receive by post. And we must get together with the box-office staff to explain why we are doing what we are doing and to brief them on the importance of selling direct to customers whenever they make contact with them. This means turning the casual telephone enquiry as to what's on next Thursday into a credit card sale there and then. Also we'll express our target in terms of real figures and keep a daily total in the box-office where the staff can see it; we'll break the target down into three stages and when each stage has been reached we'll give them a cash bonus. How are we going to pay for this?

Budgets?

We will pay the sales bonuses out of our new sales budget just as we will pay for the early purchase incentive and the 'next show' discount voucher (only when redeemed) out of our new sales promotion budget.

Where is the money to come from for these new budgets?

If all goes well, it will come from our 25 per cent increase in sales revenue—but, of course, quite a lot of our 'new budget' expenditure is directly pegged to sales results. If we don't sell more we don't have to pay out more. If we do not achieve our target we shall have to cut back expenditure until we recover. Of course, if our sales rise but by not quite enough to cover the extra expenditure we shall at least have a strong argument to present to the people who support us financially; we shall have shown that we are in the growth business.

How does this affect our publicity?

It means that we shall be shooting a great big rocket up into the sky to say 'HERE WE ARE WITH THE BEST OFFER YOU'VE SEEN ALL YEAR!!!' Now our advertising has something to say. We know all about describing our shows excitingly now let us also advertise the experience of coming here, having a great time and at a price that is unbeatable, not only for this show but for the next one as well! It is so good that you had better book now or you may never get to see it! Just think of all the other people who have seen this press advertisement or received this sales brochure—they'll be flocking to us. And then, with all this success, we can do some real PR—we can do some boasting at last!

Aren't we getting just a little excited over this?

If we don't get excited, how are we going to get them excited? Now, calm down and write down the outline of your campaign plan. State your objectives in terms of audience figures and revenue. Under the headings of Product, Market, Sales, Pricing, Sales Promotion, Advertising, Public Relations and Financial Planning, put down a summary of what you intend to do and what you expect will happen. Where there is a high element of risk, state it—make sure you admit to yourself where you feel you are on shaky ground and where you feel more confident. You may not be called to show the plan to anyone but make it just the same. You will find that the very act of writing down your intentions will clarify your thoughts and as you write you will start to improve the plan.

Monitoring and Assessment

Once the planning is complete and the organisation has agreed on how it is to proceed, the flurry of implementation begins. It is an absorbing business concerned with copywriting, design, commissioning print, making

expenditures fit budgets and working to deadlines as the start of the campaign draws near. There is never enough time and there was never a perfectly executed campaign. You will almost certainly find yourself short of 'thinking time' and that is the one thing you must not allow yourself to be denied. If a piece of sales material has to be planned, the copywriting and design brief to be completed, put yourself away from distraction, and give yourself time. I find that as my experience grows I become faster in every aspect of marketing work bar the thinking and there I need more and more time, not less.

As you work, try to identify your organisation's strengths and weaknesses—and your own. Always be thinking of how you can make the next campaign better.

When the campaign starts, begin to monitor the results and make your assessment as to the effect your various marketing decisions, and those of your colleagues, are having. If you have built in a date-limited special offer, does the rate of selling increase as the closing date approaches? Is the change in price in one of your seating areas resulting in a shift in the buying pattern? Stay close to the box-office and listen to what your customers are saying. What are their reactions to the shows and to the way you have described them through your advertising? Are your customers avoiding any particular evenings of the week? Is there anything you could do next time to even out the demand? Are there things that your customers do not understand in your sales material? Are your sales staff having to spend time explaining things which you could have made clearer?

Monitor your sales figures on a daily basis. Report your findings to the sales team. Discuss progress with the sales team. Make them fully aware of how important they are in the process.

If you are producing sales brochures in some quantity, to be distributed to different groups of people—known purchasers, people who live in a certain area, people who read a certain publication, people who have certain occupation, and so on—code your brochure by putting a special mark on the booking form. The easiest way is to put a row of crosses on the artwork for the brochure. The printer produces the first batch with, say, five crosses on it. When the correct quantity has been printed, he stops the machine, erases one of the crosses (it is a very simple matter involving little or no cost) and prints the next batch. When the sales period has ended you can easily check which sources have been the most responsive.

If you are encouraging people to make telephone bookings, make sure you brief the sales staff to ask customers where they saw the advertisement or how they received the brochure—and make sure the sales staff keep good records for you.

See what it is like being one of your own customers. Leave the building and try to make a telephone booking. How long were you kept waiting

before your call was answered? Did the sales person follow the brief you provided? Be a little difficult, perhaps unsure of what you want; how well are you guided into making a decision to buy?

When the campaign is over, write an assessment of all aspects. How close to your target did you get? Which ideas worked, which ones failed? Be absolutely honest with yourself.

Now compare your assessment with your earlier marketing plan. What conclusions can you draw? What new ideas emerge to be thought about for next time? What must be done *now* to improve your efficiency? Arrange a meeting for all concerned with marketing and discuss the campaign with them.

Safeguards

There is no way you can guarantee results. All you can do is plan your steady progress towards greater achievement so that risk is always containable; do not put the organisation's shirt on one horse. Do not be frightened of risk but do not be reckless. Good planning combined with creative thinking and experience should carry your organisation forward. Unfortunately, you cannot take out a commercial insurance policy against marketing failure. You can, of course, take out insurance to protect you against loss incurred when either an artist or a show fails to appear on the due date, but that is about the only protection available. When it comes to the uncertain response of Mr and Mrs John Public you are in the trembling hands of fate and the only way you can protect yourself is to make sure that when you fall you do not fall too far.

Good luck!

APPENDIX A

SUBSCRIPTION-BASED MARKETING

This appendix is a slightly edited version of my contribution to the TMA
Marketing Manual *Volume 2 which was published as a revised edition in 1983.
It is written for people in the theatre business but the principles apply to all
situations where subscription-based marketing is feasible.*

1 INTRODUCTION

The definitive work on subscription-based marketing is *Subscribe Now!* by
Danny Newman, and anyone thinking about the possible introduction of a
subscription (or season ticket) scheme should start by reading this book. It
is written by an American, it is mainly about schemes in North America
and it is a very American kind of book. A few years ago its American-ness
worked against its missionary-like intentions because its enthusiasm—
almost passion—jarred with the traditional reserve of the British arts
administrator. Furthermore, it advocates a very active approach to ticket
selling—a view which does not always find favour in this country where so
many people still believe that audiences are made by God and not by man.

More than three years have passed since Danny Newman's evangelical
visit to this country in January 1980; we have had time to relate his message
to our own situation so that we no longer try simply to copy the examples
given in *Subscribe Now!* and, with a clearer understanding of the principles
involved, we can develop schemes which are purpose-built to suit our
individual requirements. The principles are intrinsically the same as those
of 'ordinary' marketing but certain aspects, which we in the UK have not
fully appreciated, are highlighted and emphasised.

2 YOUR PRODUCT

The first major difference lies in the realisation that while you are selling
one thing you might just as well set out to sell several. Once you have a
direct contact with a known buyer of what you have to sell it is generally no
more difficult to sell a package of theatre tickets for a series of plays than it
is to sell one ticket. Naturally you will not succeed every time but when
every sale means the purchase of, say, six tickets you are ahead of the game
if you can sell your package to, perhaps, one in five customers or more.

Your product, therefore, is a package. Within the package there should be the components that will strike your potential customer as being very attractive as a package. The shows themselves should look good as a package, and how successful you are in achieving this will be governed by the extent to which your artistic direction can co-operate and how good you are at describing them. Exactly what the contents of your package should be is between you and your artistic director but, if a general principle is to be drawn, one might say that for a first subscription scheme there should be no major departure from the kind of programme with which you both feel confident. Given that you will be trying to sell to those people who are already customers, albeit occasional, it would not be wise to introduce a radical change at the initial stage. As your scheme develops and subscribers grow in number your relationship with them will become closer, they will trust you more, and you can move towards more adventurous programming if that is the kind of theatre you want to have. It also depends on your starting-point. If you start with a reasonably good level of attendance then you would probably not want to run the risk of alienating those customers. If you are trying to build a regular audience from almost nothing, then in one sense you have greater freedom—that's about the only advantage.

You should also try to remove the obstacles to the customer in taking up your offer. A big disadvantage may be the time commitment involved: too many shows in too short a period of time or a period of time that stretches out too far ahead, will make your selling task more difficult. The price of the package may be another disincentive—we'll come to that later.

The theatre world is currently divided over how we should solve the problem of selling a number of tickets for specific performances within a package that may span several months of theatre-going. One view is that the public may not wish to commit themselves to specific dates so far ahead and it is better to sell them a set of vouchers which can be exchanged for tickets for specific performances later on, when they have a clearer idea of when, for example, their holidays occur. The inbuilt risk of this system is that customers may then still behave as they used to behave when they attended on a show-by-show basis: they may wait to read reviews or they may leave the decision until later so that there is a tendency for sales to 'bunch' towards the end of each week and towards the end of the run. This can be overcome in part by having two sets of subscription prices, one for, say, Monday to Thursday and another for Friday/Saturday.

It is still very difficult to stop people waiting until the last Friday and Saturday in the run, and then there is the risk of disappointing the people that you are trying to keep as regular customers.

My own view is that the voucher system can work if you are satisfied with fairly small numbers of subscribers and that, I believe, is contrary to

the whole point of subscription and, indeed, arts marketing in general. In the theatre, where we may have typically, 18 evening performances of one play in the average regional theatre, and, six plays in the package, we run into the problem of complexity (which is a major barrier to selling) if we attempt to sell packages of tickets for specific performances. I have made use of the play/date grid idea with some success (in, for example, the Churchill Theatre scheme: see Sheila Dunn's report which follows this appendix). It is basically a table showing play titles along one scale and specific performance dates along the other, grouped into Mondays, Tuesdays and so on. This identifies each run of Mondays (there would be three runs of Monday subscriptions in a typical three weekly rep—perhaps only two if Monday is not a performance evening) by, say, the letters A, B, C. The Tuesday runs would be D, E, F; and so on. The customer is then encouraged to choose one night of the week for regular theatre-going and then to select either the first, second or third week run—as identified by the appropriate letter. This is less complicated than it sounds. The advantages of this system are that once the purchase has been made it is truly 'firm' and the customer has nothing more to do (the voucher system obviously involves another process which if they have to be exchanged early is another obstacle to the customer and if they can be exchanged late is risky because the customer may not receive particularly good seats). It also ensures that you allocate the best seats to your best customers (with dwindling audiences customers do feel that they are in a buyer's market and may not realise until it is too late that good seats are now going to be hard to get). Also, and this is a subtle point, it draws the attention of the customer to the traditionally less popular evenings; if someone is about to make a long-term commitment there is some justification for thinking that he might choose not to tie up a series of Friday or Saturday evenings but will opt to put a little life into the arid part of the working week. One can enhance this effect by, perhaps, having two price scales (as with the voucher-system already referred to) so that there is a financial advantage in choosing an early series. Design can also be used to give greater emphasis to early series as, indeed, can copywriting; one could easily develop this into a special feature of the sales message.

Another approach is to show all dates for performances and to allow customers to pick their own dates: this is sometimes called a 'rover' subscription. I personally question what at first appears to be a very good customer benefit. If too much choice is given, then this itself becomes a barrier to purchase: it is unlikely that the customer will have a full diary several months ahead and there are no particular criteria to guide him, so, faced with the maximum choice, he may well delay while he tries to think of some. When booking a subscription series the customer is more concerned with negative criteria such as holidays, other engagements and so on. It is

preferable, I believe, to offer fixed date series and then, if the box-office and the accounting system will tolerate it, to be accommodating over ticket exchange. If the customer does get to the point of purchase, then one of the problems that faces the voucher system will apply: there will be a tendency for sales to 'bunch' at the end of the week. If the customer is encouraged to make a choice of, say, four shows out of six (which is fairly common with rover subscriptions) then there will be a tendency for sales to bunch around what the customers perceive to be the 'popular' shows. This is contrary to the idea of subscription which is to bring the customer in to see shows which, given the normal show-by-show freedom, he would ignore.

This kind of 'organising' of the customer's choice strikes some as being manipulative and somehow wrong, as though we are interfering with the customer's freedom. Some people, who are extremely knowledgeable about theatre, may indeed object to the contents of our packages: they may see something in the package which they know they will not like and so will not buy it. They will prefer to attend the theatre on their own terms and so will not subscribe. Others will be less discriminating and any negative feeling they may have towards a play may be more a matter of ignorance (*I don't know it so I don't like it*) or a reaction to a specific advertising message (*I don't like the look of that*) than any real knowledge. In the latter case I see no reason why, if we believe in the integrity of our artistic programme, we should not use the subscription method to widen people's experience.

You should never underestimate the size of the task you are setting yourself when introducing subscription. If we go back to that typical regional theatre with its 18 performances per play and its six play season and assume that it has a capacity of 600 seats we see that we have a maximum target of 10,800 subscribers and if we achieve that number we shall have sold 64,800 tickets. Anyone who has tried subscription will confirm that 10,800 subscriptions take some selling.

One of the early British objections to subscription was that it would deny the casual purchaser the opportunity of going to the theatre 'on spec'; those of us who have tried it know that it takes a long time and a lot of effort before we even begin to approach total sell-out on subscription alone. And if we do, is that something to worry about? I don't think so. First, if we have to turn a few people away, it means we have turned things around so that we are in a seller's market (whoopee!) and then we expand each play's run by another week which gives us another 3600 subscriptions to sell; that should occupy us for a while!

3 YOUR MARKET

Your first and major target must be those people who are already your customers. Because you have a more complicated proposal to put to these

people and because you must be thinking about the best way of communicating this to them, you will want to 'speak' to them personally rather than through the media of posters and ordinary press display advertising. I'll come to the detail of this later (under Publicity) but you must start with the best, most up-to-date mailing list you can compile. In traditional 'show-by-show' marketing, where you treat each play to its own special advertising campaign, you would avoid very large mailings because of cost, but with subscription you probably need to mail out only once or twice a year. A piece of advice I have not yet been able to take myself is to plan for subscription at least a year ahead and use that year to capture the names and addresses of as many customers as you can. Although you cannot be sure of their potential to you, you must accept that someone who has voluntarily come to your theatre to see a show must be more likely to become a subscriber than someone who doesn't know you at all. (Of course, if what they see is junk . . .)

Your second target is the hard one. It is made up of those folk who are favourably inclined towards theatre, who have perhaps often thought about visiting yours but haven't quite got around to it. They could be new to your area or they could be parents whose children have reached the age where they can be trusted with a baby-sitter. They might even have attended your theatre but your system allowed them to get away without capturing their names and addresses. The problem is, you don't know where these people are. So, in the initial stages of building your subscribing audience (which could take a couple of years or more) you must face the expense of speaking to many in the hope that the few will hear.

You will not sell to people who don't like theatre. No matter how much you want them to be part of your audience you will not be able, within the time-scale on which you work, to make them change their minds.

4 YOUR PRICING POLICY

If your theatre pricing policy is to offer seats at a range of prices, then presumably you will want to maintain this in your subscription system. This means that you have to offer a choice of subscription prices as well as some way of guiding customers into a regular commitment. This adds to the complexity of the information you put before people. It is not an insurmountable problem but it is one that I would avoid if local circumstances permit.

Part of my initial work on the Churchill Theatre, Bromley scheme was to recommend a one-price house so that the idea of subscription was linked to one price. It gave us the advantage of being able to offer our first-time subscribers the 'pick of the seats' and it meant that those who booked first had the advantage and, when later they sat down in a full house, they were

reminded of that. A vital part of the selling process is to find ways of getting customers to buy now and a one-price policy helps you in this. I have recommended it to other client theatres and where they have tried it they appear to have adhered to it. There are other considerations, of course, and if you are forced to have very high prices then the one-price approach might founder if your subscription price is too high; you will then need a range of prices in order to have lower prices to attract people.

An advantage that theatre has over, say, orchestral music or opera, is that prices, even subscription prices which have to cover the cost of our notional six play season, are relatively low. My client, the Philharmonia Orchestra, in its subscription series in the Royal Festival Hall, has to offer a multiple price subscription with a maximum price of as much as £50 or £60 before discounting. English National Opera at the Coliseum has subscriptions in the same price range. So has Scottish Opera. Theatre subscriptions tend to be lower, in the teens and twenties.

However one approaches the matter of pricing, therefore, there is the sales barrier of what must always be a higher price for the customer and this must be reduced (it can never be eliminated) by discounting and by strong emphasis on the benefits of subscription to the customer—the benefits to your theatre are obvious and should not, I believe, be stated.

5 YOUR SALES PROMOTION POLICY

I have heard people talk of subscription as though it consisted only of offering a discount to make people buy more and because this is definitely not the whole story I have lodged this part of the appendix firmly in the context of all the other considerations. We are trying to persuade people to make a greater time commitment and to spend more money than we have ever asked them to do before, so it does make sense to offer a financial inducement. As with all sales promotion techniques we should offer no more than we need to and we should stop it altogether once we have the confidence to do so. I must confess that I have not yet reached the point with any project where I could do this, but I live in hope. I have, however, significantly reduced the level of discounting with no disadvantage in terms of sales.

At the introduction of subscription, the discount should be large enough to be significant to the customer: figures of 30 per cent or so are common. The reduction can take the form of 'One Play Free' or 'Two Plays Free', which is generally more appealing than a stated percentage which, after all, doesn't mean very much until it is specifically related to the starting price. It can be expressed as 'Save £8' or, if the resultant price after discounting is attractively low, the statement can be 'See Six Plays for only £14'.

Sales promotion devices such as these should be thought of as ways of stimulating sales and as ways of accelerating sales. The basic discount is intended to overcome the sales resistance I have already referred to. Because a delayed sale can be a lost sale, there is something to be said for offering another inducement to encourage people to buy even earlier than your stated closing date for subscription selling. I have used devices such as competitions (free) but the most effective has been the 'bonus' discount, a flat price reduction, quite small, open to those who book within, say, the first four weeks of a campaign. If we refer back to the one-price approach we can see that this is a kind of special sales promotion method which offers the best seats to the first customers.

Once the subscription system is well under way and a substantial body of subscribers has been gathered in, consider their importance to you and start to develop special 'subscribers only' bonuses. So far (in 1983 as I write this), I feel that not enough thought has gone into ways of keeping the subscribers in whom we have invested so much. I have experimented with extra discounts, that is having one level of reduction for first-timers and a preferential rate for old-timers, and the results have been pleasing.

I cannot go into all the possible changes that you can ring on the discount and incentive theme. It is an area wide open for creativity and I can only counsel the first-time subscription theatre to be alert to the many ways in which customers can be motivated and to keep ringing those changes so that familiarity does not set in, and what was first offered as 'special' becomes the norm and so is taken for granted.

6 YOUR SALES APPROACH

Subscription marketing focuses the mind on the importance of the sales function. You are making contact with your market by means of pieces of printed paper and these are, at best, relatively impotent: they may make people want to buy but you must have more than that—you want ACTION. Experience tells you that while people may believe that they will make their purchase tomorrow, when they are in town, they often don't and the sale is lost. Because you have invested much money, effort and imagination in the campaign, and because you really cannot afford to have it fail, you must do everything in your power to make that purchase happen. The whole thrust of your advertising message in the leaflet is to that end.

Your leaflet, therefore, becomes much more than an advertisement, it becomes your salesman. It is conceived so that it will take your potential customer through the stages of Awareness, Interest, Desire and ACTION—which means that your leaflet will contain the information and means to make purchase easy and direct. The leaflet contains all the

necessary sales information plus an easily-completed application form and, as an alternative, a telephone number for instant purchase by credit card. You try to remove all possible barriers to purchase. Credit card booking not only enables the customer to book by telephone but also, in the case of Access/Visa gives credit, which can be valuable where the cost of subscription is relatively high and is a sales barrier.

The leaflet is accompanied by a Freepost address so the customer doesn't have to hunt for a stamp to put on the envelope. You do not insist on the inclusion of a self-addressed, stamped envelope—so the customer doesn't have to hunt for another stamp. The same applies to a press advertisement used for the same purpose.

If your leaflet is to be posted, or distributed on a door-to-door basis, don't send it out all by itself. Introduce your theatre and your leaflet by means of a letter, not just a 'Hello there, come to our theatre' kind of letter but a *sales* letter, one which is intended to complement the sales message of the leaflet. The letter personalises your mailing, it makes it a message from you to the individual, so make it as personal as you can. If it is going to a small (in relation to a mass mailing) identified list of known customers, address it to the customer and have it signed by your top person. Use the letter to give greater emphasis to your main sales points contained in the leaflet and to bring into the story any recent supportive information such as customers' reactions to the new scheme, how well the scheme is going and so on. If you are using one leaflet to go for several different groups of people use the sales letter to target your message more accurately. If the budget will stretch to it, put in either a Freepost addressed envelope or a reply-paid envelope: it will improve your sales chances. Give thought to the envelope that contains this potent package. If it is going to very well-known customers such as subscribers in a developed scheme, then keep it looking good in terms of quality and how it is addressed (ideally, it should be individually typed—and, of course, nowadays the word processor can assist in this). If it is going to the broad mass of new people then take a tip from the professional direct mail experts and 'trail' your sales message attractively on the outside of the envelope.

You can do more. Build into your campaign as much ACTION of your own that resources will permit. Within the theatre foyer create a special sales point, a counter or booth, which is a strong focal point, that has plenty of your sales brochures available and a staff member there to explain, guide and SELL. It would be splendid if we could develop this within the box-office but, in a busy theatre, it will be hard to achieve. Even in a not-so-busy theatre, given prevailing attitudes and levels of training, it would be hard.

Hold a sales party (only don't call it that); invite a few hundred of your known customers to come along to hear about the new season, offer light

refreshments and any other inducements (perhaps a very short entertainment or the personal appearance of a friendly 'star') you can think of.

Hit them hard with the benefits of the new scheme and how easy it is to purchase. *Why, you can even do it NOW! Cash, cheques, credit cards—we'll take anything—look, just over there you'll see five separate tables and five people ready to take your subscription booking. We'll take your orders now and send you your tickets for the BEST seats available, tomorrow. And I have here a magnum of champagne and I am going to present it to the member of the theatre's staff, sitting at one of the tables, who achieves the highest number of subscription bookings in the next 30 minutes. So pick your winner and join the queue. In 30 minutes' time I'll ring a bell, we'll all gather again and I'll tell you how many subscriptions have been sold and which staff member you have made the winner. And then we'll all have a glass of wine (but not the prizewinner's champagne) and go home.*

Oh, isn't it vulgar! Believe me, people—your customers—like it. Remember what the word vulgar means.

But don't get carried away with your activity and make sure that your time is well spent. Telephone selling, for example, may not be appropriate for your first campaign. If you have sent out your sales brochure to a good list of your known customers, give it time to work. If you have given good emphasis to your deadline, the final date after which orders cannot be accepted, and if you have built in some good sales promotions such as special early booking discounts, then wait until you are within a couple of weeks of the deadline. Then, you might reasonably begin to approach people by telephone, not overtly to sell but to remind them that booking closes fairly soon and to offer them the facility of booking now by credit card. If it could be organised, have the booking plans to hand and offer them the extra benefit of having a specific seat allocation made then and there. If they do not have a credit card, make the booking anyway and ask them to put the cheque in the post (no stamp needed, remember) marking the envelope for the personal attention of the caller. What you are seeking is the commitment: most people, once they have agreed to purchase and know that their tickets have been allocated, will not renege on the deal.

In this way you bring the number of people to be called down to the minimum. With this in mind don't necessarily mail out only once. If you have allowed a three month sales period (which is quite normal for a subscription campaign) you might very easily send out three mailings containing the same brochure but a different sales letter, each of which carries a greater degree of urgency.

I have found it valuable to use the sales letter to give people an up-date on the sales position: 'the Friday and Saturday series are very well taken up now but there is first class availability for the last two of the Wednesday

and Tuesday series. Please note that this special subscription offer must close on the last day of this month so don't delay. If you prefer, you can book over the telephone using this special, direct, "subscribers' line".' Be careful not to let those sales letters sound desperate: urgent, yes! Desperate, no! No matter how sales are going you must keep your head and look confident. Nobody goes to the theatre out of charity.

Telephone selling requires skill and experience and it is particularly hard if you are speaking to customers in this way for the first time. They are not used to it and you are not used to it. So, prepare yourself, and your staff, with an outline script and a special booking form on which they can write easily as they take down information over the telephone. Improve the script as you go along. When you have built up your subscribing audience over a number of campaigns you will find it very easy to call the people who are your special customers and they will be pleased to hear from you and grateful for the reminder. Even on a first-time campaign I have found that people don't mind being called, provided that they know who is calling them (make sure from the start they know who you are, where you are from and that you are not selling double glazing) and, indeed, they are quite flattered to be called. Most of them will thank you for calling even if they don't buy. If you have a team working on it, devise an incentive scheme with payment by results (if your system will permit it) and prizes for star sales-people. Make it fun.

7. YOUR PUBLICITY

If you see your targets as I have defined them, you will accept that the direct mailing of leaflets to your prime target, the known customers, is the main element in your first campaign. Your second target, the great unknown, poses for you the problem of distribution and hence heavy cost.

The production of a leaflet addressed to your known customers should not present any problems for you. Because you have accepted (you have, haven't you?) that you cannot sell to those who don't want to buy, this leaflet will do as well for those people you haven't yet met because, although you don't know them you know that they will have similar tastes to those you do know. So, at least you don't need to produce two leaflets—well, actually, I think you do but we'll come to that in a while.

Within the geographical limit that you define for your theatre audience the ideal must be to put your enticing message through the letterbox of everyone. In some communities that is not as impossible as it seems. Your major cost factors will be the production of lots of leaflets and sales letters all packaged into their attractive envelope and getting them through those letterboxes. If the sheer size of the task is too great from a financial viewpoint, and because you do not want to waste money if you

can avoid it, you can attempt some form of classification of neighbourhoods according to how they stand in the socio-economic scale. People often do this from personal knowledge, having lived in the place for a long time or they can use information based on market research. It is intelligent to look hard at your existing list of known customers and to base your assessment of neighbourhoods on the basis of where you are presently drawing people. Whether you do it by this rule-of-thumb method or resort to more sophisticated methods is up to you.

What you can be sure of is that the level of response to this kind of distribution will be surprisingly small. Whether you go for a blanket distribution or a more selective approach, whether you buy special mailing lists of, for example, accountants who have qualified since 1975 or people who have bought records and tapes of classical music within the past year, the response will be low. Of course there will be variations, with some methods doing better than others but do not expect anything more than a low response.

On this kind of relatively random distribution one would be happy with a response rate of 1 per cent; look at it in terms of results. Suppose you distribute 10,000 leaflets and get 100 responses: each response will contain an average of, say, 2.4 subscription series orders (that is how it seems to work out on the schemes I have handled) which means you have 240 subscribers.

If the cost of subscription is £14 you have orders worth £3360 and you have sold (given our notional six play season with each play running for 18 performances) 1440 tickets which is 2.4 full houses. Out of your 108 performances you have sold 2.22 per cent. Do the same exercise over a distribution of 100,000 and you have (if you are lucky) pre-sold 22.2 per cent. The costs we'll come to later.

How you get those leaflets through the letterboxes can be comparatively simple and not overwhelmingly expensive. If you decide to post *en masse* to named individuals it will cost whatever the prevailing rate is, less any discounts available for large mailings. However, the Post Office has its Household Delivery Service with charges of around £30 per 1000 households which means that the 10,000 distribution will cost approximately £300.

Another approach is to use the newspaper medium instead of mass leaflet distribution—given certain conditions. We go back to the problem of complexity which demands that we use larger pieces of paper to make our leaflets in order to carry all the information. If we need, say, an A2 sheet of paper to carry our message (which, being used on both sides gives us the equivalent of an A1 sized space) then it is going to be difficult to cram all that on to a piece of a newspaper and make it work as an advertisement. However, it can and has been done. If there is a regional edition of the

paper, as there is, for example, in the case of the *Sunday Times* and *Observer* colour magazines, the *Radio Times* and the *TV Times*, then the distribution of the paper and cost of advertising in it will bear some relationship to your own geographically defined target market and your financial objective. As an alternative, one might consider paying to have the leaflet inserted in a regional edition: this has the advantage of allowing you to use the medium of the leaflet with its size and colour combined with the distribution advantages of the paper. The disadvantage of this can be (as it is in the London and South Eastern region) the sheer size of the distribution which calls for huge print runs and takes the leaflet well outside your target area.

But, again, do not expect large returns; response will be probably be lower in percentage terms, in relation to circulation, than the large-scale, door-to-door distribution.

Between the two extremes of those you know and the mass of people you do not know there are, fortunately, two groups of people that you can contact cheaply and easily. The first is those people who are friends of your known customers. In the initial stages of a subscription campaign one might consider sending more than one leaflet, with a covering letter asking your known customer to pass the good news on to friends. The other group consists of those people who just drift into the theatre to see what is going on, at any time of the day and those who come to individual shows during your subscription sales period. They may not buy a ticket, they may be there for a quick cup of coffee, but they are there and so define themselves as people who don't actually detest the thought of going into a theatre. It is, therefore, worthwhile thinking about making a special effort to draw attention to the new scheme within the theatre building: to have that special sales booth and display with plenty of leaflets ready. During the sales period of the campaign the theatre is still open and attracting customers, customers who may easily evade your attempts to capture their names and addresses, so make sure that theatre programmes carry big advertisements for the scheme and put leaflets on the seats to await these people. Make sure that your public address system draws attention to the scheme as well.

As for the subscription leaflet itself, that is something either to be treated at length or very briefly. I must opt for the latter. If you have taken my points about the sales approach in Part 6 of this appendix then you will accept that the idea of subscription marketing has moved us from the concept of 'advertising material' to that of 'sales material'. In the leaflet we are attempting to make people want what we have to sell and then to sell it to them. Although we do not know all the people to whom our leaflets are addressed, we have made the assumption that they are well-disposed towards theatre and we do not need to try to 'hype up' what we have to sell (and we know that if we do, we might well alienate our known customers). That doesn't mean that we have to be sterile and boring, it simply means

that we should not let our enthusiasm run away with us. There is plenty of scope for energetic design and copywriting between the two extremes.

I have observed a tendency towards leaflet copying which is not such a clever idea. Just because a leaflet is part of a successful campaign *there*, it doesn't mean that it is going to work *here*. Also, plagiarism will not make you popular with your colleagues—people like me who earn their livings creating design concepts and writing copy. Your leaflet should be wholly developed from your own unique concept, tailor-made for you and for your customers. Don't think that the famous words 'SUBSCRIBE NOW!' have any magic power either; you may want people to Subscribe Now! but your wishing won't make it so. So, start from first principles and try to produce an *original* leaflet that will convey your selling message effectively; you will achieve more in the end and you will learn from the experience.

You start your subscription campaign by concentrating on your known customers (who cost you comparatively little to contact) and by trying to draw into the fold those anonymous folk 'out there' (who cost the earth to reach). The successful progress of your scheme should be marked by the regular renewal of a substantial percentage of your ever-growing group of subscribers and the constant addition of the newcomers, season by season. Once the central core of subscribers has been formed you should then start to think about reinforcing the relationship through the introduction of special 'old subscriber' privileges such as additional discounts, priority booking over new subscribers and a range of new, original, sales promotion devices that will hold them to you at minimum cost. At this stage you may well consider the production of a special leaflet intended only for people on your 'old subscriber' file: this can be, in most respects, almost identical with your leaflet aimed at newcomers but with certain key differences in respect of discounts, other incentives, in the information you give them and in the language you use. These subscribers were hard won and you must use all your imagination to keep them.

8 FINANCIAL PLANNING

It is in the area of financial planning that your courage and that of your theatre board will be most tested because the introduction of subscription will almost certainly involve you in greater financial risk than you have ever faced before. There is always financial risk in theatre marketing but, if it is approached in the traditional way, the risk is spread over many separate campaigns and limited to expenditures that have become traditionally small. What seems to happen is that the theatre 'matures' with just so much being spent on publicity and just so much being achieved at the box-office. Because of the irritating phenomenon that turns stasis into contraction, the

theatre looks up one day and realises that its deficit looks like being bigger than its grant this year. *Oh, My God!*

What are we to do? Cut production expenditure? *Yes!* Cut publicity expenditure? *Yes!* Cut staffing? *Yes!*

NO!

It is often only when it has reached the point of desperation that the theatre considers subscription and then it really does need courage because it is about to put the shirt it hasn't got on a horse without a jockey. Because subscription is a good horse it sometimes manages to win despite the handicap, but how much better it is to plan to introduce subscription when you are doing reasonably well, are enjoying reasonably good audiences, have adequate staffing and do not quake when the bank statement arrives.

Whatever your state of health, however, you will still need courage when you introduce subscription. You introduce it because you intend to increase your audiences and the income derived from them—but before you reach this position you must make a greater financial outlay than you have ever done before. You must produce SALES material, probably bigger and more colourful than hitherto. And more of it. So you have larger design bills, larger print bills. And you have to distribute it. Larger postage bills. You may wish to advertise it. Larger press advertising bills. Sales letters. Special envelopes. That is just the start of it. What about those discounts?

This is where subscription really begins to hurt. I have seen accountants really wince over discounts. 'What you are proposing to do is to give money away, aren't you? You are going to sell tickets to all those people who would have bought tickets anyway, but at a lower price. And credit card companies: you are going to be paying those parasites a commission! That reduces your income even more. Freepost? Even more. You will end up giving the tickets away.'

There is only one way out of this dilemma and that is to produce a realistic and optimistic set of estimates of income and expenditure. If you are presently playing to 50 per cent houses then set yourself a target of 75 per cent and see what that would mean in terms of gross income. It will mean more than you have been getting. What is the difference between the gross yield on 75 per cent and what you are presently taking? Write it down.

If you spend all of this sum on launching your subscription campaign in the first year and it works, that is, you achieve your 75 per cent target income, will you be better off or worse off? You will have bigger audiences and that is what you are there to get.

You will be better off. Next year, of course, it will not cost you so much to run the scheme because you will have captured your audience and then you can start to make financial gains as well.

So, what you must do is to reach out into the future and take hold of that extra money you intend to make and start to plan how to spend it now. It is a gamble. An act of faith. You need self-confidence. (Of course, you don't have to spend *all* that extra money—I was exaggerating to make my point—but you still need self-confidence!)

In this way you begin to establish a TARGET INCOME and an EXPENDITURE BUDGET. Remember that your target income is gross income: you have made no allowances for discounts. The next step is to allocate budgets.

Budgets? Surely there is only one budget, the publicity budget? No, there are three principal budgets. Currently few, if any, theatres operate them. You have your publicity budget, naturally. And your sales budget. And your sales promotion budget. Each of these three contribute to your achievement of the target income. Each should be thought of as areas of expenditure and properly quantified.

Sales promotion is likely to be a larger expenditure than publicity. Let us go back to our example of the 600-seat theatre, with six plays, 18 performances per play, and therefore capable of holding a maximum of 10,800 subscribers. I said that those subscriptions might be sold at £14. Let us assume that we have offered an introductory discount of 30 per cent and we plan to sell 75 per cent of our seats on subscription. First, we are aiming to sell 75 per cent of 10,800—that is 8100 subscriptions. The price-before-discount of each subscription is £20 (30 per cent off £20 leaves £14) and so, each subscription carries a discount of £6. If we achieve our target of 8100 subscriptions we shall have 'spent' £48,600 (i.e. 8100 × £6) on this sales promotion alone. Of course, our target income (gross) is £162,000 (i.e. 8100 × £20).

This is not playing with figures: £48,600 is what you have spent—if you achieve your target income. You must work in this way because you must always be aware of what you are spending.

I meet many people who will argue for hours over the size of a publicity budget and make decisions over the size of a discount in minutes. Yet, in the case above, a reduction in the discount from 30 per cent to 29 per cent would drop the expenditure by £1620 if the target were achieved. You can buy nearly 13,000 second-class postage stamps for that sum.

How can it be worth it to spend such a sum on discounts? Would it not be better to stay as we were? Assume our typical theatre was playing to 50 per cent. It would be achieving an audience equivalent to half our maximum of 10,800 subscribers: that is 5400. They would be paying full price: £20. The yield from this audience would therefore be £108,000 (i.e. 5400 × £20). This is £5400 less than the net yield of our 75 per cent subscribing audience (i.e. 8100 × £14). So, we could go out and spend £5400

on publicity and sales and, provided that we achieved our target, we could consider ourselves successful.

The sales budget will be smaller. We do not have to cost into the campaign the wages of our box-office staff and we will probably find it impossible to introduce incentive schemes which pay staff commissions on sales. In practice, therefore, our sales budget may need be no larger than is required to pay credit card commissions, cost of Freepost responses, telephone charges for a telephone sales campaign, the 'sales party' and any other sales activity. But, by having a sales budget, no matter how small, we are approaching our marketing task in an efficient manner, we are reminding ourselves (and those within the organisation who do not approach problems with the same degree of determination) that there is such a thing as the sales function. Then it can grow from there.

Do not take this one example too literally. The figures were chosen for the purpose of illustration. This kind of calculation is usually the starting point from which one jigs and rejigs target income and the three main budget areas until one arrives at estimates that make some kind of sense. Until one has established a scheme and a pattern of figures this kind of estimation is little more than a guesstimate. However, so important is it to break out of a 'mature' and static position that, in my view, it is perfectly justifiable to set out to spend an extra £1 in order to achieve an extra £1. Later, the ratio of new income to new expenditure will improve.

I cannot over-estimate the importance of creating these budgets and of approaching sales and sales promotion as one does publicity. It will help the accountants to understand what is going on and it will help you to make better marketing decisions.

One must think in terms of £1 expenditure going out to generate income and whether that £1 is spent on advertising, on a discount or a sales commission, it is still a £1 and it still has a job to do.

The whole exercise is, as I have said, a gamble that takes courage, but it is preferable to sitting paralysed by imminent disaster and then being swept down the plug-hole of the deficit spiral.

When the campaign is over you will know how closely the reality compares with your estimates. Draw up the final figures quickly, under the same headings that you have used for the estimates. Publicity expenditure should be as in your estimate and so will some of your sales costs. Discounts and commissions are linked to results so, if you fail to achieve your target income, at least some of the expenditure will fall below estimate as well. At this stage it is a good idea to write yourself a report on what you planned to make happen and what actually happened. Look at the financial relationships and draw some conclusions as to where you might reduce expenditure and where it might be increased. Refer to your report as you plan the next campaign and add to it as you go. It is very easy to forget

the rationale behind a marketing strategy, and if you keep a good record you can remind youself why you took a certain course of action.

The end of the subscription campaign and the drawing up of the final figures is not the end of it. The season has not yet started. You have sold, we hope, a large number of subscriptions and, in many cases, you have the money before your theatre has spent anything on actually creating the product. You have sold a lot of promises and you have the money in hand, now. Put it in the bank and let it grow.

When the season starts you should begin to observe an interesting phenomenon. Your sales of ordinary full price tickets should be greater than you would normally expect. I have seen this happen on several occasions and it seems to obey a sort of 'critical mass' theory; if your campaign has made an impact on the community and enough people have subscribed and are talking to their friends about it, you have created a word-of-mouth campaign that results in extra full-price sales. It is also the result of creating greater awareness of the theatre and its work through your much larger than usual campaign: it is as if all the people who nearly bought subscription decide to come along to see what it is all about. Make sure that when an assessment is made of the results of your scheme, that the income directly attributable to subscription sales is seen in the context of the theatre's marketing achievements as a whole. If you have made subscription work, then you can take credit for the increase in ice-cream sales as well.

9 TIMING

If we take into account all the work involved in subscription marketing the ideal must be to run one campaign a year. In theory, we might package up the whole year's product, have a 'Grand Sale', and then sit back to enjoy the fruits of our labour. Two things work against this. The first: if yours is an active theatre there will be so much to sell that the size of your subscription packages, and hence the commitment required of your customers in terms of money and time, will probably be too great. The second: you will not sell all your seats on subscription and so you will have to maintain some regular form of advertising, albeit at a reduced level one hopes, throughout the year.

In my experience, there is much to be said for running two campaigns a year. The first being the major one that carries the shows running from, say, September through to April. The second, a smaller one to sell the shows from May through to July.

For the major campaign, a typical time-scale might run like this (the dates have been put in reverse order because this is usually the way we plan them):

Mid-September	Season starts
Mid-August	Box-office opens for first play
July 31	Subscription booking closes
July 14	Telephone sales start to known customers
July 1	Final reminder mailing to known customers. Press announcement giving final reminder to 'new' customers.
June 1	Campaign launched to 'new' customers. Second mailing to known customers
May 1	Campaign launched to known customers by mailing

(It is assumed that the theatre will continue to sell tickets for individual shows approximately one month before they open and that the box-office will need about ten working days to reconcile the books after subscription and prepare for ticket selling in the usual way.)

How long it will take to prepare for May 1 depends on how soon the artistic director can fix the product and how fast you can work. For a first subscription campaign one needs a three-month period in which to make detailed planning and to organise the department. Tickets for the season will have to be ordered and special box-office systems devised to allow for discounts. This gives a starting date of February 1. Inevitably committee approval will have to be obtained for this innovative step and so, in order to introduce subscription in time for a September start, one might easily begin preparing for it well before Christmas of the previous year. This is beginning to approach the period of time I recommended in Part 3 when discussing 'Your Market' for the building up of a mailing list of known customers.

The second campaign will cover the May to July period. It will include fewer shows over a shorter time period and will therefore require less of the customer in terms of time and money. You may be able to get away with a smaller sales brochure because you have less to sell. If your first campaign has been successful you will now have the hottest of all hot mailing lists, not merely known customers, but subscribers who, while you are planning and implementing your second campaign are actually experiencing the reality of the first. Not only do you have these people's names and addresses, you know when they will be at your theatre and what seats they will be occupying. You will be able to make something of that, surely?

The time-scale for this campaign, again in reverse, might be:

May 1	Season starts
April 1	Box-office opens for first play
March 12	Subscription booking closes
February 25	Telephone sales start to unrenewed subscribers

February 11	Final reminder mailing to subscribers and press announcement
February 1	Campaign launched to 'new' customers. End of subscribers' priority booking period
January 4	Campaign launched to subscribers

This second campaign is shorter than the first because it is squeezed between the two holiday periods of Christmas and Easter. This is not a serious matter if the first campaign has done well because the main target is the first group of subscribers. As experience grows, it will be possible to close the shorter campaign sales period at the end of February and include in the subscription package plays that run from April to July. The larger campaign can then include plays running from September to March. To have one season covering seven months, and the next four months is an almost perfect sales strategy.

10 CONCLUSION

Subscription marketing is probably the best thing that has ever happened to the performing arts but it is not like a recipe where you just mix ingredients and everything works out as you hope. To make subscription work you must be skilled and experienced in all aspects of conventional arts marketing. This means that you must be able to analyse marketing situations, develop strategies that relate to those situations and have the ability to implement the strategies. As I write this, some four years AD (After Danny), I know of many, many cases where all the characteristics of the classic subscription scheme appear to be present but there is little or no significant achievement. For a theatre of the kind I have used throughout this appendix as an example, which I believe to be typical, to have a subscribing audience in the hundreds is not success and there are, regrettably, more cases like this than there are where the numbers run into many thousands. If I were asked to give a mid-term report on the state of the art I would say, 'Very enthusiastic, tries hard but so far is under-achieving. Can do better'.

Now, you go out and do better.

APPENDIX B

SUBSCRIPTION AT THE CHURCHILL THEATRE, BROMLEY

by Sheila Dunn

Full houses were predicted for the opening season of a brand new theatre in the centre of a prosperous town, and the Churchill Theatre was a name people were hardly likely to forget. Playgoers had been without a professional theatre in Bromley, Kent for over seven years—since the former New Theatre in the High Street burned down in 1971. A specially written new musical by local author Lord 'Ted' Willis, based on Bromley writer H.G. Wells' *The History of Mr Polly* was to be staged with a talented cast headed by popular and versatile Roy Castle in his first major theatre role.

When HRH Prince Charles opened the Churchill Theatre on 19 July 1977 euphoria was only superseded by relief that the planners had got it right. Patrons, some of whom had been on the waiting list for five years, packed the sublimely comfortable auditorium for two weeks of gala nights. Then, for the remainder of the six week run, the Churchill played to less than half full houses.

Then things improved for a while. With an auditorium seating 785, three-week runs and popular shows, the theatre seemed hardly big enough and yet, during the months which followed, in spite of well-known actors, two new plays and a new musical played to paid attendance figures as low as 28 per cent. This attendance see-saw resulted in an average attendance for the financial year 1977/78 of 64 per cent.

Theatre director, David Poulson, kept to his resolve to present as wide a range of plays as possible with more adventurous new productions alongside classics, revivals and recent successful West End runs.

During the summer of 1978 he disproved the theory that in August everyone leaves town; he put Alfred Marks into *How the Other Half Loves* and pushed the figures up to 75 per cent. Maugham's *The Letter* with Honor Blackman followed, still in August, with just a 10 per cent smaller audience.

Then, just when it looked as though a pattern was emerging it reversed again.

Many well-known actors were contracted for 'A Festival of Comedy' during the Autumn 1978 season. Only one play, Wilde's *An Ideal Husband*,

managed to achieve an attendance as high as 67 per cent. During the winter and following spring—considered to be the favourite time of the year for Bromley playgoers—Ayckbourn's *Relatively Speaking* reached 69 per cent and Alan Bennett's *Habeas Corpus*, 66 per cent. Only John Fowles' *The Collector* with Robin Nedwell and Susan Penhaligon played to 74 per cent. The financial year ended with an average attendance of 58 per cent.

The new theatre director, Ian Watt-Smith, came to a theatre with diminishing audiences and it seemed that there was little he could do to arrest the decline. Out of 16 plays which followed his arrival, only Neil Simon's *The Odd Couple*, reached 60 per cent, *Arsenic and Old Lace* reached 74 per cent and *Joseph and his Technicolour Dreamcoat* reached 80 per cent; these three productions managed to keep the year's overall attendance figures up to around 50 per cent.

At the time I was working in the theatre as party organiser, bringing in as many party visits as possible, giving talks across a wide radius and adding as many group organisers' names to the mailing list as I could. It was hard work and not always rewarding.

It was towards the end of 1979 when I saw an advertisement in *The Stage* for a book by American, Danny Newman, called *Subscribe Now!*. Selling subscriptions the North American way was in such contrast to anything we were doing that I was prompted to send a personal cheque to secure a copy right away. Later, I put the book down, fascinated and inspired, and passed it straight on to the theatre director. He read it, reacted to it in a similar way, and passed it on to the chairman of the board.

We started to think seriously about introducing a subscription scheme. The chairman, Councillor Denis Barkway, was in favour. During Danny Newman's memorable visit to London both Denis Barkway and Ian Watt-Smith met Danny Newman privately and they were convinced that the scheme would be advantageous to the Churchill.

The timing was just right!

We were in the middle of a Russian season. The play at the time was *The Promise* by Arbuzov. The excellence of the direction, acting and design was seen by only a very small number of people. Why? The Russians had invaded Afghanistan.

Something had to be done about world events influencing our attendance figures!

Keith Diggle was asked to carry out a study into the feasibility of introducing a subscription scheme. At the time the publicity budget was £39,000 which had to sell eleven plays, Sunday concerts, visiting touring shows and a pantomime. 60 per cent of the budget was spent on classified advertising in the national press and display advertising in local, London and outer Kent newspapers. Four or five calendar-of-events leaflets were distributed to a mailing list of around 5000 people who paid a small sum

annually. An extra 700 were on a free mailing list as potential party organisers. Other leaflets were despatched to free sites: libraries, dentists' and doctors' waiting rooms etc. and the rest were available in the theatre. The way we approached the selling of theatre was typical of most theatres around the country.

Keith Diggle's recommendation was that we should go for subscription and he estimated that it was going to cost us an extra 40 per cent of our planned publicity expenditure to carry out the two campaigns he thought we should mount during the year. It was felt by all concerned that we should not abandon our other publicity and that a 'belt and braces' policy would be wiser. The extra expenditure would have to be approved by the Churchill Theatre Trust.

There were members of the board who were doubtful about the claims put forward for the proposed change in marketing policy and were not happy about the extra expense involved. The recommendation was debated over several board meetings with Ian Watt-Smith and Keith Diggle having to put their arguments to the test of some rigorous questioning. The treasurer was asked to meet Keith Diggle and to go into the financial implications very carefully; after some initial scepticism based largely on the belief that subscription would only be taken up by those who would have bought tickets anyway, he spoke up in favour of the scheme. Reaching a decision took time, but finally the answer came in the affirmative. It left very little time to run the first campaign.

Keith Diggle was retained as marketing consultant to the theatre, to work with Ian Watt-Smith, the publicity officer, Ann Crick and myself.

As a first step Keith Diggle recommended that as the theatre had excellent sight lines and equal comfort throughout the auditorium, a one-price ticket policy should be adopted. Only on Friday and Saturday evening performances would an extra £1 be charged throughout the house. Subscribers, however, would be asked to pay just one price to attend the six plays in the first season—no matter which night of the week they chose. The thinking behind this was simply to encourage early purchase; we wanted to create yet another reason why people should book now rather than later.

The subscription brochure was written and designed by Keith Diggle and planned to unfold from an A5 size up to a full A2 layout showing the six plays. The headline, 'Curtain Up On A Wonderful Season' was expanded throughout the copy and the theatre's best advantages boldly stated. 'The best seat in the house is the seat you want—and you can have it if you book now!' the brochure shouted. 'Any seat in the house, any night of the week', it added equally loudly. People said that it was a 'brash way of selling seats—hardly theatre!'.

As an added inducement we offered a prize competition to all subscribers, the prize being a pair of first class return tickets

London/Manila which Keith Diggle obtained for us from Philippine Airlines. Later my own contacts with British Airways resulted in free holiday prizes for subsequent campaigns. To what extent these sales promotion devices actually increased our subscription levels I shall never know but I can say that they made our brochures more exciting and added a lot of glamour to our campaigns. They cost us nothing beyond a little space in the brochure that we really did not need anyway and they did bring some tangible rewards to a few of our valued customers.

The scheme offered tickets for six plays for just £11.40. Customers had a free choice of seat and a free choice of night. 2800 people took up the offer. The result fell short of our ambitions but it was the first campaign and we all had lots to learn. We spent money unproductively and we were short of time. There were box-office problems too; our staff were not geared up to all that is involved in the processing of a deluge of postal bookings.

While all this was going on the theatre's pre-subscription season drew to a close. Of the final three plays, two recorded a paid attendance of 32 per cent and the last play achieved just 34 per cent.

Our 2800 subscribers already guaranteed us 20 per cent capacity before the six play season started and we eagerly awaited the response of all those who had 'nearly bought' our subscription offer. The first play recorded 56 per cent paid attendance, the second 61 per cent, the next 79 per cent, then 83 per cent, 82 per cent and finally 92 per cent as the season closed.

After this campaign the theatre director reorganised the marketing department and made me press and public relations officer/subscription manager.

The second campaign required us to sell a four-play season over the spring and summer period. The subscription price was £7.60 and the same basic sales message, with the same customer advantages, applied. We used a smaller brochure, A3 when unfolded, printed in two colours. 76 per cent of our 'old' subscribers renewed. New subscribers brought the total up to 5930. That was a jump to be proud of!

The third and fourth campaigns covering autumn/winter 1981/82 (six plays) and spring/summer 1982 (four plays) maintained the level at around 6000 subscribers which meant that some 50 per cent of our seats were sold before the seasons started. In the fourth season the play run was extended from two and a half weeks to three and a half weeks so the theatre director experienced a summer season with more seats per play to sell at a traditionally difficult time, where attendance held up well. Before subscription summer season plays running for a similar period had achieved as little as 30 per cent. The worst selling play in our fourth season, a new play with a very difficult title, achieved 46 per cent.

Keith Diggle's consultancy period with the theatre ended with the fourth campaign and although we remained good friends I must admit I was champing at the bit towards the last few months in my enthusiasm to 'run my own show'. I was looking forward to the fifth campaign!

As Keith would put it, our level of marketing activity and achievement seemed to have matured at a set level. We would have to spend more to achieve more. Our total subscription budget for 1981/82 had been £20,000. We increased it to £27,000 at the expense of newspaper advertising for individual shows and so moved away slightly from our 'belt and braces' policy. I spent the extra money mainly on more brochures and a much wider distribution for them and backed it up with substantial press advertising for the subscription offer. I also offered an extra £1 discount to all current and lapsed subscribers as a 'fifth birthday celebration offer'.

For campaign number five I had five plays to sell for £12.50. We achieved subscription sales totalling 6975. That was another jump to be proud of!

APPENDIX C

ARTSBANK

I have included this appendix on Artsbank because it suggests a new approach to arts funding which, if implemented, would greatly stimulate new marketing activity. The present system creates conservatism because the implications of failure are more than most arts organisations dare risk. Artsbank is also intended to encourage and reward the entrepreneurially inclined individual so important to the expansion of our arts activities.

I first put forward the idea of Artsbank at the start of 1979; I referred to it during my lecture tour of New Zealand and Australia in March/April 1979 and it was very nearly taken up by the Western Australia Arts Council. I published an outline of it in *The Stage* in May 1979. In 1980, David Pratley, then director of the Greater London Arts Association, expressed interest and a joint paper was produced over the names of Diggle, Pratley and Tony Gamble. When David Pratley became regional director of the Arts Council it was agreed that Tony Gamble and I would carry on with the project and a revised version of the paper was produced which took the form of a proposal to possible sponsors. The paper was sent to, amongst others, the government's Office of Arts and Libraries, ABSA, the Gulbenkian Foundation and several leading commercial sponsors. The Arts Council was not approached because at a much earlier stage an outline of the idea had been put to its then finance director, Tony Field, who had discussed it with colleagues who 'were adamant that they could not recommend the Council to take any financial interest in it'.

Reactions were mixed. The Gulbenkian Foundation liked the idea so much that it asked us to put the proposal to its Arts Initiative and Money (AIM) committee with a view to obtaining seed-money so that we could take the idea further. The discussions ultimately foundered and we withdrew the application we had been asked to make. Several sponsors replied with favourable reactions, in that they thought the idea a good one, and took the time to make a number of constructive criticisms. One of the most encouraging replies came from the head of public relations of one of the major banks who said that he had sought the views of a banker colleague. 'He first of all thought your proposition was hopeless, but on closer examination he agrees with me that it is highly original and contains a lot of sound sense'. He went on to say, 'there is no doubt that there is indeed a need for this kind of source of funds, particularly with those arts activities which find it difficult to attract commercial sponsorship'. He

concluded by telling us frankly that he thought our chances of finding sponsor members were low.

Tony Gamble and I, with other, pressing, things to do, decided that the best thing to do was to let the idea lie until circumstances were more favourable. Perhaps the idea was simply ahead of its time.

What follows is a resumé of the Diggle/Gamble paper.

The Artsbank Idea

The idea of Artsbank grew from two sources: the first, my concern with our system of subsidy and the second, my belief that success derives from individuals not organisations. Invaluable as it is and in spite of all the care that goes into its disbursement, subsidy is not being used to best effect; it is directed where there is seen to be need and where the quality of the organisation is judged to be worthy of it. Both of these criteria are perfectly reasonable—in an earlier life they were the criteria that I used when I made recommendations on applications for grant aid—but they do not recognise the prime objective that an arts organisation must have, which is to have its high quality art experienced by as many people as possible. Money, earned money, cannot be separated from this objective for the more money that is earned the more art there will be to be experienced. If the arts organisations are to be vital their focus must be upon people and upon money as well as the artistic activities that are the reason for their existence. If more money is earned it could be argued that the organisation's need is lessened and so its entitlement to subsidy is lessened also, but the organisations have come to see growth in subsidy as being one of the measures of their success so we are faced with a paradox.

The present system takes a very optimistic view of the arts organisations that it subsidises; it assumes that they will always try to achieve the best they can and that they need no more incentive than their own ambition and pride; it fails to recognise that organisations are just that—organisations—and organisations often do not have a corporate ambition or a corporate pride. The arts system is made up of many small arts organisations, some successful, others not so. The successful ones all have one common characteristic, the presence at a senior level, of at least one individual who is totally dedicated to the success of the organisation. Such individuals, who are highly motivated through their ambition and pride (clearly I see both as virtues), also have the professional competence to carry their organisations through to success. We may fairly assume that such individuals also exist within the less successful arts organisations but they may be either too low in the management hierarchy to have any real influence or they may be overwhelmed by other factors such as inadequate funding or a dominant but conservative committee.

These individuals are vital to the health and success of the arts organisations of the country because they provide the will, the driving force. The subsidy system, with its view concentrated upon organisations, does nothing to encourage and reward the individuals beyond supporting the organisations that employ them. The progress of these people through their careers is haphazard and wasteful for a variety of reasons. There is no overall career structure but rather a whole mass of tiny career structures. There is not one big pyramid but lots of small pyramids that are not in any practical way connected. In the arts context this is a contributory factor to the problem because success in one part of the country does not automatically mean recognition in another. Appointments, and hence career improvement, are usually decided by committees of lay people who may be able to recognise the outstanding individual (that is, someone who has managed to climb to the top of a pyramid) but, in general, do not have the ability or experience to spot the individual of high potential. Also, there is no yardstick of success for the individual just as there is none for the organisation. The outcome is that people of talent often become stuck on the top of their particular pyramid, or worse, are left lodged halfway up one where they are invisible; they become frustrated and either leave or slowly lose their drive.

The Artsbank idea offers a way of helping the subsidy system to get more for its money. It can help the arts organisations to see success for what it really is and it can provide the financial help necessary to overcome the barrier of risk. It also sets out to build relationships with individuals rather than organisations alone so that the successful Artsbank 'customer' carries his or her 'creditworthiness' through a career, irrespective of place or type of arts organisation and can thus assist in their career growth which, in turn, will make the organisations healthier and more success-orientated.

Sales are the real barometer of achievement and in most cases it is in this sector that the potential for growth, and hence progress, exists. Sales—sales of any kind, whether at the box-office or anywhere else—do not happen unless money is spent and in a buoyant, efficient and achievement-conscious organisation, the more money that is spent the greater will be the income from these sales.

Unfortunately, the present system does not encourage the spending of more money; indeed, when the level of subsidy is threatened and when the overall state of the economy makes the achievement of sales more difficult, the tendency is to spend less rather than more.

The creation of a money-lending organisation, run along the lines of a bank rather than a traditional arts funding body, would be an invaluable complement to the present system and would encourage the entrepreneurial element in a consistent, reliable way. It could also do something which has never before been attempted; it could encourage and

reward the talented individuals who work in the organisations so that eventually the proposed Artsbank would build up business relationships not only with arts organisations but also with individual arts administrators and with the individual artists and craftsmen who are attached to no recognised arts organisation.

What follows is an explanation of what Artsbank might do, how it might work and how it might be brought into existence. It is emphasised that the scheme must be flexible so that it can respond to the realities as they are discovered.

The Artsbank

The idea of Artsbank is to create a central source of money that can be loaned to arts organisations, artists and craftsmen to provide short term working capital; this can be used to encourage and make possible projects that are worthwhile and ambitious within the context of the applicant and the relevant field of activity.

Basic to the idea is the need for a relationship between the applicant and Artsbank to develop over a period and for that relationship to be founded on business agreements which are adhered to. Artsbank would lend money over an agreed period at an agreed interest rate with an agreed system for repayment. Artsbank would expect to have agreements honoured. As in the normal bank/customer relationship, the consistent honouring of agreements leads to trust and the willingness to take greater risks on the bank's part.

Although Artsbank would attempt to follow normal banking criteria in assessing applications it would have to take a less stringent view and recognise the particular difficulties facing applicants; this would also apply to the conditions attached to any loan. Artsbank must, therefore, accept from the beginning that it cannot operate commercially and that inevitably, because of the risk factor and the frequent need to be generous in terms of interest rates, it will lose rather than make money.

Because Artsbank would be run on quasi-banking principles and would in every possible way be 'businesslike', it would not lose all its money, all at once. It would recirculate its money so that each pound it has is made to do the work of many pounds—unlike the subsidy system where each pound is used only once. In the process of using and re-using money it would lose some of it but Artsbank would have to be a dynamic and expanding organisation itself and would always be looking for more funds to make good the operating losses and to finance more loans. There would also be the cost of running Artsbank to be taken into account.

Artistic Quality

The present system of arts funding is heavily biased towards considerations of quality; it does not follow that a complementary approach such as Artsbank should be so orientated. A commercial bank when asked to fund a small company making, say, handbags, will be less concerned with the quality of the handbags than with the entire financial viability of the project: quality will be a factor but it will be quality in relation to cost, selling price, market demand, the handbags made by competitors and so on.

Artsbank, when created, must decide for itself how much it wishes to be concerned with quality: at this stage it is enough to say that where expert opinion is needed Artsbank has only to turn to the traditional sources of funding for guidance. It may be that in many cases the very fact of support from those sources would be sufficient for Artsbank to be assured of the worthiness of an organisation, individual or project. Thereafter it becomes a business decision as to whether a loan will be granted or not.

Criteria for Making Artsbank Loans

Artsbank would generally need to be assured of the artistic worthiness of the applicant and the project but would see this in the context of how and where the applicant was working. The interpretation of what is and what is not 'art' would be generous.

Artsbank would expect to see a defined objective within any application and a clear, rational plan for achieving it.

Artsbank must be able to satisfy itself that the applicant organisation or individual is likely to make every effort to meet the mutually agreed terms for the repayment of a loan and to this end would be influenced by how earlier Artsbank loans have been repaid. The taking up of professional and/or trade references would be advisable with new, unknown, clients.

Artsbank would relate the size of any loan to the general level of operation of the applicant and would try to avoid making very large loans to very small organisations and vice-versa.

Examples of Artsbank Loans

A festival wishes to prepare a presentation kit including slides, projector, audio commentary, brochures, colour prints etc. to be used in seeking sponsorship. The loan to be repaid from the sponsorship money raised.

An arts centre wishes to equip a small screen printing studio for the production of posters and other advertising material as well as for certain

kinds of visual arts work. The loan to be repaid out of savings made on print expenditure and from sales.

A craftsman wishes to buy equipment that will enable his products to be produced more quickly and cheaply. The loan to be repaid from sales.

A theatre wishes to enter the field of merchandising and wants to buy stock such as T-shirts, ties, scarves, bags, umbrellas and so on. The loan to be repaid from sales.

A theatre wishes to up-grade its marketing effort through greater publicity expenditure, use of sales promotion techniques and the introduction of an incentive scheme for sales staff. The loan to be repaid from sales.

An opera company wishes to produce an educational kit intended to be used in the classroom as an introduction to opera and to the company. The loan to be repaid from sales and hirings.

A dance company wishes to produce a videogram to be used in obtaining engagements overseas. The loan to be repaid from fees earned.

A choir wishes to produce and sell a record. The loan to be repaid from sales.

A regional arts association wishes to make advertising a significant part of its monthly magazine's revenue and wants to employ specialist staff for the purpose. It is under pressure not to increase its administration costs and in the present climate any increase in staff will be regarded as an increase in administration. The RAA is confident that within four months the income from advertising will be substantially greater than the cost of employing staff to sell it and a loan is required to cover the 'pump-priming' period of four months' staff salaries. The loan to be repaid from the advertising income once the project has moved into profit.

A photographer wishes to compile a set of high quality presentation folders showing examples of his colour work to be sent to art and photographic galleries overseas in order to obtain exhibitions. The loan to be repaid from his general income as a photographer.

A poetry and music ensemble wishes to produce a simple brochure giving details of what it does, what it has done, how much its fees are and how to engage it. It also wishes to advertise itself in a number of publications. It thus needs a loan to help it launch itself and will repay it from fees earned.

The Financing and Management of Artsbank

Artsbank, as a project requiring funding in itself, falls between the fields of benefit of sponsorship and patronage. Support of the project could offer a limited number of commercial sponsors very real and significant returns in terms of public relations because Artsbank embodies the very business

principles that good sponsors (i.e. good commercial companies) hold dear in their normal course of business. Provided that this limited number of sponsors was offered the opportunity of being directly involved in the running of Artsbank and that the financial support (as well as other kinds of support) was clearly stated to the world at large, it would be possible to make out a convincing case for sponsorship.

At the same time, Artsbank would clearly benefit from 'no strings' financial support, so money from foundations, trusts and private individuals would be welcomed. There would be no reason why the Arts Council of Great Britain should not contribute or, indeed, join as a member.

Artsbank would need money to pay for its own running costs and to provide a fund from which loans can be made. This fund should be in the region of £250,000 initially. We have considered two ways in which this fund might be created: both involve finding a small number of sponsors—ten, each providing £25,000, has been used as a starting point.

One approach would be to find a joint stock or merchant bank willing to grant an overdraft of £250,000 against guarantees of £25,000 each provided by the ten sponsors. The bank itself could become a sponsor of the Artsbank by providing the overdraft at a lower than usual interest rate. Artsbank then has money. At the end of the trading year, the sponsors are called upon to meet their share of whatever the final overdraft might be. To this share would be added a proportion of the running costs. In this form Artsbank would have interest charges to add to its costs. The second approach is to seek ten sponsors each willing to put up £25,000 to go into the Artsbank fund. Again, a host bank would be sought and favourable terms negotiated. This approach would allow Artsbank to earn interest which would reduce operating costs.

The running costs of Artsbank would be its administration plus or minus any bank interest. The objective would be to generate enough returns from the successful loans to cover running costs, to make good the less successful loans and to create growth in the fund through sponsorship and patronage. If this objective is not achieved and the fund is slowly eroded at least the money will have been recycled many times into many different projects. The rate of growth or erosion of the fund would rest very largely in the hands of its management.

The control of Artsbank could be placed in the hands of members who would be the representatives of the 'charter sponsors' that is, the ten sponsors putting up the £25,000 each towards the fund. Membership could, of course, be open to foundations, trusts and individuals, provided the first basic contribution was made.

There would be a board of directors, elected from the members and, initially, almost certainly made up wholly of the members. Artsbank would

have a chairman and directors who would be unpaid and receive no expenses. There would be a full-time paid director and secretary and a paid advisory panel (probably on an honorarium basis) to provide professional guidance in the fields of finance, tax, law and business. The director would be chosen for experience in both business and the arts. The advisory panel would be made up from people with expertise in their own fields when applied to the arts. The intention, cost permitting, would be to assemble the most skilled team available as this would be the best way to protect the fund.

Making Artsbank happen

What is needed now is for the idea to be given its own status and for time to be devoted to finding the first member sponsors, developing the ideas of Artsbank in further detail, agreeing a constitution—in short, taking the project through to realisation. For this to happen Artsbank needs a prime mover.

APPENDIX D

MARKETING IN THE VISUAL ARTS

One of the recurring problems I face as a teacher is to persuade those who work in art galleries that marketing has an application for them. It is easy to see why they feel the way they do. If we say that the objective of the gallery is to bring people into it so that they can look at works of art, we have a situation where it is not usual to charge for admission, where sales promotion therefore seems to be ruled out, where there appears to be no way in which the sales function can apply and where the only useful aspect of marketing appears to be publicity. If we say that the objective is to sell paintings or sculptures there is still the problem of first attracting people into the gallery. Almost always these works of art are unique items and so one of the most important aspects of marketing, the 'reproducibility' of the product is not present. Marketing for this objective reduces to a minimal level; there is the product with a price tag attached to it, there is a small group of people one of whom may turn out to be a buyer. Rare are the occasions where one would spend money advertising this one product.

The absence of income from attendances or the relatively low level of income from sales (true for most non-commercial galleries I should think) means that the 'money out to bring money in' argument does not apply. There is no real way of measuring success other than by a simple head count unless we employ what we might call the 'Tony Gamble Method of Attendance Evaluation' (see Chapter Ten) where we put a price on the head of everyone who walks into the gallery and create arbitrary goals and levels of achievement. The financial planning aspect of marketing, which provides the structure for marketing the paid-for performing arts, becomes no more than spending as little as possible whilst trying to attract as many people as possible. The galleries operating within the subsidised system with its emphasis upon product rather than audiences, have this financial strait-jacket buckled around them willy-nilly.

It is very difficult to practise marketing in the visual arts.

In response to the question, 'Just how does one use marketing in a small, art gallery?' put to me by a student in arts administration at The City University, London, I prepared a written answer that was intended to offer some helpful suggestions. What follows is based upon that answer.

The Galleries

Their characteristics are:

They are small, they have small staffs and small budgets for marketing.

They tend to have artistic policies which do not follow the public taste but are more esoteric in character; they thus tend to build up small followings of people who are in tune with their artistic policies and find it hard to expand beyond this point. These Attenders can be effectively (although not deliberately) exclusive in their attitudes towards others and can actually discourage others.

They may be satisfied with their present following and may be capable of sustaining themselves at this level (i.e. they have 'matured') or they may be unable to change the situation (because they do not know how) or they may not want to change the situation because (a) they do not approve of marketing, (b) it seems more productive to look for extra subsidy or, (c) at a personal level it is easier to look for another job when disaster strikes. Or they may decide to do something about the situation.

Artistic Policy

It is best to start by assuming that there should be no change in artistic policy. After all, the artistic policy provides the *raison d'être* for the gallery and change in this should only be considered as a last resort, in order to stave off closure.

Financial Planning

Finance is what really ties our hands. Unless the gallery is carrying out a secondary policy of selling things other than original works (e.g. prints, books, records) in some considerable volume, its only income will derive from commission on sales of original works and from subsidy. Both of these sources are unlikely to increase significantly. This means that it is extremely difficult for the organisation to set in motion the highly desirable expanding economic spiral caused by speculatively increasing expenditure to generate greater income. There is nothing that can be done about this and so the exercise is mainly about how to redeploy existing resources.

Sales

Sales, being the process of converting the desire to do something into the act of doing it, is as big a problem as the financial straitjacket. Because the

gallery does not charge for admission it cannot sell tickets like a theatre and because it cannot sell tickets it cannot bring its 'product' closer in time and distance to its market. Our publicity may be creating great excitement and interest now, five miles away, but it has all evaporated before it is any use to us. A sale, to the gallery, is what happens when someone walks into the place. If we want to achieve sales we must make our publicity very, very, powerful so that it makes people very hot about the show, hot enough for them to hold it in their minds for some time, hot enough to want to talk about it to others, hot enough for them to feel in some way deprived if they do not get to see it. This is very hard to achieve. Is there anything else that can be done to supplement the publicity, something to make people hotter about it?

Some ideas

Can you arrange special sessions where the artists and/or critics can present and talk about the exhibition? The attendance can be restricted on these occasions so that everyone is there for the session which starts at a certain time—rather than drifting in at any time which means that they usually do not drift in at all. You could charge for admission. You could sell tickets. You could sell tickets in advance . . .

Can you create the idea of membership amongst your market? It does not have to be a club as such (in fact, there is much to be said for avoiding the word altogether), but it could have club characteristics. If carefully managed the 'club' could be very supportive in terms of helping to disseminate advertising material, the members might be interested in fund raising and it would tend to encourage regular attendance. The special sessions above could well provide the core of the activities. Fortunately a gallery has much more time than a theatre or concert hall, more time to meet people so that these sessions could take place during the daytime as well as the evenings.

Rethink the 'private view' idea. What is the function of the private view? To provide an opportunity to see the exhibition, to assess it, to buy from it, to socialise. It is part PR (product and corporate), part sales. Who are invited? Critics, artists, friends and known buyers. A typical private view gathering represents the exclusive group of Attenders referred to earlier. The private view, with its club-like character, reinforces the relationship between gallery and attending group but does little or nothing to expand it. Why have only one private view? If the exhibition lasts for three weeks, why not hold 21 private views? Who would attend them? How would you find enough people? Just like a theatre you would build a mailing list from people who just happen to drift into the gallery. Develop a policy of getting hold of their names and addresses (one of the best ways is

to ask them!). Someone who walks into a gallery is, by definition, an Attender, and you must draw them closer to you. A personally addressed letter of invitation from someone in the gallery asking them to attend on a certain date at a certain time will be more effective than an impersonal printed invitation. And when they arrive do not have them floundering around, not knowing a soul and feeling lost, but have the person who signed the letter meet them and greet them—it should be just like a well organised party, with introductions to other people and an attempt made to put people at their ease.

Can you arrange other events within the gallery? This is where the arts centres score. Art galleries are amazingly hard to enter, even for 'fairly-regulars' and the smaller they are, the more intimidating they are. The intimidation is subtle and not intentional but it is there for most people and is possibly more of a barrier than art gallery folk ever realise. Lectures, discussions, recitals, poetry readings and so on, give people another reason for going into a gallery and being part of a crowd. One can be anonymous in a crowd whereas the solitary visitor alone but for the person sitting at a desk in a corner feels exposed.

Can you sell things? Not just to make money but to provide another reason for people to visit you.

Can you help people to buy pictures? I have never been in a gallery where it is easy to buy a picture. Of course, the catalogue carries the prices and there are lists available but it is still left to the visitor (who will probably be more intimidated about this than about entering the place) to make the first approach. I do not mean that customers should be hustled but something can be done to make it clear that you want to sell. Perhaps the price list could carry a short article on picture-buying, how to build a collection and what actually happens if you want that picture on the wall now. If the show is planned to last three weeks what happens if I want the picture now? And what about the cost? You know that most picture prices are negotiable. It is bad sales technique to flaunt the fact but a willingness to accept a good offer is something that people in the antique business (not so very far removed from art galleries) know how to suggest. What about credit facilities? Pictures are expensive. A £350 price tag will scare most people whereas £50 down and £25 a month for a year will scare fewer (I have not allowed for an interest charge in this because if you really want to sell you will see the interest free credit as being just another sales promotion which is the equivalent to, for example, a price reduction of possibly 15 per cent).

Can you let people see paintings being painted? Most artists would not like it but some would (perhaps artists who also work commercially as illustrators and are used to working in the company of people). To have

part of the gallery set aside for an artist at work would provide a fascinating experience for visitors.

Publicity

If we accept the idea of publicity as being a combination of advertising (which costs money) and public relations (which mainly costs time) we see we have one area where we cannot spend more (money) and one where we can spend more (time). We might also reassess the money we are spending on advertising to see if we can make savings, or redeploy, or both.

Because there is usually not a clear idea of how advertising works and how it should be used there is a tendency amongst the galleries to make the same mistakes in advertising as do the performing arts bodies. One mistake is to create advertising material that will only mean something to a few people and then try to disseminate it *en masse*. If you have lots of money this can be a good way of picking 'your' people from the crowd but the gallery usually does not have much money. Also the cost of the advertising material is often higher than it needs to be. Producing a full colour leaflet may please the artist and may please you (it will certainly please your printer) but it may not be necessary. If you have built up a mailing list of visitors then perhaps all you need is a letter which uses words to describe the exhibition and invites them to attend one of your many private views. So, if you have built up a large mailing list you spend money on postage stamps and the use of a word processor rather than on expensive printing.

Your developing mailing list is probably the most fruitful source of new customers. It is generally true that people who like something will tend to gravitate towards people who like similar things so extend your invitation to include a guest, perhaps two guests (three people are a party, remember). Make sure you get hold of the names and addresses of those guests.

For the small gallery this may be the only advertising method that can ever make sense. Everything that is being done in the way of leaflets, posters, and press advertising should be scrutinised to make sure that it is not just being done because it has always been done that way, or because you think your advertising is potent enough to turn on people who do not like the visual arts (it will not) or because you are looking for a creative outlet (paint pictures if you are).

From a PR standpoint the gallery is just the same as a theatre. You want to generate a high level of favourable awareness combined with basic information on where you are and what you are doing. The gallery has to spend time (rather than money, which it does not have) in achieving this through the media. This is why you want reviews of exhibitions to appear in the papers—but reviews are not enough. Instead of spending time thinking

up amazing advertising ideas, spend it thinking up amazing press stories and fixing up interviews for newspapers, magazines, radio and television. You have to work hard at product PR and corporate PR.

Corporate PR really begins with the gallery itself. It has a physical presence in the community and how it appears·is important. Just by being there it is forming attitudes in the minds of people who pass by. Look at your gallery from the outside, look at it as an outsider. Does it look like the kind of place you would walk into from the street, just as you would a shop? Go closer. Look through the window. Do you see half a dozen of the gallery assistant's cronies sitting on the floor having a noisy chat? Do you see an aloof, severe looking person staring intimidatingly back at you? Do you see anything of interest?

Go inside. How comfortable do you feel? Are you ignored? Are your ears blasted with loud music? Is the silence deafening?

You can see how important is the appearance of the gallery, the kind of people who work in it and the general ambience of the place. If you are serious about building up attendance all these things must be considered and managed.

What I have said here may make it appear that I think all galleries should aim for customers who are nice, quiet, respectable members of the middle class. I am not actually saying that. What I am saying is that the gallery must make up its mind what kind of place it wants to be and then look and behave like that as part of a conscious effort. If what it wants to be is really exclusive then it must accept the problems that will inevitably arise and not squeal about them.

A final note

Recently I commissioned a painting from an artist. It was a private transaction, not involving a gallery, that took place because ten years ago I went into a gallery and bought a picture by this man. I collected my new painting from his flat and was well pleased with it. He told me that some months later he would be exhibiting some pictures with several other artists in a small London gallery: I made a mental note. An invitation to attend the private view arrived but on the date concerned I was on holiday. I asked my friend Tony Gamble to go along (he had seen the picture I had bought and was very impressed with it). He attended and spent half an hour alone in a room full of people. He could not see the pictures because there were too many people. He left. Later I went to the gallery during the day time and it was empty but for the gallery director sitting at a desk talking to a girl. As I walked around I was totally ignored. The director and the girl were discussing the sexual proclivities of a mutual friend very loudly and very explicitly. Fascinating stuff! After a while I left. As it happened I did not

like the pictures painted by 'my' artist but seen from the gallery's viewpoint, there I was—not just an Attender but a real, live *Buyer*. Not just a buyer of pictures but a buyer of pictures of one of the artists in this exhibition. And they let me go!

Give your theatre the flexibility of BOCS.

GOSDEN'S
(Established 1837)
Specialists in
Music Concert Advertising
in ALL MEDIA
Newspapers, magazines, radio,
print, photography

D. GOSDEN & Co. Ltd.
Suite 25-30
12/13 Henrietta Street
London WC2
Tel: 01-240 2121
Telex: 261830 CARADO G

THE CITY UNIVERSITY
Centre for Arts and Related Studies

TRAINING FOR ARTS ADMINISTRATORS

M.A. (Part-time) IN ARTS ADMINISTRATION
Attend the University for one day a week for four terms, then write an in-depth report. A course for practising administrators taken without interrupting a career. A number of local authorities have already supported employees of the course.

M.A. (Part-time) IN LIBRARIANSHIP AND ARTS ADMINISTRATION
This course is intended for senior staff in the public library service who are seeking to advance their qualifications (details of this course are available from the department of information science).

M.A. (Part-time) IN ARTS MANAGEMENT IN EDUCATION
A new course starting in October 1984 designed to meet the requirements of those working in education concerned with the arts.

PRACTICAL TRAINING SCHEME
This scheme is run in conjunction with the Arts Council of Great Britain and involves periods of secondment with arts organisations and six weeks spent in the University. Arts Council Grants available.

RESEARCH
Facilities exist for students to study for the degrees of M.Phil and Ph.D. by submission of a research thesis. Practising Administrators wishing to pursue their own research may use the Centre's Resource Rooms by arrangement.

IN-SERVICE COURSES
A number of intensive short courses are offered during the spring of each academic year. In addition there is a programme of occasional forums, one-day courses and short courses offered in conjunction with other organisations.

Details can be obtained from the Arts Administration Department, Centre for Arts, City University, Northampton Square, London EC1. Please enclose a 9″ × 6″ SAE.

M&T J
LIMITED
IN THE FRONT ROW OF THEATRICAL PRINTING
89/91 Norwood Road, London, SE.24 9AW. Telephone 01-671 3211

TO HELP YOU IN YOUR WORK ...

CLASSICAL MUSIC MAGAZINE
The fortnightly news magazine for music, opera and dance covering all aspects of performance and music education. Special artists' advertising feature *Concert Choice* and a host of job opportunities.

CONCERT CHOICE ANNUAL INDEX
The concert promoter's guide to performing artists in music. Paperback.

BRITISH MUSIC YEARBOOK
The indispensable directory for everyone involved in music plus a review of the previous season by leading writers. Paperback.

KEITH DIGGLE'S GUIDE TO ARTS MARKETING
A theoretical and practical approach to audience building. 'Literate, lively and lucid', Danny Newman author of best selling *Subscribe Now:* Hardback and paperback.

BRITISH MUSIC EDUCATION YEARBOOK
A directory of musical training throughout the UK educational system — from choir schools to further education. Paperback.

THE MUSICIAN'S HANDBOOK
Everything the aspiring and practising musician needs to know for a long and successful career. Paperback.

WHO'S WHO IN ARTS MANAGEMENT
For the profession about the profession, a directory of arts managers in the UK and those from the UK working abroad. Paperback.

For further details, please write or telephone:

R• RHINEGOLD PUBLISHING LIMITED
52A FLORAL STREET LONDON WC2E 9DA
01-836 2534